The DUKE of WELLINGTON, *KIDNAPPED!*

Library of Congress Cataloging-in-Publication Data is available.

Cover design by Jarrod Taylor
Interior design by Tabitha Lahr

ISBN 978-1-61902-591-2

Counterpoint
2560 Ninth Street, Suite 318
Berkeley, CA 94710
www.counterpointpress.com

Printed in the United States of America
Distributed by Publishers Group West

10 9 8 7 6 5 4 3 2 1

The DUKE *of* WELLINGTON, *KIDNAPPED!*

THE INCREDIBLE TRUE STORY OF THE ART HEIST THAT SHOCKED A NATION

ALAN HIRSCH

INTRODUCTION BY NOAH CHARNEY

COUNTERPOINT

Berkeley

INTRODUCTION

The only successful theft from London's National Gallery took place on August 21, 1961, when a brazen thief stole Goya's *Portrait of the Duke of Wellington*. One of the most bizarre incidents in the history of art theft, the Goya heist baffled police. Someone somehow sneaked into the National Gallery through an unlocked bathroom window, evaded security guards, and made off with a painting that had just been saved from sale to an American tycoon by the British government. The portrait of the English war hero had gone on display at the National Gallery on August 3—less than three weeks later, it was gone.

The press had a field day, and the theft infected the popular imagination. In the background of the first James Bond movie, *Dr. No,* which was filmed soon after the crime, one can see a copy of the missing Goya portrait decorating Dr. No's villainous hideout.

Just ten days after the theft, the London police received the first of many bizarre ransom notes. They promised the safe return of the painting in exchange for discounted television licenses for old age pensioners.

Surely this was a joke? But the ransomer identified marks visible only on the back of the painting, proving that it was in his possession. The ransomer, whose notes were theatrical and flamboyantly written, thought it outrageous that the British government would spend a large sum on a painting when retired British citizens had to pay to watch television. There seemed to be no personal motivation for the theft, only outrage at the government's TV license scheme.

But the police would not negotiate, and a merry dance ensued: part true crime, part farce, all fascinating and set against the backdrop of Swinging Sixties London. The story is irresistible, and perhaps the biggest surprise of all is that there has never been a book on the most famous art heist in British history—until now.

Alan Hirsch's fine book tells the story of a cinematic, quirky, relatively harmless art crime—the sort that echoes popular film and fiction (it certainly sounds implausible) but that represents the exception in this type of crime rather than the rule. Thanks to media attention, we tend to think of art crime as a handful of big, bold, entertaining museum heists of famous artworks per year. In fact, tens of thousands of art crimes are reported every year the world over. (And many more go unreported.) Knowledgeable sources like SOCA (the UK's Serious Organized Crime Agency), Interpol, and the US Department of Justice have noted that art crime is among the highest-grossing criminal trades worldwide, up there with the drug and arms trades, and is a major funding source for organized crime and even terrorist groups, as recent headlines regarding ISIS have made painfully clear. It is certainly not just the art that is at stake.

While all the tea in China couldn't convince me to spend a day with armed fundamentalist terrorists, I'd gladly take tea with Kempton Bunton, the portly retired cab driver at the center of Alan Hirsch's book. He is the sort of character who would be more at home in a nineteenth-century comic novel than a real-life art heist. When I teach the history of art crime at the ARCA Postgraduate Program in Art Crime and Cultural Heritage Protection, which runs every summer in Italy and is the only interdisciplinary academic program in the world where one can study art crime, Bunton is inevitably the best-remembered of the scores of thieves, traffickers, forgers, tomb raiders, and, yes, terrorists my students encounter. While his bizarre story is an exception to the general rule of art crime as sinister and very serious indeed, it is a bright star among real stories that often eclipse their cinematic counterparts in panache, surrealism, and audacity. Everyone loves a quirky character, everyone loves a true crime story (especially if it has a cinematic courtroom scene at its heart), and everyone seems to love to hear about art theft. This book has it all. As long as the realities are kept in perspective, we can choose the charming true crime story over more gruesome, messier ones. And you'll find no true story in the history of crime that is more charming, implausible, and Dickensian than this one, cleverly told by Hirsch. It is a must for anyone who likes to be entertained and diverted while also receiving a sound and important history lesson.

When Bunton's case went to trial, the defense ingeniously invoked an odd loophole in British law. It had to convince a judge who, like Bunton, seemed to have tumbled out of the pages of a Dickens novel. The courtroom drama that ensued was sometimes hilarious, sometimes tense, and always riveting, but was the wrong man on trial? This book provides the definitive answer. It also explains how the case sparked a major change in UK's criminal law.

Another law eventually changed too. Television licenses were revoked for old age pensioners, satisfying, long after the fact, the unusual ransom demands of Kempton Bunton. Floating on his cloud up in heaven, Bunton must be looking down upon us with a satisfied smile. For not only was his motive for the theft (eventually) fulfilled, but for decades the police believed what he wanted them to: that he was, in fact, the thief.

Drawing from exclusive new archival material, including Bunton's own unpublished memoirs, Alan Hirsch sets the record straight and, for the first time, tells the complete story of London's most famous art theft and kookiest criminal.

Dr. Noah Charney
Ljubljana, Slovenia
February 2016

For more information on real art crime and how to study it, visit www.art crimeresearch.org.

FOREWORD

For years I planned to write a book about the theft of Goya's *Portrait of the Duke of Wellington* because it had everything: an impossible crime and wacky investigation culminating in a bizarre confession and courtroom drama; a stranger-than-life culprit with a ludicrous motive; and an outcome so improbable that it inspired the United Kingdom to change its criminal code. All of that would have been more than enough, but something extra made the case irresistible: I doubted Kempton Bunton's guilt. The only thing better than top-flight true crime is unsolved top-flight true crime.

While I planned to research the case thoroughly, I was under no illusion that I was likely to solve the case. After all, the theft had taken place a half century before, and most of the major players, including Kempton Bunton, were deceased. But I could pore over the trial transcripts and National Gallery records and talk to members of Bunton's family (if they were willing) and the few survivors with some connection to this ever-receding event. Even without solving the crime, there was a great story to tell.

I took the opportunity of the fiftieth anniversary of the crime, in August 2011, to author two articles: one for the Association for Research into Crimes Against Art (ARCA) website and the other for the *London Guardian*. The articles were coauthored with Noah Charney, a leading art crime writer who shared my fascination with the story and encouraged me to pursue it. Each article expressed skepticism that Kempton Bunton was the actual thief; the articles further noted that I was working on a book about the case.

The publication of these articles triggered an incredible event: an email from someone claiming that we were correct about Bunton's innocence and implying that he could prove it. He also revealed something almost as intriguing: After his trial and conviction, Kempton Bunton had authored an autobiography. My new correspondent claimed that he could help me get my hands on Bunton's unpublished memoirs.

But the man came armed with demands. He would share his knowledge about the case only under certain conditions that were difficult to meet. How this all played out will be revealed in due course. For present purposes, suffice to say that the man eventually came through, leading me to crucial new information about the case and to Kempton Bunton's memoirs.

The memoirs evince an attitude at times in sync with what everyone knew about Bunton, but at times sharply discordant. The surprises start with the fact that Kempton Bunton, bookie and lorry driver, had a real flair as a writer—a most engaging storyteller. His colorful recollections, like the new information about the case, proved indispensable to the story that follows.

Chapter 1: **MISSING**

Scotland Yard detectives receive many calls a day, and each one stirs them, if only a little, because it could be *the* call, the one that changes everything. It could bring word of a crime that seizes the imagination of the nation or even the world. Solve it and you carve out for yourself a permanent niche in the annals of history. Fail to solve it and the case becomes a migraine that never completely goes away.

Such a call came the Yard's way on the morning of August 22, 1961. A prominent painting had been stolen from England's leading art museum, the National Gallery in London—the first such occurrence in the gallery's 137-year history. One week later, *Time* magazine would describe a theft "so brazen that Agatha Christie herself would most likely have dismissed it as too farfetched even for Hercule Poirot to solve." *Newsweek* weighed in that it was "the most spectacular art robbery since an Italian workman lifted the Mona Lisa from the Louvre"—exactly fifty years to the day. The prominent journal *Arts Review* went further, calling it the most spectacular art theft of the century. The feverish response transcended the short-lived hype that often greets juicy current events. More than three decades later, in his book about historical robberies, Sean Steele still ranked this theft "the most famous art rip-off England has ever known."

How could someone seize a closely guarded painting undetected and undeterred by a world-class security system never before penetrated? Another London museum had experienced a high-profile theft just five years earlier. In 1956 *Summer Day,* by French impressionist Berthe Morisot, had been taken from the Tate Museum. As it happens, Morisot's work had belonged to the National Gallery until 1955. Could it be written off as a coincidence that it was stolen so soon after it moved? Perhaps not. Perhaps the gallery's reputation for tight security deterred theft, even made it seem unthinkable. When a painting left the gallery, suddenly it became fair game.

The fact that the August 1961 theft from the National Gallery was unprecedented only begins to explain the hoopla that ensued. The thief (or thieves) hadn't taken any old painting but rather one of the nation's most treasured works of art—Francisco Goya's *Portrait of the Duke of Wellington*. They hadn't simply stolen a valuable object; they had kidnapped England's foremost military hero. The Duke of Wellington (christened Arthur Wellesley) is akin to America's George Washington or France's Napoleon. Indeed, he *bested* Napoleon. Even without that crowning victory at Waterloo, Wellington achieved Napoleonic stature. He was a hero for the ages—for thirty-two years his nation's leading military officer, who did not lose a single important battle. Military historians credit the duke with mastering the art of defense, enabling him to defeat numerically superior opponents. Whatever the method, his track record on the battlefield surpassed the body of work of Napoleon and Washington.

In one respect, though, the duke lagged far behind his French and American counterparts. Napoleon's official portraitist, Jacques-Louis David, produced several memorable portraits of his patron, and painting George Washington was virtually required among leading American portraitists. Depictions of Washington at various stages of life by Gilbert Stuart, John Trumbull, Charles Willson Peale and his son Rembrandt, among others, appear in museums around the United States. For whatever reason, British artists produced relatively few portraits of the Duke of Wellington, and none by an artist as celebrated as Goya.

But while painted infrequently, Wellington had the good fortune to be immortalized by two masters: not only the Spanish painter Goya but also the great British poet Lord Alfred Tennyson. In his funeral ode for Wellington—nine stanzas and 281 lines of mournful exaltation—Tennyson christened him "The Great Duke" and "England's greatest son."

Goya's *Portrait of the Duke* (1812) stemmed from a rare crossing of paths of two world historic figures from different nations and realms. The painting was an act of transnational homage—a Spanish master honoring a British warrior who had recently helped liberate Madrid from the French. Rumors that the two giants did not get along only added to the lore surrounding the portrait. According to one popular if apocryphal story, Goya persuaded the duke to pose by threatening him with a pistol.

Perhaps belying this improbable tale, Goya actually painted three portraits of the Duke of Wellington. Two are minor works known only to scholars and connoisseurs: a hastily composed equestrian portrait (now in the Wellington Museum at Apsley House at Hyde Park Corner in London) and a red chalk drawing intended as a study for the equestrian portrait (which now sits in London's British Museum). But the third portrait, the one that really matters, was altogether different. Art historians consider it one of Goya's more extraordinary works.

Internal National Gallery documents describe Goya's duke as "strained but full of energy, as well he might be after he defeated the French in what has been described as his most brilliant victory and while he was yet enjoying only a brief lull in his campaign." The half-length portrait on a fairly small (27" x 25") canvas depicts Wellington in resplendent glory, wearing a crimson military coat adorned with metals, including the Order of the Golden Fleece, awarded to him by the Spanish government. Goya set the duke against a plain dark background, but the portrait itself is richly colored—unusual for Goya, who was much afflicted with illness and depression starting in the early 1790s and thereafter generally given to somber coloring.

In Goya's hands, the duke's jutting jaw projects power, but his tense expression seems more meditative than martial. The left of his large blue eyes is alert and focused on the viewer, but the right is lazy and gazing off to the side. A gap separates the only two teeth revealed by his parted lips. Goya's duke has a sharper, more angular face than other depictions of the man, and his intensity practically leaps off the canvas. Even so, the brightly lit forehead and contemplative countenance suggest a man of thought as well as action. Despite his decorated military garb, Goya's duke seems more troubled than triumphant and exudes no sense of self-grandeur. It is a portrayal befitting a man who once said, "Nothing except a battle lost can be half so melancholy as a battle won" and "I am wretched even at the moment of victory."

The Spanish understandably did not share the duke's ambivalence about victory, at least not the one that had rescued them from foreign oppression, and he was feted on his entry into Madrid by a rapturous public. Goya depicted the liberator with vigor appropriate to the occasion. The portrait of

the most famous Englishman by one of Europe's most celebrated painters, to mark a momentous achievement, had few art historical precedents.

The British treasured this painting but did not own it, as they were painfully reminded on June 14, 1961, just a few months before the painting's disappearance. The Duke of Wellington had given the portrait to a sister-in-law, the Marchioness Wellesley, who bequeathed it to her sister Louisa, wife of the seventh Duke of Leeds. The eleventh Duke of Leeds lent it to London's National Portrait Gallery, where it resided from 1930 to 1949, but he eventually decided to auction it off. Sotheby's held the auction on June 14, 1961, which became a day of infamy in Great Britain. The painting was purchased by . . . *an American.* Charles Wrightsman, an oil tycoon and trustee of New York's Metropolitan Museum of Art, bid £140,000 (or $392,000—the equivalent today of roughly $3 million) and came away with a nation's proudest canvas.

Wrightsman, known for his staggeringly impressive and eclectic private collection (which included paintings by Renoir and Vermeer and an extensive assemblage of furniture once belonging to Louis XV), presumably planned either to keep the work for himself or to donate it to the Metropolitan Museum of Art. Either way, England was mortified and desperate. The day after the fateful auction, Conservative members of Parliament convened the Arts and Amenities Committee and summoned for questioning Selwyn Lloyd, the chancellor of the Exchequer (the British equivalent of the secretary of the US Treasury). Members grilled Lloyd about the debacle, demanding to know why the Exchequer had not bid for the painting. The failure to do so seemed especially galling given that the Exchequer had recently authorized a grant of £163,000 to purchase two paintings by Renoir. Lloyd, once described by eminent British historian Arthur Marwick as "inarticulate almost to the point of incoherence," unsuccessfully tried to fend off the attacks.

Other members of Parliament, less interested in pillorying Lloyd than proposing a solution, emphasized that the nation was not without legal recourse and urged action to prevent the loss of *The Duke.* British law decreed that artworks more than fifty years old have an export license, and some suggested that Wrightsman be denied one. Lloyd agreed to look into whether "a license should be refused because of the picture's national importance." He

would refer the matter to the appropriate body—the Reviewing Committee on the Export of Works of Art.

British law also authorized a seven-month freeze on the export license to enable the raising of funds to keep the work in the UK. Though this law may seem a quirky carryover from quaint times, it accommodates a reality that continues to surface in the modern art world. For example, in 2003 the law was invoked to freeze the sale of Raphael's *Madonna of the Pinks* to the Getty Museum in Los Angeles, and the National Gallery subsequently raised £39 million to purchase the work and prevent its export.*

Would such a law be invoked in 1961 to prevent an American from raiding England's treasures and taking *The Duke of Wellington*? Chancellor Lloyd said that this question, too, would be referred to the Reviewing Committee on the Export of Works of Art. But after the government froze the sale, the legal maneuvering was short-circuited by Wrightsman. Fortunately for the UK, *The Duke*'s new owner was allergic to controversy. (He once remarked that "Mrs. Wrightsman and I lead a very quiet life and we try to avoid publicity. . . . I had a father who told me, 'I never saw a deaf and dumb man in jail.'") He offered the painting back to the National Gallery at cost, because he "would not wish to export the painting if it was considered of overriding aesthetic and historical importance to Great Britain."

That still left the National Gallery in the position of needing to raise £140,000. Its director, Sir Philip Hendy, declared that the gallery could not raise such an amount by itself but would be delighted if others came to its assistance. The *London Times* revealed that, in the run-up to the original Sotheby's auction, the gallery trustees had raised a mere £8,600, which explains why the gallery hadn't bid—the bidding began at £10,000. Even raising the £8,600 had been a hardship, requiring the gallery to use all its available resources as well as successfully elicit a £5,000 contribution from the National Art-Collections Fund. Perhaps the gallery could have come up with more if anyone had anticipated that an American would win the bidding.

* *The United States witnessed a similar phenomenon in 2008 when Walmart heiress Alice Walton purchased Thomas Eakins's* The Gross Clinic *from the Philadelphia medical school where it had hung for seven decades. Walton intended to bring the painting to the Crystal Bridges Museum of American Art in Arkansas, but public and private funds combined to trump Walton's offer and keep the painting in Philadelphia.*

In any event, upon hearing Wrightsman's offer, a Conservative member of the House of Commons, Sir Hamilton Kerr, called on Chancellor Lloyd to commit the government to making a special grant to the gallery to acquire the painting. As it happens, only limited government largesse proved necessary. In early August, the Wolfson Foundation, a private philanthropic organization established six years earlier and dedicated to funding the arts and sciences, agreed to contribute £100,000, or five-sevenths of the purchase price. Parliament approved the remaining £40,000, which was provided by way of a special Exchequer grant. All ended well: Goya's *Duke* remained in England, and everyone hailed the public–private partnership that made possible his rescue from the foreign predator. Indeed, the Wrightsman bid had proven downright beneficial. The United Kingdom now owned the painting. A leading member of Parliament put out a statement thanking everyone in sight and exulting that "a great and historic picture should now become the property of the nation."

The National Gallery capitalized on the publicity surrounding the near loss of *The Duke*, putting the painting on special exhibit beginning on August 2. It hung alone on a portable easel in the North Vestibule, on brackets to enable instant removal in case of war or fire. With the recent auction and its aftermath having reinforced the sense of Goya's portrait as a national treasure, the painting drew more than five thousand visitors daily. Nineteen days later, it vanished.

Shocking though the theft was to England, it was just another in a string of major art thefts worldwide. The previous eighteen months had produced seven significant thefts in southern France alone. The latest, the pilfering of eight Cézannes totaling roughly $2 million from the Vendôme Pavilion in Aix-en-Provence, occurred just a few weeks before the taking of *The Duke*. In the week prior to that, on July 28, thieves made off with $1 million worth of art, including six Picassos, from famed Pittsburgh steel man and art collector G. David Thompson. In the wake of this rash of thefts, the media coined and bandied about a new term: *paintnapping*.

Two weeks before the taking of *The Duke of Wellington*, *Time* magazine made a droll observation that would later take on special significance. Noting a few partially botched thefts that had damaged masterpieces, the magazine

suggested that "stealing art is a branch of burglary suitable only to the most skilled criminal. . . . But with all the news of high prices at art auctions and of recent art burglaries all over, a lot of crooks of the wrong kind are getting into art theft." Indeed, the possibility of inadvertent damage by sloppy thieves weighed on the custodians of culture. Concerned about the delicate condition of Goya's *Portrait of the Duke of Wellington,* National Gallery director Philip Hendy publicly appealed to the thief to "protect it from moisture and strong light."

Though art theft had become increasingly commonplace, to the British public, the taking of *The Duke* obviously merited special attention. The media gave it saturation coverage. "NO GOYA—NO CLUE" screamed the *Daily Express* headline. The *Guardian* explained why this theft was more noteworthy than the theft of the Berthe Morisot painting from the Tate just five years earlier. In the prior case, "the sensation was dampened by the fact that everyone believed it to be a political gesture. And so it turned out to be."* Moreover, Goya's *Duke of Wellington* was "valued at 10 times as much as the Morisot." The day after the theft, the *Times* began its large cover story, "£140,000 GOYA VANISHES," with characteristic sobriety: "Goya's portrait of the Duke of Wellington has disappeared from the National Gallery, it was announced yesterday."

The *Times* reported that the painting was noticed missing a little before 11 P.M. but was initially thought "removed for a legitimate purpose, such as being photographed elsewhere in the building." Once it was discerned that the painting had in fact been stolen, an intensive search of the gallery was followed by the calling in of Scotland Yard. In addition, "Interpol have been warned and ports and airports are being watched to prevent the picture from being smuggled out of the country."

The *Times* further noted that when the gallery opened at 10 A.M. the next morning, members of the public who inquired about the empty spot where they expected to see *The Duke* were told that the painting had been removed for conservation—which must have struck experienced museum-

* *The culprits were partisans in a long-standing dispute over a bequest. The will of Sir Hugh Percy Lane, who died in 1915, bequeathed his extensive art collection to the gallery, but a later codicil bequeathed it to the city of Dublin. The gallery held on to the works until 1959, when an agreement specified that it would lend half of the works to Dublin every five years.*

goers as odd, given that it had been put on special exhibition just three weeks earlier. It wasn't until 3 P.M. that the public was notified of *The Duke*'s disappearance.

A separate sidebar in the *Times* noted that 1961 had been a banner year for art thieves throughout Europe and North America and observed that "the wide distribution of the thefts might suggest that an international gang is at work." This article further noted, "The motive for them seems obvious enough, namely the huge monetary value placed on works of art at present," but "how and why they may be disposed of is more of a puzzle." It closed by observing that "no doubt many thieves count on being able to extract some form of ransom"—an observation that, before long, would prove prescient in the case of the missing *Duke*.

The ensuing days witnessed extensive coverage and, on days when there was no news related to the theft, letters to the editor. On August 25, 26, and 28, the *Times* ran letters under the identical title, "The Missing Goya." The August 25 letter criticized security at the National Gallery, with an emphasis on the missing painting going unreported for many hours. A letter to the editor published the next day praised the earlier letter for drawing attention to the weaknesses in gallery security and proposed a solution: Trustees, currently appointed by the Treasury "from the same small group of artists and connoisseurs," should henceforth include some people with "practical experience of security in other fields." A short letter two days later cautioned against quick fixes that would create a "false sense of security." On August 31, the *Times* ran a piece that echoed the concerns cited by readers in their letters and called for an "independent inquiry" because "the nation's art treasures are too precious for their safety to be left in the least doubt."

The issue of museum security became paramount. Eric Crowther, an attorney who later became involved in the case, recalled that the theft "had considerable repercussions, even worldwide." Especially considering the earlier rash of thefts, museums felt nervous about security and underinsured. In Britain, Prime Minister Harold MacMillan's government proposed a charge for museum admission to raise money for heightened security. The measure never took, but individual museums adopted other means of safeguarding their collections.

Meanwhile, the theft produced a short-term benefit to the National Gallery. All the publicity led to a spike in visitors (from the usual August average of five thousand daily to more than seven thousand in the weeks following the theft), and reportedly even more people came to see the empty space where *The Duke* had hung than had come to see the painting itself.

Chapter 2: TOM SAWYER MEETS OLIVER TWIST

In the opening paragraph of his unpublished memoirs, Kempton Bunton observes, "I always went my own way regardless of the frowns and comments of others," a self-judgment confirmed by history. On the other hand, not everything Bunton says in that opening paragraph is equally believable, starting with his promise to provide "the plain unvarnished facts" of his life. Even assuming Bunton could be trusted to give an entirely accurate autobiographical accounting (a tall order for anybody), *plain* and *unvarnished* are adjectives not applicable to the bizarre memoirs recounting his incredible life.

Commentators have remarked on the nursery rhyme quality of his name, and Kempton Bunton himself observed in his memoirs that Kempton was "a strange name, and one which I have never come across again in my sixty odd years." Apparently Bunton's mother, fond of the racetrack, named her boy after an accomplished British jockey, Kempton Cannon, who, riding a horse she had wagered on, won the ballyhooed Epsom Derby just days before she gave birth to a son on June 14, 1904.

The equine origin of his name apparently stuck with Bunton. Throughout his life, whenever asked how to spell or pronounce his unusual name, he would reply "Kempton, as in Kempton Park racecourse"—a well-known course in a western suburb of London. Bunton's double association with horse racing is appropriate, given his dalliances with bookmaking and his eventual notoriety for an egregious gamble.

In his memoirs, Bunton describes having a mother from "hardy working stock," and primarily businessmen on his father's side of the family. He recalls his paternal grandfather with particular fondness and vividness. He was a blacksmith who acquired substantial wealth through lucrative real estate deals but whose personality made more of an impression on Bunton: "a Rebel, often at war, defying the local Council over drains, boundaries, or what

have you, and the curious part is that he too, would seemingly always lose." He too? No other losers were referred to, leading one to conclude that the un-named fellow loser in this passage is Bunton himself. The memoirs poignantly convey a man at war with the world and getting the worst of it.

Bunton's father, Harry, one of fifteen children, was a bookmaker, or "turf accountant," who impregnated the housemaid, Dorothy Hudspith. In Eng-land in 1899, this must have been shocking on several levels. In the telling of the man whose birth would result from this impropriety, this "lurid happen-ing" triggered the prompt sacking of Hudspith, "the only thing which could be done in that Victorian era." But young Harry Bunton shocked everyone by declaring his love for and intention to marry the disgraced wench. So he did, and he was promptly fired from the family contracting business.

Newly married, unemployed, and facing a tough economy, Harry joined the army. He was based in Aldershot, three hundred miles from the family home in Newcastle upon Tyne, a situation he found unfortunate and unfair. So he did the natural thing and walked the three hundred miles home. But the army scooped him back up, and the young man became reconciled to life in the military. Indeed, he soon found himself promoted to the cavalry, where he served in the Boer War—sans "medal or heroics," according to his future son, "but no doubt of some help to the making of an empire."

When he returned from the war, Harry Bunton worked various jobs for modest wages and promptly squandered at the racetrack whatever dispos-able income he managed to attain. Though his wife's street-corner business selling dead rabbits brought in a bit more cash, the Buntons struggled. They lived in a small house in Byker, a suburb of Newcastle. It is unclear whether they engaged in a shady activity Kempton Bunton claims was accepted in that time and place: "It was common practice for familys [*sic*] to run up arrears of many months, and then with the aid of a wheelbarrow, shift to another house a few hundred yards away, and start afresh leaving the landlord to sing for his back rent."

The family fortunes changed when Bunton was a year old, when his fa-ther launched his own business as a street bookmaker. From noon to two each afternoon he accepted bets, and he paid off winners at six that evening. Bunton notes that these transactions, while "illegal of course," continued for

some time, "mostly in favor of the booky [sic]." Harry Bunton accumulated sufficient cash to gain a reputation as "the millionaire of the district." His newfound wealth attracted women, "which in turn attracted bitter feuds between his lawful wife and himself."

Actually *bitter* seems euphemistic. Kempton Bunton recalls his mother bopping his father over the head with a "heavy glass ornament" and Harry retaliating by slashing her dresses with "an old type of cut throat razor." The unhappy couple stayed together, raising Kempton, his older brother (who would die from an abscess when Bunton was nine), and three sisters.

Bunton's teenage years combined the swashbuckling ne'er-do-well rebelliousness of Tom Sawyer with the hardscrabble privation of Oliver Twist. He received no formal education ("very few people worried about my schooling, least of all myself") and starting at age twelve took on a dizzying array of jobs. His mother, whom he describes as "fat and aggressive," somehow became owner of a tavern in Amble, thirty miles north of Newcastle, and put twelve-year-old Kempton to work as a bartender. Needless to say, this was a challenging assignment for a preteen, who on one occasion had to tell a pair of feisty seamen that neither beer nor whiskey was on tap. They accepted the only available alternative, brandy, and after substantial indulgence were literally fighting drunk. His mother returned from shopping just in time to avert a disaster, and she "gave me a lecture about serving spirits to young seamen."

Amble was site of the happiest memories of Bunton's gritty childhood— "fishing, digging for sand worms, swimming back and forth across the harbor"—but he rarely fared well on the employment front. The boy bounced from odd job to odder job (bartender, shipyard digger, tea boy, tea maker, seaman, bookie, cook, auto mechanic, driver, and salesman), getting fired or quitting in each case, usually in the wake of some malfeasance by himself or others.

He took these jobs less as a matter of financial necessity than because his mother wished to keep him out of trouble, but the occupations repeatedly failed to achieve that goal. Not only did his employment invariably end in mishap, but Bunton managed to find time for mischief in the off hours. Indeed, Bunton as scofflaw is a recurring theme of his memoirs. He casually recounts "scallywagging around with a group of orchard raiders, sour apples are the coveted loot," and "illegal sailings in the harbor with other people's

boats" as well as assisting his father's illegal bookmaking operation, where crime begat crime: Harry Bunton routinely bribed the police to avoid a bust.

This is all recounted somewhat self-effacingly and with the occasional burst of surprising literary flair. This uneducated man writes passages like the following apropos of his mother preventing him from getting on a steamship that ended up being torpedoed by the Germans: "Such are the fates in which we flitter, and who can call himself really lucky until he is dead?" The echo of Sophocles ("Count no man happy until he has passed his final day free from pain") is perhaps even more impressive if it was inadvertent.

Bunton's frequent unself-conscious asides take on special meaning in light of his subsequent history. He writes, for example, that "a biography to be worth its salt, must deal with all sides of a person's nature—everyone has at times done something which they ought not to have done, and even though the years may have covered up these 'dark deeds' in obscurity, it is only right they should come to light." That observation comes in reference to his accepting a bet from a drunkard on a horse that paid off one hundred to one, with the winning ticket never claimed because the drunkard forgot he had made the bet. Despite presenting the story in confessional mode, Bunton says, "I never considered [not paying him] as a mean act," because his father frequently gave the man free drinks, so he "received the money in bits." Throughout his memoirs, he comes across as master in the art of rationalization.

He also comes across as a schemer and a dreamer, with a knack for adventure and pulling off the improbable. He boasts about using inside information gleaned from his bookmaking to "pinch points" at the racetrack, a process that required "flitting from course to course." Bunton won a fair amount of cash but never amassed a fortune because he was a spendthrift. In general, he paints a self-portrait that would shock those who knew him only as a relatively staid lorry driver in later years: "Young, free, well dressed, I knew how to spend, travelling always by rail . . . a gay life indeed." Of course, a synonym for professional gambler is *loser*, as Bunton learned the hard way. On those days when his system broke down, "I had to crawl home."

Even so, he reached adulthood without much trauma. In 1922 he met, and three years later married, a housemaid. The following year, with unemployment rife in Newcastle, his mother sent him to Australia (sans wife) to

start a hotel (then send for wife). He made it down under, but the hotel never got off the ground. Instead, Bunton wandered around Australia living hand to mouth: "If I had a family motto it would be 'steal but never beg.'" Eventually he landed a job in Lithgow as a boilermaker. He had not been on the job long when he was accosted at work by a policeman and falsely (he says) accused of stealing £50 from his landlady.

Such harbingers dot the landscape of Bunton's memoirs. In story after story, he gets himself in trouble through some combination of his own stubbornness, the malevolence of others, and bad luck. He had to leave Lithgow because, on one not atypical occasion, friends dragged him into a bar. Closing time by law was six, but Bunton, when told to leave at that hour by a cop, insisted he was entitled to finish his beer. A difference of opinion ensued, followed by a brawl in which Bunton inadvertently "put my rear end through the glass panel of the door," followed by a hasty exit and a chase through the streets. Bunton remarks that "a camera could have made a good Comic Cuts film of this incident, of which I have no reason to be proud." Then this man, who would find himself in prison for wacky crimes in his fifties and sixties, asks forgiveness on account of youth: "Remember that I was still in my twentys [sic]. Today I think it stupid but then I thought it comical." He managed to outrun and avoid capture by the rotund cop and concludes that this was "not a glamorous incident, but this book is not meant to be such, just a true outline of memories as they come to mind."

Those memories are nothing if not action packed. Back at his lodge after successfully fleeing the law, Bunton encountered one Paddy Edwards, "a boxer of sorts who fought an occasional ten rounds in the ring." Edwards whisked him off to a pub whose back door remained open after hours, and the two indulged in beer and billiards. Gambling and alcohol don't mix well, and Bunton and his friend soon engaged in his second "half drunken scuffle" of the day—with one another. That, in turn, gave rise to a new wager: whether Edwards would defeat his professional opponent in a bout scheduled for a few days later. Since Bunton himself had held Edwards to a draw in their barroom brawl, he placed £5 on Edwards's opponent. But Edwards prevailed. Such bad luck, and a growing reputation as a troublemaker, led Bunton to abandon Lithgow for Sydney.

His experience in Sydney reinforced Bunton's contempt for law enforcement. He encountered all sorts of public debauchery in plain view, leading him to observe that "Sydney police work just in spurts, and have one day a month in cleaning up the city." They could have devoted that day to cleaning up Bunton, for whom Sydney offered too much temptation. Though he labored to find employment, he had far more success finding racetracks and pubs, and the two combined to ensure that whatever money came went just as fast. Even apart from finances, not all the entertainment was harmless. He recalls witnessing a barroom dustup that aroused his curiosity. Alas, "I remember going toward the dispute, and that is all—complete blackout. It must have been an hour later when I woke up on a hospital bench."

This episode marked Bunton's first stay in prison. A policeman visited him in the hospital, accompanied by a van, and arranged a "free journey to the lock-up." It also marked Bunton's first appearance in court, where he "pleaded, argued, denied" in vain. He was found guilty and sent back to prison, sentenced to two weeks, which provided a much-needed opportunity to take stock of his life. His ruminations produced a stark assessment: "I had tried, strived, and still remained in the gutter." His morale plunged but his pride remained steadfast: "I would starve, but I would ask no man for a handout." Instead, he scraped up enough money to return to England, where he settled down (after a fashion) in Newcastle with his wife.

He continued to bounce from job to job while also taking up a new hobby: "Between jobs my main pastime was writing novels, books, and articles for the newspapers—books and articles which never seemed to get published." The Dickensian figure with the Dickensian name kept plugging away in what "I shall always remember as the empty years." But writing his memoirs in 1966, a time of abundance, he sounded nostalgic for the England of the empty years. There had been abundant poverty, yes, for him and his country alike, but not the violent crime "and countless other evils persistent today." He came to see "money to be an evil. . . . Yes, there is something definitely dangerous in affluence." Indeed, "it is much easier to live a healthy life if one hasn't a lot of money."

Chapter 3: WHEN AND HOW

Just four days after the disappearance of the painting, Philip Hendy drafted a "Director's Interim Report on the Theft of Goya's 'Duke of Wellington'" (stamped at the top "STRICTLY CONFIDENTIAL, PLEASE"). It consisted mostly of an hour-by-hour account of the security situation starting at 6 P.M. on August 21, when the National Gallery had closed its doors to the public.

As per the daily routine, security personnel had patrolled the entire building for roughly half an hour, starting at 7 P.M. Around 8:30 or 9:00, the automatic alarm system (consisting of "electric contacts of doors, invisible beams where there are no doors and in certain rooms supersonic machines") had been switched on. Hendy observed that the alarm system alone "should rule out the possibility of theft," whereas "further patrols made [were] primarily regarded as precautions against fire." The next patrol of the building commenced at 10 P.M., when the new warder began his shift.

Goya's *Portrait of the Duke of Wellington* was seen in place at 7:40 P.M., during the first patrol, and was noticed missing by a warder at roughly 10 P.M., during the second patrol. There is confusion about whether its absence was reported to the warder sergeant as it should have been. The warder claimed he noticed it missing, assumed a benign explanation, but nevertheless reported it—albeit "in a jocular manner, to keep myself clear in case something had happened." Perhaps he was so jocular that his report made no impression, for the warder sergeant denied learning that the painting was missing. However, the latter himself noticed the painting missing around midnight. He made written note of this observation, but his report was not received by the deputy head attendant until eight the following morning.

Hendy's confidential report was for the gallery's internal files, but the details about the theft were passed along to Scotland Yard almost immediately on the morning of August 22—albeit presumably a good ten to twelve hours after the theft. That lag time exacerbated the major challenge facing the

Yard, which sensed that it was not dealing with an ordinary thief. The bandit had somehow seized a painting and transported it from the National Gallery undeterred by guards, infrared beams, and photoelectric barriers. He clearly knew what he was doing. As unnamed gallery staff told the *London Times*, "Only an expert could have removed the picture undetected."

Yet a review of the museum's security system suggests that the miracle was not that a creative thief had penetrated a world-class system but rather that no one before had penetrated what was actually a porous system. The security shift on the night of August 21 consisted of a handful of men on a site covering more than two acres. The building had forty external doors and 250 windows spread out over four floors—three displaying works of art and the Conservation Department on the top floor. The main floor alone featured thirty-four exhibition rooms open to the public and five additional rooms closed to the public. The ground floor included a restaurant, lavatories, a lecture room, a seventy-five-hundred-square foot reference room, and ninety other rooms, many of which were accessible to authorized visitors. The basement, inaccessible to the public but used by workmen, encompassed ninety additional rooms. Between floors were various small rooms off staircases and corridors. All in all, the ratio of security personnel to space was staggeringly small. To make matters worse, the site backed onto a three-quarter-acre yard where construction was taking place, and thus machinery and equipment lay around. (Major reconstruction of the National Gallery building and rearrangement of the collection had been ongoing for five years.)

All of that made the museum susceptible, despite its technologically impressive security system. On the fateful day *The Duke* disappeared, the inherently shaky security situation was made vastly more vulnerable by a series of improbable coincidences and contingencies.

———

Museums guard against four primary security risks: war, fire, defacement, and theft. Internal National Gallery memoranda dating back more than a century document that defacement was the most significant security problem facing the National Gallery until the late 1930s. Records reveal that in 1913 four pictures were "damaged by a maniac." The following year, Velázquez's famous

painting *Rokeby Venus* was defaced by a suffragette. At a later date, suffragettes damaged five pictures by the Renaissance painter Giovanni Bellini.

The gallery's voluminous internal security files show that because of the threat of war, beginning in 1937, "easy detachment of pictures"—which would assist gallery personnel in saving works of art—became the paramount concern. War and fire endangered the entire collection, whereas theft tended to involve only one or a few works of art. For that reason, and also because the gallery had not experienced a single theft in its history, protecting against theft became a relatively low priority.

As usual in the world of security (museum or otherwise), protective measures exact a tradeoff. In the event of fire or war, "easy detachment" would help in saving works of art, but on August 21, 1961, it no doubt assisted those who illegally removed the Goya.

Like generals who always fight the last war, museum security safeguards against the last crime. One finds many examples of this phenomenon in the National Gallery's response to the theft of Goya's *Portrait of the Duke of Wellington*. For example, in his aforementioned interim report about the theft, Director Hendy observed that the thief probably came through a lavatory window, and he noted, "Since August 22 the windows of both lavatories have been sealed."

One finds similar benefits of hindsight in Hendy's final report, two weeks later, under the melancholy title "Security before and after 21st August, 1961." The report notes that formal "Instructions to Warder Sergeants" were issued in 1952 and that "an instruction particularly relevant to the events of August 21 was that during closed hours a post was to be maintained if possible in the vestibule." However, because of cutbacks, "this has been impossible since 1957." And, inevitably, the report features the too-late adjustment: "Immediately after the theft the Instructions were revised orally," and "a completely new series were typed and issued before the end of August." These included: "At least one Warder is stationed in the Vestibule during closed hours."

The theft of the Goya would have been impossible if these new practices had been in place. Owing to measures taken in the wake of the Goya theft, all works in the gallery became safe short of someone sending in a SWAT team to remove them. All pictures not in public exhibition were withdrawn to rooms

"kept permanently under lock and key, day and night." Exhibited pictures, too, received far greater protection. The burglar alarm was activated earlier and its weekend hours extended considerably. Plans were introduced to add another dozen men to guard exhibition rooms during open hours. At least for the foreseeable future, uniformed police patrolled outside the gallery and plain-clothes officers patrolled inside. Eventually the gallery added a night patrol with a dog as well, and Parliament created a new position: a senior police officer as security adviser for all the UK's national art collections.

The theft of *The Duke,* however, wasn't simply a function of inadequate security arrangements. Rather, existing precautions and protocols were not followed. As a result, *The Duke* was noticed missing many hours before anyone became sufficiently alarmed. As *Newsweek* would immediately declare, "Of all the incredible aspects to the theft last week of the famous painting, perhaps the most astonishing was that it went unreported for eleven hours."

A major source of this neglect was understandable: paintings get moved around. Accordingly, when security personnel do not see a work where it belongs, they may infer a benign explanation. However, *The Duke* had been on special exhibition, and by well-established gallery practice, when a painting from an exhibition was moved, a tablet explaining its removal was to be substituted. Had that practice been in place on August 21, an investigation would have commenced as soon as security personnel noticed the painting's absence (without tablet). Instead, crucial hours were lost because, as Director Hendy's interim report noted, "These rules have had to go into abeyance during any large-scale rehanging of the Gallery such as has only recently been completed."

However, in a subsequent report, dated February 21, 1962, Hendy acknowledged that he had misdescribed the situation—not simply in his interim report but also to investigators. The tablet practice had indeed been suspended from January through June 1961, but after the gallery's rearrangement had concluded in June, "the fixing of tablets had been resumed immediately" and thus had "certainly been resumed nearly two months before the theft." All of this was much ado about nothing, he insisted, because "the practice of fixing tablets was never regarded as a security measure. Tablets are sometimes stolen; they are easily switched from one place to another."

Perhaps the lack of a tablet was indeed irrelevant, but the thief undeniably benefited from other blunders by gallery security—a comedy of errors with serious consequences. As the police quickly discerned, at the closing of the gallery at 6 P.M. on the night of August 21, a man lingering in a men's room stall had to be ushered to the lobby by an attendant, in keeping with the normal closing-time procedure for clearing all visitors from the building. But when it comes to museum clearance, the key is follow-through. Normally, the warder sergeant stood atop the stairs leading to the lavatory to assure that no one returned. On this occasion, however, he was summoned across the vestibule by an attendant who needed assistance clearing umbrellas and other materials from the cloakroom. This departure from protocol stemmed from the regrettable combination of a large crowd and a shortage of staff. Accordingly, the authorities determined, the man removed from the lavatory likely returned there. One of the workmen reported finding the same stall occupied at 7 P.M.

Allowing lingerers in the men's room was hardly the gallery's only mistake on August 21. Deactivating the alarm system during the evening constituted another. Several construction workers had wandered around the building after six that night, along with eighteen gallery employees. The warders had failed to activate the burglar alarm system until 8:30, slightly later than usual, after the last of the workers on duty—several floor polishers and charwomen—had checked out.

Various documents pertaining to the crime, produced by both the police and the National Gallery, revealed a devastating combination of negligence and bad luck. To take one of numerous examples, a National Gallery document tersely reported, "Warder Sergeant Barber on leave. Acting W.S. knew he should inspect lavatory but did not." Another report mentioned that construction on the outside yards had commenced on July 4, seven weeks before the theft, and remarked that this work unfortunately coincided with leave periods and a change of staff.

Although, as noted, security personnel failed to report *The Duke*'s absence when it was first noticed the night of August 21, relatively little harm resulted because the warder sergeant himself noticed the painting missing around midnight. However, his report did not reach his superior until the following morning. Dissemination of the news then became more rapid, as

suggested by the minutes of a National Gallery emergency board meeting on September 11, describing activity on the morning of August 22:

8:15 A.M.: [Painting] reported missing to the Keeper by the Deputy Head Attendant

9:15–9:30: Director & Keeper notified

9:30: Police summoned by Deputy Head Attendant

10:05: C.I.D. take over.

At some point that morning, police and security personnel searched offices and studios throughout the National Gallery. It was too little and certainly too late. Assuming that the painting had been taken the previous night, the thief had had many hours to escape London before the police were even notified of the theft.

The eventual report by a government committee of inquiry, while criticizing a wide range of conduct by the gallery's security apparatus, focused on the lag time between recognition that the painting was missing and notification of the authorities. The committee's findings emphasized a wholesale sloppiness with respect to tracking the movement of paintings. As for the breakdown in security that allowed the theft in the first place, the committee saw much blame to go around. Doors had been left open, patrols had been too infrequent, staff had been too scanty, and there had been no comprehensive list of people entitled to be in the building after it was closed to the public. In addition, the gallery had been insufficiently apprised of the construction work outside. And so on.

The committee's findings did not satisfy everyone. In a report responding to those findings, Director Hendy criticized the committee's modus operandi, noting, among other things, that the assistant head attendant, "a first class man" named Turner, "was on the list of staff which I recommended the Committee to interview; but he was not interviewed. The Head Attendant, who was interviewed, states that he was not questioned about 'day-book' or tablets." Hendy's own summary of the situation, which sounds like a passage from Dickens, suggests the difficulty of reconstructing exactly what did and did not happen on the night of August 21:

Frequent failure to fix the tablets is stated to have been alleged by Mr. McGarrity, a Warder who has since been asked to go not because of the theft but because of a general incapacity which the effort to improve security after the theft soon made very obvious. Mr. McGarrity told the Police that he had reported the absence of the stolen picture to Sergeant Havell "in a jocular manner more or less to keep myself in the clear in case something happened." Sergeant Havell said that [McGarrity] had not reported it. It does not therefore seem to me that McGarrity is a reliable witness. . . . Sergt. Havell told the Police: "It is usual for the Working-Party to put a tag in place when a picture is removed for any reason and I saw that no such tag was there." He gave no explanation of why he did not consult the "day book" or of why he decided only to report the matter to his successor at 7 A.M. He has since died from thrombosis . . . and he may well have been in a very bad state of health at that time.

Cutting through all the predictable finger pointing, butt covering, and other inconveniences to the fact-finding process, one thing seems safe to surmise: The two officials who noticed the painting missing on the night of August 21 were not sufficiently alarmed because they assumed the painting had been moved. A 135-year track record of zero thefts can beget such complacency, but perhaps the gentlemen should at least have consulted the museum's daybook. Indeed, the daybook included several entries describing various movements of Goya's *Duke* from the time of its reception until it was placed on exhibition. Had the men consulted the daybook on August 21, the absence of a relevant entry describing movement that day might have alerted them to the fact that something was amiss.

The lead warder was an ailing gentleman (he died three months later) who had served the gallery loyally for thirty-four years. In his more than three decades at the museum, no work of art had been pilfered, whereas works were routinely moved around. Thus one can understand his assumption that the

missing Goya had simply been moved. On the other hand, perhaps one reason works were never stolen is that security staff generally followed protocol. Here, protocol required immediately trying to ascertain the whereabouts of the missing picture, a task nonchalantly neglected.

In sum, an awful lot had to have happened for the painting to be seized and removed and for the theft to have gone undetected for so long. These events included, among other things, the outside construction (with someone supplying a ladder and extra people floating around the building), the night warder being ill, an assistant dealing with umbrellas, and personnel failing to check the daybook or otherwise take more timely action when they noticed the painting missing.

On the surface, then, the thief benefited from astonishing luck. But, as the saying goes, luck is the residue of design. Top-flight criminals often *seem* lucky because their painstaking preparations are unseen. It was possible, even likely, that this professional bandit knew exactly what good luck lay in store—that is, he stole the painting precisely because the outside construction facilitated entry and exit, he knew when the alarm system would be off, he knew when the painting would be unguarded, and so forth.

Under normal circumstances, there was no easy escape route. Assuming the thief exited the gallery through the lavatory (a safe assumption, as we shall see), he found himself in a courtyard. In normal times, that courtyard and another it leads into yield no exit except into other parts of the museum building. However, as one of the director's reports noted, "From July 28, those yards have been made accessible to the Old Barrack Yard by the removal of windows in the intervening buildings and from August 5th by the enlargement of these apertures to ground level. This gave ready access therefore to the internal courtyard." Note that these changes happened less than a month before the theft of the Goya. More amazing luck? More likely, the thief had cased the joint, figuring out entrance and exit possibilities. Someone hadn't jumped out the lavatory window and found himself an escape route by sheer serendipity. Rather he had entered and exited through the lavatory window precisely because he knew what changes had taken place in the previous weeks.

But it would be equally mistaken to attribute the success of the theft entirely to foresight. It would have been impossible for the thief to foresee the

various violations of protocol that gave him a several-hour head start before the police even learned about the crime. Surely shrewdness and careful planning intersected good fortune.

———

Once the police got in the act, at roughly 9:30 A.M. on the morning of August 22, they hit the ground running. After Detective Inspector John MacPherson led a group of officers from West End Central Police Station to the National Gallery, he immediately ascertained that the window on the ground floor male lavatory was open and found (as he characterized it in a deposition years later) "a piece of mud which looked as though it had been left by someone's shoe." He further noticed, under the window, a ladder resting a foot or two beneath the sill. MacPherson also observed marks on the south gate, abutting St. Martin's Street, which "I assumed to be marks of egress," especially when "on that gate I found long vertical marks on the inside as though someone had climbed over the gate."

MacPherson and his underlings took over an office in the gallery and spent several days searching the building and interrogating staff, amassing a large pile of written statements. It did not take long for them to ascertain how the crime had gone down, based on MacPherson's instant deductions and two key aforementioned facts learned from interviews with security personnel: (1) The painting was seen during the early evening patrol at roughly 7:40 but not seen during the later patrol, sometime between 10:00 and 11:00; (2) The alarm system was activated at roughly 8:30 and took up to half an hour to become fully operational. (The lag time, as explained in one of the director's reports, stemmed from "inevitable weakness of contact in places, such as those caused by slight faults in doors, and owing to the presence of late workers in some parts of the building.") The conclusion was straightforward: "The picture must have been taken from its place between 7:40 P.M. and about 9 P.M. ... The picture appears to have been taken through the window of the men's lavatory and through two internal courtyards to the Old Barrack Yard. From there it appears to have been taken over wooden gates into St. Martin's yard."

Substantial evidence supported the inference concerning the thief's exit path. The ladder found left against the sill of the men's lavatory, the fact that

lingerers were twice spotted in the bathroom after hours, and the absence of other nearby escape routes that would enable someone to go undetected established with near certainty that the picture had been removed through the window of the lavatory.*

If the thief had indeed entered and exited through the lavatory, he had traveled some distance to and fro with the painting. There were thirty-five steps, encompassing three flights, between the lavatory and the room where *The Duke* had stood alone. The thief would have emerged from the lavatory, taken a narrow staircase from the ground floor to the main floor, turned sharply right, and ascended more steps from the main entrance to the so-called bridge, which branched in three directions. He then would have taken additional steps to the second landing, where he would have found *The Duke* on a screen. After removing *The Duke,* he presumably retraced these steps and returned, painting in hand, to the lavatory. That was the relatively easy part. The fourteen-foot drop from the windowsill to the ground presumably made it difficult to carry the painting, particularly with its heavy frame, through the window and down the ladder. Some believed that the physical dexterity and derring-do pointed to someone trained as a paratrooper with the Special Air Service during World War II.

If the thief had removed the canvas from the frame, he would have had a lighter object to transport, but such removal would have been no easy task, since the heavy 33" x 28" frame was carved from wood measuring 4.5' x 3', with miters at the corners bolstered by a diagonal batten inlaid in the wood. Extracting the picture from the frame likely required a tool of some sort and, if it was to be done quickly, possibly more than one pair of hands.

If the heist had involved two or more people, how many others may have assisted? Pulling this off without even arousing suspicion was hard to imagine without substantial resources, expertise, and support. Taking and transporting a famous work out of the building likely involved a decoy and lookout man and perhaps a getaway driver as well.

* *There were nevertheless other theories advanced. For example, Sir Kenneth Clark, a prominent critic and former director of the gallery, opined that the thief had hidden in one of the gallery's unused cellars and then slipped out with the painting in a satchel.*

The authorities felt they had at least some idea of when and how the painting was taken, but many questions remained unanswered. Who had taken the painting and with what assistance? Why? Most importantly, where was the painting?

Chapter 4: THE MAKING OF A CRUSADER

The more things changed for Kempton Bunton, the more they stayed the same. As Europe crept into World War II, Bunton continued to bounce from job to job, typically driving vehicles—first an ambulance, then a van delivering newspapers in the wee hours for W. H. Smith & Son—all the while awaiting his nation's call to service.

Bunton loved driving the van, but his wife felt differently. On account of the war, wages in factories skyrocketed, and she wanted her husband to jump on the gravy train. Bunton acquiesced "rather than strangle the wife," but not before a last bit of mischief with lasting effects. With his novelist's sense of connection and foreboding, he notes, "There was one incident that happened while I was at Smith's which was to have some bearing as to my future way of life."

Bunton was driving his van accompanied by a half dozen crated hens that he had purchased that day from a farm. (No further explanation is given.) Rounding a bend in the road slowly, on account of "an extremely high velocity gale," he noticed a large plank of railing in the middle of the road. Apparently the wind had toppled a fence. Bunton stopped the van and tossed the debris into a field off the road. A bit later he was pulled over by a cop. Bunton figured the cop must have passed him while he was clearing the wood and mistakenly thought he had stored it in the back of his van. Ever the bane of law enforcement, Bunton writes, "I must confess to the feeling that I was going to enjoy this."

The officer did indeed ask for permission to look in the back of the van, where to his surprise (or so we assume, since Bunton writes that the officer "concealed his surprise") he saw hens rather than fencing. The cop asked whence the hens had come, and Bunton named the farm. Finally the skeptical constable let him go, and Bunton "sped on my way blissfully unaware as to the sequel to this incident."

Two months later, he was summoned to court on two charges: carrying livestock in a van not appropriately licensed for that purpose, and "wasting petrol" by traveling to the farmstead for the elicit purchase and transportation. (Wartime rationing begat such laws.) Bunton was not amused: "Ye Gods, there is a war on, and we have policemen and magistrates wasting their time thus. I was naturally indignant at these ridiculous assertions." He fought the charges in court but was found guilty on both counts and fined £6. He declined to pay. He was given a month to do so, but as a "matter of principle I persistently refused." Nine months later, he was hauled off to a penitentiary in Durham. The principle for which he endured loss of liberty? "If a country could take a man from his work during wartime, and shove him in gaol for nothing, then I would go to gaol."

Although, as noted, Bunton introduced the anecdote with the tease that it was to have a bearing on his "future way of life," he failed to elaborate. With the benefit of hindsight, we can take a good guess as to what he meant: The episode presages Kempton Bunton the civil disobedient, who would find himself strangely entangled with the court system. His coda to the incident captures both his fatalism and his disappointment in his own irrelevance in the scheme of things: "I did [go to gaol], and nobody seemed to worry about it, and the war still went on."

But when Bunton returned home after his brief period incarcerated, it was not the hypothetical factory job that lured him away from W. H. Smith & Son. Instead, he took a job as a lorry driver for a cooperative milk store—"the job paid reasonably so this kept the wife quiet." So it went for seven months, until one day, in the midst of a rainstorm, Bunton took pity on his young assistants and sent them home early. His manager disapproved this act of generosity, and what "started out as a peaceful debate between us ended in a heated argument which resulted in instant dismissal for me."

He next took a job delivering beer to pubs, but after two weeks he was arrested because he still hadn't paid the fine for the hens heist and wasted petrol from the earlier incident. The arrest cost him his new job, but he landed another driving a lorry, this time for a fruit merchant. That too lasted only a short while, until "I walk[ed] straight into another transport job," driving lorries for someone else.

So it kept on keeping on for Kempton Bunton during the forties and fifties (his and the century's), one driving job to another, and in between "I often visited the local dog tracks, sometimes as a punter [gambler], oftimes as a bookmaker's clerk." This lorry driver and freelance bookmaker raised (or at least supported) a large family—five children suddenly make their first appearance in the memoirs on page 40, described as "growing up fast." At this point there was no hint that Bunton would become a figure history stooped to notice. As he put it, "Life seemed to be slipping by in unnoticeable fashion."

In 1948 tragedy struck. His daughter was killed in a bicycle accident. Bunton lost whatever religious faith he may have had: "I remember bitterly and silently cursing God. If there were such, then he must be a Demon God to have allowed this thing to happen."

Life goes on, and for Bunton it did so in a mostly unremarkable fashion. At some point in the early 1950s, he switched from lorry driver to cab driver, earning £55 a week. And though this part of his life seems relatively jejune, in the memoirs it gives rise to a curious digression. In the course of discussing the incongruities of the cab driver's graveyard shift—one minute you drive a prostitute to a pub, a few minutes later "a parson's wife going to a Mother's meeting and occupying the seat so recently vacated by the prostitute"—Bunton vents about the cabbie's plight. He posits a hypothetical situation in which he lawfully drives somebody a few miles out of town and, after dropping him off and heading back to base, is hailed by a pedestrian. Bunton notes angrily, "Even if the man's wife is expecting a baby, even if the man is in any sort of difficulty, by law I am not supposed to pick him up." Bunton does not explain the law in question but does offer a perspective on it: "The law is an ass you may think, well we drivers also thought the same—a fig for the law in such a case."

Kempton Bunton's willingness to break the law, which would eventually make him famous, dots his memoirs almost from the first page. Less obvious, if more intriguing, are the unself-conscious literary touches. Readers of *Oliver Twist* may recall Dickens's declaration that "the law is an ass." (Bunton's acquaintance with British fiction would surface, bizarrely, in connection with the kidnapping of Goya's *Portrait of the Duke of Wellington*.)

For some reason, perhaps just his usual restlessness, Bunton left the transportation business and took a job in a bakery. While there, "something

happened completely out of the blue to alter everything." The problem arose when Bunton noticed that the bakery foreman gratuitously added four hours to the time card of Bunton's colleague, a Pakistani (who was, in Bunton's oxymoronic description, "the quietest and most sociable chap anyone could wish to meet"). Because experience had taught Bunton that "certain foremen had made it a practice to give jobs to coloureds" for exploitative purposes, he sensed something unseemly. He opted to say nothing, until gazing out the window he happened to spot a poster that read: "Expose evil wherever you find it." This exhortation apparently tapped into some inner conviction, and Bunton squealed on the foreman. He summarized the ethics of his actions in a line that will resonate for those familiar with the ransom notes from the man who kidnapped *The Duke of Wellington:* "Right in the eyes of propriety, but wrong in the eyes of friendship to the Pakistani."

The manager of the bakery pledged to investigate, but the only consequence was punishment of the whistleblower: Within days, the manager discharged Bunton. In what would in his eyes become a recurring pattern, Bunton had spoken truth to power but failed to achieve anything other than trouble for himself. He "applied for justice to the head manager of the firm— no satisfaction—the matter was forgotten." But Bunton never forgot the accumulation of slights that was coming to define his life.

Following a prolonged spell of unemployment, he landed in a factory that wrapped boxes, which he did not wrap fast enough. Before long the manager informed him that his rate of 750 wrapped boxes per shift was 25 percent below the norm, and "I am sure, Mr. Bunton, you can do better than that." Bunton responded to this impertinence by quitting the job. Apropos of that decision, he makes an observation aptly supported by his actions over the course of a career involving literally dozens of jobs: "I have always been of the opinion that a man far better leave a job than hang on to a position which he is not fully able to cope with."

Next came a job in the chimney sweeping business. He seemed to enjoy that line of work, less for the work itself than for the opportunity to hear about people's troubles—another trait that would prove crucial in making him a historical figure. Apparently, many folks treat the chimney sweep as a sounding board, and Bunton found himself listening to complaints about life

"in a never ending stream." He offers no explanation for leaving this job, but leave it he did, returning to the streets as a cab driver. That apparently did not last long and was followed by another spell of unemployment, during which the law again intervened in his affairs.

Finding himself disconsolate at a bar in Durham, he encountered a friend who needed a drive back to Newcastle. Since Bunton knew the man to be reliable behind the wheel, he let the man drive his van and rode shotgun. As Bunton was himself a professional driver, his motivation for turning over the keys remains unclear. (Perhaps he had had a few drinks too many.) In any event, his friend failed to justify Bunton's confidence in him, brushing into a stationary car and choosing not to stop at the scene of this small accident.

The next day Bunton received a phone call from the police, who had received word of the accident and the license plate of the offending vehicle. Bunton informed his friend, the culprit, who pleaded that he had an expired license. Accordingly, he convinced Bunton to take the rap, promising to reimburse Bunton for the inevitable fine. At this point, and for no obvious reason, Bunton decided to do something else that would foreshadow later events: He unnecessarily complicated his planned fabrication. Instead of taking the small fall for his friend, he concocted an elaborate story in which a hitchhiker was the actual culprit. Unfortunately, "the Court treated this masterpiece with great suspicion" and imposed a surprisingly substantial fine of £15.

Bunton next turned to another self-styled "masterpiece," a fifty-thousand-word novella that he says attracted much praise but no publisher. He followed that with a ninety-minute radio play, which also languished in London at the hands of the gatekeepers of culture. This was apparently both a prolific and barren spell for the would-be author: "In all I completed four sound radio plays, three television ones, and one book, all landed in the top cupboard." The failures brought out in Bunton a mixture of perseverance and self-pity: "They say he who tries and tries again, but not for me. Interspersed between various jobs, I continue writing, and crying at the rubbish which has made the grade."

Not surprisingly, this period churning out unpublished fiction coincided with unemployment. But during this time, a seemingly innocuous incident

set in motion the improbable series of events that some years later would put the name Kempton Bunton on the path to infamy.

On a dreary, snow-filled Newcastle night, Bunton found himself in the shelter of a city doorway next to "a tramp-like sort of old man." Seemingly harmless conversation ensued, and Bunton discovered that the man was in fact "not of the tramp class" but rather "an old aged pensioner of Newcastle," a widower who lived alone. The man had a pet peeve that he no doubt shared with many a stranger, but none more sympathetic than Bunton: "Although his relative had given him a television set, he could not use it, because £4 for the license [to watch BBC] was out of the question."

Bunton's response reflected his iconoclastic mind-set: "Why not view without a license?"

But the "frightened little old man" did not share Bunton's anarchic streak. The more Bunton learned about the man, the more he seethed at the injustice. The man had fought in World War I, and all he wanted from the government was to be allowed to watch a little telly. Bunton reports that he headed home, and then he resorts to remarkable understatement: "Somehow the incident did not end there."

Until encountering the pathetic veteran, Kempton Bunton was a rebel without a cause, unless an amorphous sense that the world was irrationally stacked against him can be said to constitute a cause. Now, as he reflected on the injustice of the BBC licensing fee, Bunton became a man with a burning cause that would occupy him for the rest of his life.

To be fair, there was merit to Bunton's position. When the BBC was literally the only show in town, the licensing fee amounted to a defensible user fee. But starting in 1956, commercial television in Great Britain existed side by side with BBC programming. Yet all those with television sets were forced to pay the BBC fee, even if they had no interest in watching anything on BBC.*

* *The television license was introduced after the war, in June 1946, to coincide with the postwar resumption of BBC TV service that same month. It cost anyone with a television set £2 (about £73 today). The fee was increased to £3 in 1954, and when Kempton Bunton refused to buy his license in 1960, it cost £4 (the equivalent of £86 or $130 today).*

In Herman Melville's novel *Billy Budd,* the narrator observes that "Passion, and passion in its profoundest, is not a thing demanding a palatial stage where on to play its part. Down among the groundlings, among the beggars and rakers of the garbage, profound passion is enacted. And the circumstances that provoke it, however trivial or mean, are no measure of its power." That Kempton Bunton felt a profound passion about an obscure cause cannot be doubted. That this passion would in fact play out on a prominent London stage could not have been predicted.

Chapter 5: ANATOMY OF AN INVESTIGATION

It is never uplifting for a nation to wake up and find one of its treasures lost, but 1961 could be seen as a relatively good time for the United Kingdom, and especially London, to handle such a blow. London, and especially its art world, was brimming with confidence. On the other hand, one could see the timing of *The Duke*'s disappearance as devastating for exactly the same reason: A city (and nation) finally flourishing after a long period of stagnation hardly needed to suffer such a loss.

Time magazine coined the term *Swinging London* in 1966, the same year Roger Miller's hit song "England Swings" captured the city's casual swagger ("Take a tip before you take your trip / Let me tell you where to go, go to England, oh / England swings like a pendulum do / Bobbies on bicycles, two by two"). Four years earlier, the *Daily Express* referred to "the rollicking revolution of merrie England." In fact, the cultural revolution that produced Swinging London traces back to the 1950s and a long overdue social and economic recovery from World War II. From 1951 through 1964, average wages in real terms rose 50 percent.

Wealth accounted for only part of the city's and nation's transformation. The lid came off a city steeped in fear and austerity, and a flashy, freewheeling modern culture emerged, with particular indulgence in cigarettes and automobiles. (Expenditures on cars and motorcycles rose tenfold, from £90 million in 1951 to £910 million in 1964.) The Beatles and rock took to London, along with miniskirts and minicars, bright red buses, and black leather jackets. The art world bustled, with new galleries springing up all over the city, and London threatened to replace Paris as epicenter of the European art scene.

Baby boomers reached adolescence en masse—teens with vastly more disposable income than their parents had enjoyed when young and influenced by a range of left-wing social and intellectual currents, including the

Beats (imported from the United States) and existentialism (imported from France). These movements celebrated freedom and the individual, while artistic movements in England, including New Wave cinema and its literary cousin the "Angry Young Men," championed the heretofore neglected working class.

The energy from the youth-oriented culture and avant-garde art world only intensified the city's attachment to its time-honored icons. The National Gallery thrived in Swinging London. Such was the state of affairs when, on August 22, 1961, both the gallery itself and the arts community learned that Goya's *The Duke of Wellington* had vanished.

Responsible parties honored the long-standing tradition in Great Britain and offered their resignations. Acknowledging that "I missed that window"—meaning the one through which the thief had apparently entered and exited—the gallery's head of security, George Fox, announced his intention to resign to Philip Hendy, the gallery's longtime director. Hendy replied that Fox's fate was in the hands of the trustees and that Hendy himself would not endorse Fox's resignation. Rather, he planned to tender his own. The next day he did so, but he was informed that only the prime minister or chancellor, not the gallery trustees, had the authority to accept his resignation.

While insiders took responsibility, the public at large sought to solve or exploit the crime. Announcement of *The Duke*'s disappearance triggered an inundation of letters and phone calls to police and media, spouting theories, claiming knowledge (including numerous alleged sightings of the painting), taking credit, and making accusations. Various hoaxes included a man who called Reuters Fleet Street office to demand ransom money for the Campaign for Nuclear Disarmament (CND) "in the interests of humanity at large." A CND spokesperson disavowed any knowledge of the matter.

The early response also included a few leads whose specificity made them more promising. On August 24, three days after the theft, a man reported seeing a painting resembling the Goya in the backseat of a car on Tottenham Court Road on the night it disappeared. But follow-up inquiries did not yield anything concrete. On August 31 an anonymous caller informed Reuters that the painting had been sold and would be whisked out of the country the next day on British European Airways flight B292 to Rome. On September 1, de-

tectives were waiting at Heathrow Airport and delayed that flight thirty-five minutes with an extra search of luggage that unearthed nothing untoward.

Amateur sleuths also offered assistance. An anonymous two-page letter from the self-styled "Infuriated Art Lover" to the chief superintendent of Scotland Yard, postmarked August 24, offered detailed knowledge of the missing painting and the gallery's electronic security system. The art lover presented an elaborate theory pinning the crime on a "closely organized gang" that had hired someone wearing a tailored suit with a forty-inch chest and seventeen-inch sleeve, who had slipped the painting into "a specially contrived pocket in the back of an overcoat." If nothing else, the impressive detail made the letter writer himself a suspect, but tracing anonymous letters was nearly impossible.

Media hyped the theft as well. On the ahead-of-its-time television show *Three after Six*, in which pundits sparred about current events, high-profile newspaper columnist Dee Wells (the wife of eminent British philosopher A. J. Ayer) predicted that the police would beat up "the poor hopeless little nut" who had stolen the painting. Wells was forced to apologize, but the episode amounted to more than an ill-considered comment by a celebrity provocateur—it presented an alternative profile of the criminal. Might Scotland Yard be wrong to assume the kidnapping of *The Duke* was a professional job?

It was at least worth considering that anyone acquainted with the art world would have known the difficulty of doing anything profitable with a famous work by Goya. No one would be foolish enough to purchase and display such a recognizable work. Could Dee Wells have been right? Could a "poor hopeless little nut" be behind the theft? Half-right maybe. A nut perhaps, but the act almost certainly required resources and resourcefulness.

One intriguing aspect of the crime—the calendar—commanded everyone's attention. Investigators could not help fixating on the date *The Duke* had been kidnapped: August 21, 1961, fifty years to the day of the theft of the *Mona Lisa* from the Louvre, the most famous art heist in history. Unless this was a staggering coincidence, the culprit knew something about art history and had a mischievous streak to boot. Or, as the *Daily Mirror* cheekily implied in its initial story about the theft, the man who had stolen the *Mona Lisa* and the man who had taken *The Duke* could be one and the same! After all, a twenty-year-old in 1911 would now be just seventy.

The improbable single-thief theory to the side, the *Mona Lisa* coincidence suggested ingenious pranksters. And in the immediate aftermath of the theft, the media quoted an anonymous senior police officer in London who believed that the theft "might be a crank, someone playing a joke, someone who doesn't like the Duke of Wellington."

The supposition that the thief was a prankster fit the other circumstantial evidence alluded to above: Anyone daring and savvy enough to pull off this crime had done his homework and thus would have known that *The Duke of Wellington* could never be displayed and therefore probably could not be sold. The prankster angle thus supplied a plausible motive to an otherwise bizarre move for professional thieves. But some observers, emphasizing the rash of thefts of major artworks in the 1960s, conjured a reclusive millionaire hiring thieves and secretly amassing a collection of masterpieces for his own enjoyment. Sir Kenneth Clark, former director of the gallery, forlornly declared, "I wouldn't be surprised if the painting isn't already on its way to one of those very, very private collectors in the U.S." The writer Richard Condon (famous for his novel *The Manchurian Candidate* from two years earlier) concurred, observing, "If a miser can find joy sitting within a double locked room and counting gold doubloons, there are any number of art appreciators who would gladly dine quite alone with a few Goyas and Breughels."

Condon was asked to weigh in because of his 1958 novel *The Oldest Confession,* about a wacky attempt to pull off an impossible art theft. Others had personal agendas or professional reasons for putting in their two cents. *Pravda,* the official news agency of the Communist Party in the Soviet Union, in full Cold War propaganda mode, offered a theory consistent with that of Clark and Condon: The thefts had been commissioned by Western capitalists. The US humorist Art Buchwald proposed in his newspaper column that the Goya had been taken by "Piccadilly Lock Pickers," who had transported it to southern France for a meeting of art thieves to celebrate the fiftieth anniversary of the theft of the *Mona Lisa.*

In a more serious vein, the *London Times* editorialized that there were four possible reasons that someone might steal a "booty picture"—its name for a work too recognizable to be sold on the open market. While minor stolen works ("say a sketch by Constable or a small Dutch flower piece") might

be placed on the art market without rousing suspicion, booty pictures could not be. However, "the theft may be prompted by misguided patriotism. It may be due to some form of mania. A picture may be stolen in order to sell it to some eccentric collector who is prepared to gloat over it in private. Or lastly and more probably, it may be stolen in order to elicit ransom from the owner of an insurance company."

While seemingly everyone had a theory about the thief's motives and the painting's whereabouts, Scotland Yard detectives could not get away from the same fact that appealed to humorist Buchwald—the theft occurring fifty years to the day of the theft of the *Mona Lisa*. That *couldn't* be a coincidence, and it suggested that the thieves were the sort to play games. A good thing, perhaps. Experienced crime solvers know that many criminals, consciously or unconsciously, wish to be caught. Other criminals may prefer to remain at large but desperately want their crimes noticed. Both groups deliberately leave clues or at least take unnecessary risks that may leave clues. Naturally, law enforcement prefers these kinds of criminals—those who almost go out of their way to assist the investigation. It would have been more problematic if the theft of *The Duke* had indeed been commissioned by a reclusive private collector who would stash the work away in some remote location, never to be heard from again. But given that *The Duke* was taken on the fiftieth anniversary of the *Mona Lisa*'s pilfering, it seemed likely that the thief would be heard from. Stealing the work on that very day expressed a message of some sort (if only "I'm having fun"), and those who get off on sending messages don't stop with only one.

Meanwhile, the overwhelming assistance the public offered the Yard amounted to a mixed blessing. Just separating potentially legitimate leads from pure cranks required substantial work. The Yard, which rarely received so many fake confessions and false tips, employed a number of men to handle the "noise" while assigning an elite team of detectives to pore over every inch of the National Gallery's two acres and 250 rooms. Still other agents conducted dozens of interviews with gallery personnel. In keeping with common practice at the time (which continues to this day in a surprising number of precincts in both the United States and Great Britain), the Yard also consulted with psychics.

In the immediate aftermath of the theft, the digging produced nothing promising. But experienced investigators know—or choose to believe—that if they are patient enough, at some point something will break. The break may not enable them to solve the crime right away, but it at least gives them something to work with. It may come at any time—sometimes within days of the crime, sometimes months or even years later. But if you keep your eyes and the case file open, it will come. Cases go cold, but they rarely freeze unless you let them.

In the case of the missing Goya, little patience was needed: The first significant potential break came just ten days after the theft, in the form of a letter, postmarked London, sent to the Reuters news agency on Fleet Street. In handwritten block letters, it began: "Query not that I have the Goya," and it sought to prove the point by identifying marks and labels on the back of the canvas. ("It has a stick label on back saying F Le Gallais & Son. Depositories Jersey. Name Duke of Leeds. Date 22.8.58 no 2. It has 6 cross ribs each way.") The note further assured that "the picture is not damaged, apart from a couple of scratches at side. Actual portrait perfect."

Then the letter writer got down to business, beginning with an oblique reference to the motive behind the theft: "The act is an attempt to pick the pockets of those who love art more than charity." An unusual ransom demand followed: "The picture is not, and will not be for sale—it is for ransom—£140,000—to be given to charity. If a fund is started—it should be quickly made up, and on the promise of a free pardon for the culprits—the picture will be handed back." The letter concluded with a point of personal privilege and a widespread appeal: "None of the group concerned in this escapade has criminal convictions. All good people are urged to give, and help the affair to a speedy conclusion."

Reuters turned the letter over to West End Central Police Station, where it was examined before being turned over to Scotland Yard's forensic laboratory. The Yard would not comment publicly on the letter, but not everyone was so circumspect. The *London Times* quoted the director of Sotheby's auction house as saying, "Personally I see no reason to doubt the story" given the description of the labels. Even more direct confirmation came from Frank Le Gallais himself, director of the depository referred to on the back of the painting and by the ransom note. Reached in the Channel Islands where he

was vacationing, Le Gallais said the description of the label sounded genuine. He added that the picture had been in his hands briefly in 1958 and that very few people would know about the label on the back.

The letter presented some encouraging news by way of omission: The thief did not threaten to destroy the work; nor did he seem intent on selling it for private benefit or, for that matter, keeping it. Rather, his plan apparently involved its safe return. On the other hand, the report that the portrait was undamaged could be seen as concerning rather than reassuring. Why had the thief bothered to mention that? Did he protest too much? Adding to this concern, the note's author seemed off the wall—who commits a major felony to raise money for charity and to punish those who "love art more than charity"? The thief was either nuts or, worse, a shrewd man pretending to be nuts.

And was he in fact a "thief," solo? It was hard to say. On the one hand, the note referred to the "culprits" and "group." But that language could have been diversionary, and the note did begin, "Query not that I have the Goya"—"I," singular.

The note flummoxed the authorities because it defied conventional notions about art theft. A half century later, in his memoirs about his career chasing art thieves, Robert Wittman would summarize what his decades in the trenches (as head of the FBI's art crimes unit) had taught: "The art thieves I met in my career ran the gamut—rich, poor, smart, foolish, attractive, grotesque. Yet nearly all of them had one thing in common: brute greed. They stole for money." But if the ransom note for the Goya was to be believed, the thief was the opposite of greedy—he had stolen the painting to raise money for charity. Robin Hood aside, criminal derring-do and charity do not go hand in hand.*

For all the wackiness, the ransom note did assist the authorities in one respect, at least if it was taken at face value rather than seen as a diversionary effort. By calling for £140,000, exactly the amount *The Duke* had commanded

* *That said, there are instances of altruistic art theft, including one that occurred in May 1962. In Tokyo, a man stole a Renoir from a private collector and promised to return it if the collector would donate it to the Tokyo Museum of Western Art, which the thief felt needed a Renoir to round out its collection. The painting, shortly thereafter found in the freezer of an ice cream truck, was indeed donated to the museum.*

at auction, and by protesting against those "who love art more than charity," the letter suggested the thinking behind the theft and its immediate catalyst. The government raising money to keep Goya's portrait in England had established the value of the work—not only in monetary terms but also by demonstrating the eagerness of the government and others to do whatever it took to keep it around. Perhaps the thief was offended by the willingness to spend an exorbitant sum on a painting and took out his anger on both the government and the painting.

But the note gave cause for concern as well. Could anyone so unhinged as to kidnap a masterpiece for the sake of charity be trusted to deal rationally and in good faith? In part because of doubts on that score, Scotland Yard might have ignored the ransom demand, if it had the option of responding to it. It did not, because UK law prohibits negotiating with or paying a ransom to kidnappers. (The relevant law makes no distinction between human collateral and other property.) So while the Yard turned the note over to handwriting analysts and psychologists to assist in the investigation, it made no response to the writer.

Meanwhile, media accounts of the letter spurred a fresh round of hoaxes. Reuters immediately received a phone call from a woman claiming to have written the letter and asking what action was to be taken. When no definitive answer was given, she hung up. Three hours later, she called back with a threat: If the ransom was not paid, "we will take the two Renoirs from the National Gallery." It wasn't, and they didn't. But such calls were taken seriously. On September 3, the *Sunday Times* reported on its front page that, as a result of the threat, "strict measures were taken by the National Gallery last night to protect their collection of Renoir paintings."

That same day, the *Daily Mirror* received a letter postmarked Epsom, Surrey. It said: "We have decided to tell your newspaper the whole truth about this sensational story after the panic has died down." (They didn't.) Three days later, Bristol police surrounded a railway station after a young man told a passenger he was carrying the Goya. (He wasn't.)

The fact that none of this, the ransom note included, gave the authorities major encouragement is suggested by internal National Gallery documents. One memorandum reports that on September 4, four days after receipt of the

ransom note, Director Hendy visited Scotland Yard to discuss the advisability of offering a reward for information leading to the painting's return. The Yard's acting chief commissioner strongly advised in favor of a reward, which he considered the only hope for the painting's recovery.

Various events, including the theft of the duke's two gold rings from the Bankfield Museum in Halifax, conspired to keep the theft of the Goya in the news. On September 4, two young men were caught attempting to steal a small copy of Velázquez's *Rokeby Venus* from the National Gallery's storeroom. Just two days after that, the wire services ran a big story from Copenhagen on how a master plan for theft prevention had been offered by Interpol to the National Gallery and other museums a year earlier. A memorandum ("Protecting Museums against Thieves") had circulated, but apparently most museums, including the National Gallery, had not seen fit to take Interpol up on the offer.

Though the gallery's trustees unanimously rejected Hendy's offer to resign, the negative publicity from the theft spurred the gallery to take other action for the sake of public relations. On September 15, the gallery issued a press release that "deeply deplored" the theft from which "the whole nation has suffered." On September 26, the gallery trustees offered a £5,000 reward to "the first person giving information which will result in the apprehension and the conviction of the thief or thieves, or receiver, and the recovery of this famous picture, the property of the Nation." Reward notices were circulated to Interpol, and thousands of reward leaflets were translated into French and sent to Paris. Apparently it was presumed that the art capital of the world was a logical place for someone to transport the painting. In addition, the gallery broadcast two appeals, one in late September and one in December, imploring the thief to return the booty anonymously and suffer no consequences.

The offer of a reward only accelerated the flow of bogus notes and calls. What slowed the hoaxes somewhat was the capture of a nineteen-year-old typist attempting to steal a tablet from the National Portrait Gallery in London. Under grilling by police, the disturbed woman confessed to having been the source of many of the hoax calls pertaining to *The Duke*. On October 16, she was sentenced to three years at Borstal, a reformatory for young criminals.

Scotland Yard continued with the normal investigatory measures, but with no reason for optimism about a breakthrough any time soon. At the same time, investigators braced for what they assumed would come next, the event they simultaneously dreaded and craved: another communication from whoever had the painting.

Chapter 6: THE CRUSADE

The encounter with the veteran who could not afford the BBC license "seemed to insist on popping up in my mind," Kempton Bunton later recalled. He brooded about the afflictions of old age and the cruelty of callous government policies compounding that state of affairs. Solitude, Bunton reflected, is the single greatest curse of aging. The elderly need companionship above all, but no one wants to visit them. "I began to romance on the ways to combat this evil," Bunton writes in his memoirs, and he came to realize that "television was the answer." Before long, the more specific solution came to him: "All old folk who wished should have free viewing."

It was only a matter of time before that simple insight became Kempton Bunton's cause célèbre and eventually his casus belli. As he acknowledges with disarming candor in his memoirs, "The problem lay forever with me." Like many a crusader before and after, Bunton recognized that his cause was not the only cause, that in fact it had infinite competition in the ranks of injustice, but that recognition did not moderate his zeal. To the contrary, it meant that he needed to do something dramatic to get the public's attention. "And then came the idea."

Given his instinct for rebellion against law enforcement, the big idea came naturally for Kempton Bunton: civil disobedience. As he put it with impeccable logic: "If one did not pay a license for their TV set, that was not news, but if everyone refused to pay a license, that was news." Bunton dreamed of inspiring an army of elderly folks to refuse to pay the BBC fee. Such a force would prove irresistible. "They could gaol me time and time again, but would they gaol a hundred or so old folk who may possibly follow me?" This plan to combat a "tyrannical law" involved "a certainty of success." Bunton would later be derided as a publicity hound, but he dismissed this criticism as coming from "nitwits" who missed the point: "Of course I was working for [publicity]. Without publicity, the plan was worthless."

The revolution starts at home. In the spring of 1960, Bunton altered the switch on his television set so that it would receive only ITV (the non-government service). Next he sent a letter to the authorities: "As my set can only receive ITV, I see no reason to pay the BBC." Having taken a stand, "I then waited for the Heavens to fall." He didn't have to wait long, at least for earthly movement in his direction. A few days later, he received a visit from two post office inquiry officers. According to Bunton, these stern gentlemen lectured him on "the sinfulness of this state of affairs." When informed that the sinner had no intention of reforming his ways, they "eyed me as some kind of nut." Eventually they left, "but not before assuring me that I was in for serious trouble."

A few weeks later, Bunton received the predictable summons, which set the stage for phase two of his plan: to use the courtroom as soapbox and set in motion the mass civil disobedience that could not fail. With a savvy sense of public relations, Bunton alerted the local media "of the time, the place, plus the novel aspects of the case," and lo and behold, "they turned up in force." And when, at his hearing on April 29, the magistrate asked Bunton what he had to say for himself, he launched into a diatribe against the BBC licensing fee, which he characterized as a "ridiculous tax." He further told the magistrate, "This is a matter of principle with me. I believe that the air should be free. Why should millions of people be deprived of the pleasures of television?" This newfound champion of free television acknowledged that some television programs were ridiculed, "but I still maintain that it is a grand time-killer and a special benefit to our old folk."

The judge pronounced himself unimpressed and fined Bunton (who had pled not guilty) £2. The contempt was mutual, and Bunton declared his unwillingness to pay. The judge informed him that he had seven days to change his mind. The scofflaw was ushered outside, where he "willingly obliged the press photographers" while feeling "extra confident as to the success of the plan."

Bunton's day in court received substantial media coverage, with the *London Times* closing its eight-paragraph account by noting that "he said that he intended to carry the case to the end even if it meant going to prison." (The article identified Bunton as thirty-five years old; he was in fact fifty-six.) Despite the publicity, it soon became apparent that Bunton had failed to inspire

an army of followers. Nevertheless, as Bunton remarks in his memoirs, "the stunt had started, and I meant to see it through for the year."

He claims that he did receive some support—dozens of letters urging him to stick to his guns. Before long, he also received another summons to court on account of his failure to pay the earlier fine. Bunton again notified the media and again attracted a large crowd to bear witness to his recalcitrance. As for what happened in court, Bunton describes the matter succinctly: Once again, the authorities were "loath to gaol me. Instead, they gave me extra time to pay, and this despite the fact of my assertions that I had no intention of paying the fine."

Bunton continued to expect his leadership to produce a legion of copycats —"oh for a few hundred devil may cares, yes just one in every 10,000." Had even a few brave souls followed his intrepid example, he later maintained, "the government would have been helpless." Alas, his crusade remained solo, and it failed to amuse the authorities. On May 19 he was summoned back to court, where he reiterated that he would prefer prison to voluntary payment of the fine. Bunton promised to continue to "treat the B.B.C. levy with the contempt it deserves," and he declared that old people are "sick of empty promises given by forgetful governments." He urged the House of Commons to rectify the situation immediately. The magistrate replied that he had no opinion about Bunton's crusade: "We are only concerned that you should pay your fine." He gave Bunton one more week to do so and decreed that thirteen days imprisonment would be the price of default.

The *London Times* covered the hearing, leading with a description of Bunton's "one man campaign against the Inland revenue and the BBC." After the hearing, the *Times* reporter caught up with Bunton outside of court and quoted the nonrepentant defendant as saying that he would serve the time and immediately resume his illegal viewing. "I expect to be in and out of gaol a lot," he remarked, though he added that he would abandon his crusade if he did not receive substantial support by January.

Bunton made good on all his threats. He did not pay the fine, and the resulting thirteen-day sentence failed to break his spirit. To the contrary, upon his release he immediately notified the government of his plan to continue his unlicensed enjoyment of television. Once again a few burly visitors arrived at his house and informed him in no uncertain terms that his resistance would

be met by the full force of the law. Once again he was undeterred, received a summons to court, and seized the occasion to "rail against the principal villain, the BBC." His performance earned Bunton a choice: a £10 fine or fifty-six days in prison. Bunton's life had begun to resemble the movie *Groundhog Day,* an endless loop.

Bunton again opted for prison, but even the longer sentence failed to knock him off course. After all, "I had made a statement that the campaign was to be continued until the end of the year, and I could not break my word." Accordingly, upon his release he yet again informed the authorities that he planned to continue watching television without paying the required fee. At this point he did so with "the full knowledge of failure," but unbowed just the same. It occurred to him to supplement his civil disobedience with old-fashioned democratic participation. He wrote to his representative in Parliament, who did in fact raise the issue of the licensing fee in the House of Commons, but "it was like a cry in the night to be forgotten five minutes later."

The year ended, and Bunton finally considered the battle lost. Unfortunately, he received another summons for January and had to appear in court and admit defeat publicly. The court responded with lenient treatment for his delinquent payment, giving him a choice of a £10 fine or a night in prison. Bunton again opted for the latter. Three strikes and he was finally out for good—or at least for several years. He abandoned the civil disobedience campaign, which had failed to bring about the desired result.

Privately he claimed a moral victory: "Yes, the plan failed, but millions of people must have realized the point I was trying to make. . . . The time will also come when an apathetic public must surely awaken to this monstrosity. The air is free, don't let them tax it."

His losing bout with the law behind him, Bunton answered a newspaper advertisement and found work as a bookmaker's clerk—returning to a vocation he had sampled thirty years earlier. But before long he decided that being trapped in an office for miniscule pay was not appealing. What next? Here, as so often with Kempton Bunton's memoirs, paraphrase won't do. For accuracy and succinctness, one can't improve on his transition: "And then came Goya."

Chapter 1 described how the sale of Goya's *Portrait of the Duke of Wellington* to an American oil tycoon set off a storm in the UK, culminating in the expenditure of £140,000 to keep the painting in England. Most Brits were outraged at the thought of the UK losing the painting. Kempton Bunton was outraged at the thought of the UK *keeping* the painting. Or, more to the point, he thought it outrageous that the government would spend substantial taxpayers' money for such a purpose. In fact, the government paid only two-sevenths of the £140,000, with the rest contributed by a private foundation, but that distinction was lost on Bunton. As he put it in his memoirs, "Something clicked within me" when he learned of the expenditure of "£140,000 for a thing I wouldn't hang in my kitchen."

From the beginning, Bunton was obsessed with the juxtaposition of the government's solicitousness over a mere canvas and its indifference to the plight of the elderly. He simply could not fathom "the Government taxing old folk to view [television], and at the same time wasting money on a useless painting." Moral outrage mingled with curiosity: "Who the hell was this Wellington anyway?"

The inquisitive (if uneducated) Bunton took to the stacks of the local library, where it appears that he read somewhat selectively. British history books treat the Duke of Wellington with reverence, as an unparalleled military officer and benevolent statesman, but Bunton came away distinctly unimpressed: "The man had been a tyrant" with nothing but contempt for the lower classes, a "flogger of men" and an overrated warrior. The lower classes the duke despised "won the battles for which he took the credit." Having immersed himself in the history books, Bunton could find "not one iota of any humane act he had done."

And so, Bunton later told the police and eventually a jury, he determined that this historic figure, so destructive in life, should be exploited for benevolent purposes more than a century after his death. He crafted a carefully thought-out plan. He would kidnap and ransom *The Duke,* and since the money would go to charity, no one could seriously object. Moreover, since he would never personally handle the money, he would be in no legal jeopardy. The portrait of an overrated man would be returned to the National Gallery, thousands of elderly people would gain access to television, and no one would suffer at all.

It is fascinating to see, in retrospect, that one man had Bunton's number all along. Scotland Yard employed profilers, consulted psychics, and engaged in extensive speculation about the thief's motives. An ingenious prankster? Cold-blooded professional? They never guessed the improbable truth. But in October 1961, two months after the theft, writing in the *Nation* magazine, novelist Richard Condon mused about the recent rash of art thefts (*The Duke* included) as follows:

> Perhaps the extraordinary price tags that have been placed on great art have affected some of the unstable. . . . Perhaps the more aberrant among them have begun to search their tilted minds to find some means of protest. . . . Perhaps they thought of the swollen prices of these paintings in terms of sums which could feed thousands, house thousands, educate thousands, clothe thousands and save thousands. . . . Perhaps it upset the unstable people so much that they began to steal paintings.

Where Kempton Bunton was concerned, Condon's impressive speculation missed with respect to one particular. While Bunton did indeed rage over the thought of what all that money squandered on art could do for the poor, he was not so much concerned about feeding, clothing, educating, and saving them but rather . . . allowing them to watch television.

Bunton's motive was no crazier than the course of action he allegedly pursued. According to his memoirs, as well as accounts he would give throughout his life, Bunton hitchhiked to London and made his way to the National Gallery (where he had never been) to case the joint. But, he claimed, as he wandered through the building, he discovered something that had not occurred to him: The invaluable art objects within were heavily guarded. On a more encouraging note, he saw that major construction was taking place outside and that, as a result, a ladder was strapped to scaffolding near the men's lavatory. In addition to gleaning such physical details, Bunton also gathered human intelligence. He chatted up a security guard and obtained important information about who guarded what works of art when. He spent sixpence for the gallery's floor plan, which provided further useful information.

Still not quite ready for the heist, Bunton returned to Newcastle and told his wife that he had been fishing. Bunton was blissfully unaware that, if he waited just a few more days, his theft of the Goya would be fifty years to the day of the theft of the *Mona Lisa* from the Louvre. Serendipitously he *did* wait a few days, the theft *did* occur fifty years to the day of the theft of the *Mona Lisa,* and from the beginning it was assumed that the thief had what one expert on art theft called a "flair for history." In fact, Kempton Bunton never even knew about the theft of the *Mona Lisa,* much less its date. That Goya's *Portrait of the Duke of Wellington* was stolen fifty years to the day of the theft of the *Mona Lisa* was a complete coincidence in a case whose bizarre aspects would continue to accumulate.

When Bunton returned to London, he made sure that the helpful situation with construction outside the National Gallery had not changed. He then formulated a precise plan, which included purchasing an old coat for a disguise and a toy gun in case he found himself confronted. Everything was in place except for one elusive detail: the absence of a getaway vehicle.

On Sunday night, August 21, as he passed the time at a pub, pondering his crusade, a despairing Bunton practically gave up on the idea of the heist because he could not afford a car and could not imagine any alternative for transporting *The Duke.* At least that is what Bunton told the authorities (as well as reiterated in his memoirs), though the absurdity of this account might have tipped them off that something was amiss. He had purchased special attire and a crime "weapon" while lacking a means of transport? If such oddities failed to establish doubt about Bunton's veracity, what he claimed happened next surely should have.

As Bunton wrestled with his despair, he prowled around in a half-hearted attempt to find a car with a key carelessly left in the ignition. No luck. But while hanging out on a street corner cursing his fate, he spotted a car driven by someone clearly drunk. The drunkard parked outside a small hotel near where Bunton happened to be stationed, then staggered out of the car and crawled into the hotel, leaving the driver's door partially open and the key in the ignition. Bunton jumped into the car and sped away. He drove straight to the National Gallery and parked outside the rear gates. He got out, then spent a few hours wandering around the street on foot, trying to embolden himself. At roughly 4 A.M., he took a swig of whiskey from a bottle he was carrying

around; donned gloves, the old coat, and a taxi hat; wrapped a clothesline around his waist; and, armed with the toy gun, made his move.

First he had to scale a wall to get into the gallery courtyard from the street. This he accomplished by placing a tarpaulin on the roof of his car, climbing atop the car, then putting the tarp on the wall and climbing on it. He found himself on top of a corrugated tin roof, where he lay and looked around. He thought he heard movement in the yard and saw a light. He feared that all his planning would be thwarted by a night watchman employed by the construction company. He lay still for at least fifteen minutes, by which time he decided that the noise and lights were, as he put it in his memoirs, "figures of my imagination."

He made his way into the yard, where he felt surrounded by total silence and vast space. After traversing what seemed like a series of courtyards, at last he arrived at the National Gallery's lavatory window. As he sought to lift and open up the ladder, a loud noise made him freeze—someone had yanked the chain to flush the lavatory toilet. Bunton waited a little longer. He had earlier determined that 5 A.M. would be the best time to enter, and the flushed toilet jarred him into returning to that plan, which meant another half hour of delay. During that time, he noticed a "sort of ventilation shaft, probably in connection with the Gallery," and thought that a professional thief might enter through that. But this distinctly unprofessional thief decided to stick to his original plan.

When the time finally arrived, Bunton picked up the ladder and moved it under the lavatory window, despite finding it "intolerably heavy." Thereafter "I remember being ultra careful in the operation." He chose this hour because his intelligence gathering had led him to expect no resistance, but in case a guard should materialize (and *someone* had flushed the toilet just a little earlier), he had a contingency plan: The toy gun would "look very real to a guard, and ensure his silence, and persuade him to unlock one of the side doors to let me out."

The weapon may have helped, but Bunton found even greater comfort elsewhere. His "main ally" was the knowledge of his own benign intentions: "I did not look upon taking the picture as criminal, and what the hell if I did fail, it was no hanging matter, and at least the failure would bring attention to my aims."

Thus calmed, Bunton climbed the ladder, lifted the bar of the window, and pulled himself into the lavatory, where he "found myself standing on a toilet basin. It was now that some luck was needed."

Listening intently, he could detect only a hissing sound, which he attributed to the boiler heating system. He walked outside the lavatory and into the gallery hallway, turned right, walked to the end of the corridor, turned left, walked down the foyer, and then walked up the half flight of stairs that left him facing *The Duke of Wellington,* surrounded by a rope barrier. He stepped inside the rope, removed *The Duke,* and reversed his tracks. It seemed like eternity before Bunton found himself back in the lavatory, where he told himself, "I must work fast. At any moment anyone could stumble upon me."

He removed the clothesline from his waist and tied it around the painting, which he proceeded to lower to the ground faceup. He then followed the same path himself and momentarily landed on the ground next to the painting. He picked it up and headed for his prearranged exit through the double gates at the rear of the gallery, abutting St. Martin's Street.

At this point, however, Bunton discovered a glitch in his well-crafted plan. The gates, which he expected to be secured by ordinary slip bolts that he would easily release, were padlocked. Through "madness or hypnotism" he had committed "a stupid oversight," and panic began to set in. He and *The Duke* were trapped. Bunton had the presence of mind to search for an alternative escape route and noticed a low wall to his left. He climbed over it, only to find a higher wall impeding access to the street. He climbed that wall as well and from the top noticed a sign: "Car Sales." He had attained the street—or at least he would once he lowered himself and his traveling partner. Panic had given way to calm, but the latter induced carelessness, as he "contemptuously ignored strands of rotten barbed wire."

He "half lowered, half fell to the ground," turning an ankle in the process. He limped to his car, stood the portrait on its floor, and at last made his getaway on the still-deserted street, heading toward the lodge where he was staying. Except he got lost, prompting this self-assessment: "I remember a feeling of irony. I was blundering this job all through, and yet getting away with it."

Roughly one hundred yards from the lodge, Bunton saw a policeman step into the middle of the road to flag him down. Bunton felt panicky, asking himself "how in hell could they have started this Goya hunt already?"

In fact, Bunton had attracted the officer's attention for a different reason: "Goya was within inches of him, and uncovered," but the cop's interest in the

car stemmed from the fact that it was heading the wrong way on a one-way street. The officer politely turned Bunton around, and that was that. Bunton soon arrived at the lodge and, after ensuring that no one was watching, whisked the painting up to his room and stood it behind a dresser against the wall.

At long last, both Bunton and *The Duke* were safe, and it was presumably only a matter of time before the elderly could again afford to watch television. But Bunton still had work to do, starting with getting rid of the getaway vehicle. He returned it to the hotel at Kings Cross whence it came, in the hope that the drunk from whom he had taken it would reclaim it. He assumed that that in fact had happened, "and I don't suppose that car owner ever realized that he was a gallon of petrol down."

Bad ankle and all, Bunton raced back to the lodge, took *The Duke* out of hiding, and looked triumphantly at his hostage. He was viewing the man Tennyson had eulogized as "in his simplicity sublime," but Bunton saw only meanness and haughtiness. He repeats in his memoirs the same poetic message he gave the cops: "Wellington returned my stare with cold contempt." Indeed, "I swear I saw his lips move, and the imaginary voice said, 'Thou low born wretch, I'll break thee for this.'"

When he was done conversing with *The Duke*, Bunton began preparations for transporting them both. He decided that the frame was "too ugly and too large to be worth bothering about" and lightened his load by removing it. With the benefit of hardboard, brown sheets of paper, and Sellotape (a British brand of transparent adhesive tape), he covered the painting to secure it from scratching.

As for what he did with the frame, Bunton told multiple stories over the years. He told the cops that he threw the frame in the Thames. At trial some years later, he claimed that he left the frame in a cupboard under the stairs in the house where he lodged. But in his memoirs, Bunton writes that he broke the frame into pieces and "distributed several parts around various building dumps." In any case, with the unframed *Duke of Wellington* now safe from injury and detection, Bunton would embark on a three-hundred-mile journey north.

A predictable intervening event, which surprisingly surprised Bunton, was the fevered reaction to the theft that swept London. He learned from media reports that airports and railways stations were being watched for suspicious

parcels. Bunton despised this "outcry over a piece of old wood," all the more so because it complicated his plan to return to Newcastle, where he was due in two days. He couldn't very well stay put because of the "danger of myself and the Goya being somehow connected by going missing at the same time."

Bunton claims that he attached "glass with care" labels to the portrait, put it back behind his wardrobe, and took the train to Newcastle without his expected travel companion. A few days later he returned to the lodge in London and found his hostage safe and sound.

It must be emphasized that the account of the theft and its aftermath just given is Bunton's—the one he gave in his memoirs and, allowing for some nontrivial divergences (such as what happened to the painting's frame), what he told on several occasions at the police station and in the courtroom. Indeed, apart from a brief period in 1969 when he recanted the entire story and declared his innocence, it is roughly the story he gave until he died in 1976 and the story that would be told many times in his obituaries and accounts of the crime thereafter.

The reader should understand, however, that the presentation of Bunton's account in this chapter is just that—his account. As we shall see, internal aspects of Bunton's story, as well as external facts to emerge over the years, cast doubt upon the essentials of his narrative of the crime. But Bunton's bona fides must be put on hold. To understand how the whole saga developed, we need to dip back before we can move forward.

Chapter 7: THE RANSOM NOTES (COMS 2–5)

From October 1961 to July 1962, nothing of great consequence happened related to the investigation of the missing *Portrait of the Duke of Wellington,* unless you count James Bond discovering its whereabouts. In an indication of the extent to which the theft struck a nerve with the British public, the makers of the first Bond movie, *Dr. No,* alluded to the theft and solved the mystery. Sean Connery's Bond does a triple-take when he spots the duke's portrait on an easel in the underwater Caribbean lair of the villain. (The convincing-looking replica was painted by the well-regarded production designer Ken Adams, based on a slide of the original obtained from the National Gallery.)

In the world bordering fiction and nonfiction, newspapers were recipients of many strange missives. One dated June 7, 1962, and sent to the *Evening Post* declared, "I am the crank. My eccentric brother-in-law has the 'GOYA.' It is safe, slightly damp but otherwise intact. We came from London recently. Free Pardon. Will contact." Signed Z.B.P.J. At the bottom was a little satanic message: "666."

Such letters were transparent phonies, but the next month brought forward what at least in retrospect could be considered the first major event of the year—a ransom note that seemed to have been written by the person who wrote the original ransom note ten days after the theft. This second half-crazed ransom note, posted at Lancaster and Morecambe on July 3 and sent to the *Exchange Telegraph,* read as follows:

Goya Com 3. The *Duke* is safe. His temperature cared for—his future uncertain. The painting is neither to be cloakroomed or kiosked, as such would defeat our purpose and leave us to ever open arrest. We want pardon or the right to leave the

country—banishment? We ask that some nonconformist type of person with the fearless fortitude of a Montgomery start the fund for £140,000. No law can touch him. Propriety may frown—but God must smile.

The thief added a PS, explaining why he called this letter Com 3 when his previous ransom note—the one sent on August 31, 1961—was Com 1: "Letter to Reuters Feb 11 was 2nd Com."

The letter's invocation of a fearless "Montgomery" was presumably a reference to Field Marshal Lord Bernard Law Montgomery, a decorated hero in World War II. It stirred Montgomery to issue a statement (released on his behalf by the National Gallery), noting his personal admiration for Wellington and pleading for the return of the "magnificent portrait of a great soldier." Montgomery lamented that "the joke has gone on long enough."

All the evidence suggested that the joker who had penned Com 3 was indeed the same person who had written the original ransom note (Com 1) ten days after the theft. It was written in the same block letters, displayed the same weird and insouciant tone, and covered the same substantive ground— an assurance that *The Duke* was safe and a demand for £140,000 and a pardon for the culprits.

Most importantly, both letters were apparently written by someone in actual possession of the painting, as this one included a label from the back of the canvas as a physical mark to confirm authenticity. The National Gallery nevertheless cautioned skepticism. A gallery spokesperson said, "Whether the label is authentic or not, we do not know" because the gallery had never photographed the back of the painting. But others in the know saw no need to hedge. After seeing the label displayed on BBC television news, the painting's former owner, the Duchess of Leeds, declared herself "quite sure" that it was from the portrait. Better still was the testimony of Frank Le Gallais, whose Jersey firm had actually stamped the portrait with the label and who had verified the accuracy of the first ransom note's description of the back of the painting. After seeing the BBC report, Le Gallais confirmed that "it is undoubtedly our label. The printing on it is my firm's and the handwriting that of our removal manager."

The *London Times* gave the new ransom note prominent treatment, a sixteen-paragraph article that closed with a statement by a National Gallery spokesperson: "This may be a clue that will lead somewhere. On the other hand, it might just be another thing like the telephone calls of last year."

In fact, assuming that the author of this new note was indeed the person who penned the first ransom note eleven months earlier, and who had the painting in his possession, the letter contained at least two troubling items. First, whereas the original note made no threat, direct or indirect, to harm *The Duke,* this one arguably contained an oblique threat—the declaration "his future uncertain." Second, the writer alluded to a February letter sent to Reuters, of which there was apparently no record.

The original ransom note, sent just ten days after the theft, called for a "speedy conclusion" to the affair. That its writer (assuming he had the painting) was then unheard from for almost a year seemed surprising. But now he offered an explanation—he had *not* been silent in the interim. He had sent a second letter, in February 1962, that had apparently fallen between the cracks. The Yard asked Reuters to search its files, but nothing surfaced. The missing epistle was perhaps not crucial in itself—the thief fortunately got back in touch—but the Yard couldn't help but wonder what other clues were lying in dumpsters or closed files in parts unknown.

In part for that reason, police made a point of following up even the flimsiest leads. In mid-July, when an Essex businessman sought to arrange a meeting to provide information about the painting, police showed up at Barking Station, the proposed rendezvous spot. The would-be informant never arrived.

Several months later, Lord Lionel Charles Robbins, elected chairman of the trustees of the National Gallery earlier in the year, received an anonymous letter (dated November 21, 1962) stating that there was now no chance that the Goya would ever be returned. Sixth months of silence followed, broken by receipt of two related ransom letters on the same day—one to Robbins and the other to Lord Rothermere, chairman of the *Daily Mail.* The two letters, both posted from Burlington and dated May 20, 1963, were typed on foolscap paper, unlike the handwritten ransom notes of August 31, 1961, and July 3, 1962. The unsigned short letter to Robbins read as follows:

I have the missing painting of the Duke of Wellington—you may have it back at £5,000—this can be arranged providing you work quietly.

It is suggested that Lord Rothermere of the Daily Mail be the intermediary—his word I will take—I am sure you can do same.

Briefly this is what you do—contact Rothermere—give him your assurance the police will be left out, otherwise his position will be untenable—it will be impossible for him to act, and at the same time safeguard his integrity.

The much longer and largely incoherent letter to Rothermere included several headings in bold type and all capital letters and set forth an elaborate procedure for the return of the painting and payment of the much-reduced ransom demand:

IN CONFIDENCE

I have the Goya portrait of the Duke of Wellington, and it is to be offered to you under certain guarantees, plus £5,000. You know why the painting was taken. I shall not try to convince you as to why £5,000 is needed now.

If guarantees satisfactory, the Goya is to be, or shall we say abandoned into the care of editor of the Daily Mail in Manchester. YOU receive the portrait first, then on your accepted word, you pay.

FIRST GUARANTEE

Your photograph to appear one day in all editions of the Daily Mail, and underneath the words, not necessarily the same but similar to following.

Lord Rothermere visiting me so & so place yesterday commented upon the position of the two journalists in the Vassal tribunal. He believes that a newspaperperson should to some great extent be entitled to treat a confidence as shared—

personally he went on, that has always been my motto, and always will be, excepting perhaps in such cases as rape, murder, and other bestial crimes.

Generally speaking, he continued, the successful men of this world, are the men who having given their word, stand by it.

―――――――

This notice will be taken to mean that you have studied the offer—that even though you may not like it—you will follow the instructions to the letter.

THE PAY OFF

You or your agent will drive up to a certain address which will be chosen at random (to be given later) at 10:30 PM on the same day as Manchester receives the portrait. Driver will sit in the parked car keeping lights ON for five minutes, and in that time will be contacted—asked a prearranged question of 5 words, at which without answering, he will hand over package containing £5,000 in used £5 notes.

Two minutes after handover, driver can leave. Any slip up, same procedure, time and place, next night.

―――――――

The address of handover, plus password question, will be received by you on the day following your photograph guarantee appears.

You must at once confirm receipt of place and password by placing the following in the personal column of the London Times—personal should give the approximate mileage from Manchester to the handover city, and should read ABOUT ? MILES. YOUR GAMBLE SOUND. SQUARE DEAL ASSURED. L.R.

This message will be taken to mean Money ready, will deliver same day as portrait returned.

Exactly seven days to the day of the Times personal appearing—your Manchester office will get possession of the painting.

I am a gambler sir, and I am putting myself completely in your hands, on the hunch that a top newspaper man will not break a confidence.

Considering this deal to be based upon a gentleman's agreement, I am making contact for the money personally.

If you work with the police, you will be a loyal citizen, but the easy conquest will make for an uneasy conscience—journalism will take on a new aspect—your most junior reporters will wonder why & wherefore.

Be careful sir—the painting is a much treasured piece—but do not let it make a scapegoat out of you.

Only you can judge if the Gallery are working honestly with you—if you consider this so, then retrieve it for them.

I am taking your word of honour—it is for you to judge if you can accept theirs.

If you decide to work with me, it is imperative that you keep these instructions to yourself.

Copy of letter to trustees chairman of Gallery encl.

Robbins and Rothermere immediately turned the respective letters over to the police. Robbins later recalled paying little attention to the letter to him because, unlike the prior ransom notes, it evinced no evidence of actual possession of the portrait. That was hardly the only difference between the letters to Robbins and Rothermere and the prior ransom notes. As noted, the new ones were typed. In addition, whereas the other notes suggested that the writer was part of a "gang," one of several "culprits," the letters to Robbins and Rothermere referred to a single "I" throughout. Finally, and potentially most significant, the ransom demand, £140,000 in the previous notes, was now just £5,000.

That dramatically reduced demand was either good news or bad, depending on one's interpretation. It could be seen as decisive evidence that the

new letters were in fact written by someone else. And since the new ransomer, unlike the writer of the previous notes, offered no proof that he had the painting, there was good reason to dismiss these two new letters as a hoax. On the other hand, the letter to Rothermere displayed some of the whimsy ("I am a gambler, sir") that characterized the August 31, 1961, and June 3, 1962, letters. If it had in fact been sent by the same person, he had clearly grown frustrated, if not desperate, which could be seen as a promising (but also frightening) development.

From the standpoint of any potential response, the amount of the ransom demand did not matter: the principle—no ransom negotiations—remained absolute. But if the culprit was getting desperate, perhaps he would be heard from again shortly. Alas, that did not happen, despite efforts to lure him out of hiding. In November BBC correspondent Richard Dimbleby brought on Philip Hendy and Lord Robbins, the National Gallery's director and chairman, respectively, who appealed to whoever had the painting to return it. No immediate response was forthcoming.

The next month, Spike Milligan, a well-known comedian and writer (his television shows were said to influence *Monty Python's Flying Circus*), took out a personal ad in the *New Statesman*, declaring that he "would like to contact those who have the missing Goya portrait in their possession. He sympathizes with them and would like to attempt to meet them with a view to raising money independently . . . to be donated to a charity of their choosing." Milligan saw fit to add, "This is a sincere offer and done without the connivance of the police or the authorities." Nothing came of the appeal, despite its shrewd effort to play to the thief's apparent altruistic motives. The thief either never saw it or didn't trust it. But he was heard from soon thereafter, sounding anything but desperate.

A long letter, posted in Birmingham on December 30, 1963, and sent to the *Exchange Telegraph,* in the same block capitals as two prior ransom notes, not only reprised the steep original ransom demand of £140,000 but mocked the authorities and kidnap victim alike. The handwritten letter was titled "GOYA" at the center top and began by listing in a vertical column the prior correspondence, as follows:

Com 1, To Reuters Asking Ransom and Pardon (Genuine)
Com 2, To Reuters FEB 62 Suppressed (Genuine)
Com 3 To Exchange Tel From Morecambe With Label (Genuine)

This prelude to the new ransom note was noteworthy in two respects. First, it reiterated what the ransomer had stated as a PS in his July 1962 letter: He had written a letter to Reuters in February 1962. Second, it pointedly omitted mention of the May 1963 letters to Lord Robbins and Lord Rothermere. In any event, the long letter that followed began by declaring itself "Com 4" and then engaged in a combination of lamentation and a scheme for returning the painting even more detailed than the one proposed in the sprawling letter to Lord Rothermere six months earlier:

THIS IS COM 4

Terms are same. Rag students kidnap living person for ransom—they are not charged. An amnesty in my case would not be out of order. The Yard are looking for a needle in a haystack, but they haven't a clue where the haystack is.

Mr. Commissioner your men are clever, But do not ask the impossible of them. My scheme was meant to be a clean, humane antic—You have turned it into a much more serious affair.

Will other paintings be safe if I get away with this? I think so—I would certainly not react same again—too much risk—too little thanks.

I ask you in the position as it stands—have you the right To deny the Gallery the chance to regain the portrait? I ask you to make a special concession in this affair, decreeing that as the act has already been accomplished, all proceedings will be dropped if the Goya is returned. And now for the matter of £140,000. The Art World Has Made No Effort At Subscription—There Remains The Press—Will They Rescue The Duke? Here is my plan in brief—turn it down offhand, and I Go to sleep for another year. Full details will be sent if acceptable.

On the night of the 'borrowing' I was hooded with a silk stocking. I propose to be picked up hooded in a dark London side street with Goya. Your pick-up car to have 3 guards. To safeguard me from interference from the photographers Assembled At The Gallery—I am Not To Be Questioned. Press men will take pictures of return of Goya after which I am to be secreted out of rear door, and driven to any London side street named. Guards to drop me without speaking and drive away. I to be hooded throughout. My identity to remain secret on your honour.

The Press will now have some photos—will they be gentlemen? I am suggesting that each individual editor should pay 5 per 1,000 of his circulation. Editors to send money to a certain London Bank. Bank to issue full subscription lists to national press. Within 2 weeks bank to send full cheque to a certain London establishment of national repute. A committee of 5 to agree to my selection of charity, With rights to redirect money. Pinchpenny editors who do not print, to be sent to Conventry, print and don't pay editors to be sent to Tristan. The Yanks like a lark—they will cooperate. There are gentlemen in the foreign press too. Mr. Robbins assert thyself and get the damn thing on view again.

I am offering three-pennyworth of old Spanish firewood in exchange for £140,000 of human happiness.

A real bargain compared to a near million for a scruffy piece of Italian cardboard.

The "near million for a scruffy piece of Italian cardboard" clearly referred to the National Gallery's recent £800,000 purchase of da Vinci's cartoon *Virgin and Child*. Those trying to profile the thief could file this item in the same compartment as the fact that the theft had taken place exactly a half century to the day of the theft of the *Mona Lisa*. He apparently kept up with the arts.

He also appeared to have a screw loose, or was having a grand time pretending to. Taken at face value, the latest missive suggested someone in major denial. After all, the previous ransom demands had been ignored, but he still felt it worth his while to trot out increasingly elaborate schemes for the return of the painting and dispensation of the ransom payment (including reprising the idea of a "committee of 5").

That the ransomer was getting nowhere with the would-be ransomee is suggested by a National Gallery document, "Report from the Director," dated January 9, 1964. It noted receipt of the December 30, 1963, ransom note and how Scotland Yard and gallery officials "agreed that the letter came from the same source as two previous communications from the present holder of the picture" but further agreed that "there was no action which could usefully be taken."

As it happens, the December 30, 1963, ransom letter coincided with another development in the case: The next day, New Year's Eve, an anonymous caller told the authorities at Victoria Station that a black-and-yellow box in the left luggage office contained the ashes from Goya's *Portrait of the Duke*. Railway police rushed over and found the box in question, nine inches wide and two inches deep. It contained, along with ashes or rubbish that looked like compost wrapped in paper, a sheet of paper with an ominous message in newspaper type: "The last of Goya." The man in charge of the office told reporters that "to me they were the ashes of something hard. . . . I am no expert, but it might have been the painting." (The luggage room assistant who received the baggage, a few minutes before the office closed at 11:30 P.M. the previous night, recalled that it was deposited by a young, heavy man in a light raincoat and a trilby hat.) Expectations were raised but quickly thwarted. Forensic testing of the ashes revealed no trace of either paint or canvas.

With the authorities determined to outlast the idiosyncratic ransom note writer, 1964 was mostly quiet on *The Duke* front, apart from a flurry of activity early in the year. On January 6, the *London Times* ran a brief editorial suggesting that the thief take the opportunity to add the duke's portrait to a Goya exhibition then on display at the Royal Academy. In a transparent effort at flattery, the *Times* observed, "To destroy the painting would give no real satisfaction. Any moron could do that and these are clearly men of intelligence."

The next day the *Times* ran a letter from academy president Sir Charles Wheeler responding to the editorial. Wheeler remarked that the "record-breaking crowds now coming to the Royal Academy would be delighted" if the thief handed over the Goya. He added, "I challenge those concerned with the Duke's present safety to accomplish this 'Rafflesian' task." (Raffles, the gentleman thief created by Arthur Conan Doyle's brother-in-law, stole a gold vase from the British Museum, grew tired of looking at it, and put it in a cookie canister, which he sent anonymously to Queen Victoria's secretary.) For good measure, Wheeler offered an alternative suggestion. In March the academy expected to receive more than seven thousand paintings for its summer exhibition. The man who had "so deftly stolen" the Goya might consider slipping it into the pile of received works, as the academy would "ask no questions."

Wheeler, in turn, received a letter from ANON dated January 7 and postmarked London. It praised his "well thought out scheme" but noted its fatal flaw—"You mentioned nothing about money being paid for the return. The disappearance of the painting was not conducted for fun and games, but for a specific reason—to obtain money for a good cause." The letter writer implied that he possessed the Goya, stating that "we would not gain anything" from a voluntary return of the painting, and thus the very idea constitutes "madness personified."

Although this letter was never traced to the actual thief, later events (discussed in chapter 12) suggest that Wheeler's letter to the editor did indeed get the attention of the man who possessed the Goya. Between that, the consistency of message (that the theft was designed to raise money for a good cause), and the insouciant language ("madness personified"), it seems likely that this letter was indeed penned by the man who had authored various ransom notes.

The next day, January 8, the *Daily Telegraph* printed a lengthy article titled "No Yard Bargaining on Goya Return." It included a quote from a Scotland Yard spokesman that police inquiries into the Goya "would probably be intensified rather than relaxed if it were returned anonymously" because such return would present "an opportunity for getting evidence that would catch the thief or thieves." Similar sentiments were expressed on television; all of them prompted National Gallery officials to protest what they regarded as

counterproductive comments that would only discourage the thief from returning the painting.

The next month also brought a bizarre mini-intervention by Sir Gerald Kelly, a British portrait painter and former president of the Royal Academy, not to mention a man prone to controversy. In an interview with the *Daily Express* on February 1, Kelly opined that the portrait was a fake—it was not by Goya! Accordingly, "We should have whooped with joy when it disappeared. I for one certainly hope that it will never be recovered."

When 1965 rolled around, it was looking like Kelly would get his wish. The authorities were no closer to retrieving the painting or identifying who had taken it.

Chapter 8: WAITING GAME

On August 31, 1961, ten days after the theft of the Goya, Kempton Bunton sent his first ransom note to Reuters. This was the letter informing the authorities that "The picture is not, and will not be for sale—it is for ransom—£140,000—to be given to charity." Bunton would later anoint this letter "Com 1" and explain that *com* was short for communication. Bunton fully expected that the proposed ransom would be paid in short order. When he learned through the media that the authorities had no intention of yielding to the ransom demand, he realized that "a lengthy battle lay ahead." This prospect troubled him. He had hidden the painting in the London apartment where he was staying temporarily, but he did not wish to leave it there for long. For one thing, who knows what cleaning his landlady might choose to do? Worse, he had only a few shillings on hand and could not afford to remain in London for a prolonged period. Indeed, the need for thrift produced unforeseen problems. His fingernails needed trimming for him to find work at a bakery, which he decided was the best short-term solution to poverty. Precisely because of his impoverished state, he planned to do the trimming with a scissors borrowed from (and then returned to) the shelves of Woolworth. Alas, a Woolworth employee caught Bunton in the act and forced him "to pay 2/6 of my dwindling money" for the self-manicure. The man who allegedly got away with stealing a Goya worth £140,000 got nabbed briefly for borrowing a scissors.

Bunton soon landed a job at a bakery in Camden and hoped to put away some money and make a quick getaway to Newcastle—a plan made necessary by the "very dangerous situation with that 'thing' which I had locked in a wardrobe, plus the feeling of being 300 miles from home." But the job at the bakery, like so many of Bunton's employment stints, ended in a fight with his boss. This one culminated in the boss asking rhetorically, "If you don't want the job, why the [hell] did you take it?" With that reasonable question ringing in his ears, Bunton, "without a word to anyone, walked out into the

lonely, darkened, miserable streets of London." (This grim description echoes Stephen Sondheim's "No Place Like London" from the 1962 musical *Sweeney Todd*, in which the eponymous character declares, "There's a hole in the world like a great black pit . . . and it goes by the name of London.") He now needed money more desperately than ever but nevertheless remained confident that "if I kept my head, and did not panic, I would get the cursed Wellington up to Newcastle."

Ungainfully unemployed, Bunton turned his attention to planning his exit from London. From media reports in the wake of his initial ransom offer, he concluded that "no quick fund was to be started" and "a long fight was in the offing." Accordingly, he "began to prepare the Duke for his journey North."

Publicity about the theft of the painting had died down to the point that when Bunton scouted out the Kings Cross railway station, he found an almost normal atmosphere. The police presence, vastly beefed up in the aftermath of the theft, was substantially reduced. Only days before, police at rail stations had inspected all sizable parcels, but no longer.

Bunton still had to secure *The Duke* before he could return to Newcastle. He purchased several feet of plywood and, with a Woolworth handsaw, cut it down to size and made a casing. He then added brown paper and string for the safe transport of the picture. He also took precautions with his travel plans, buying a rail ticket on a Thursday night for a Friday-morning ride, "which would save me from hanging around the ticket office next day with a suspicious looking parcel."

Bunton left London still optimistic, believing that a fund for the collection of *The Duke* was only a matter of time and that, as a result, "40 or more aged and needy folk would benefit each and every week with a free TV license." On his last night in London, he imbibed freely, drinking to "the smashing possibility that Wellington's portrait might bring more happiness into the world than ever he himself had." Bunton congratulated himself on the "perfect plan." He still viewed the affair melodramatically, with the police "doing their utmost to stop thousands of oldies from seeing and enjoying the personalities of the world."

Come Friday morning, three weeks to the day after the kidnapping of *The Duke*, Bunton took a cab to a pub near Kings Cross Station and began the

countdown before he would have to "walk the gauntlet past at least a couple policeman" with the Goya in hand. He recognized that a more prudent man would have allowed more than three weeks to elapse from the time of the theft until his escape, but prudence was not his strong suit. And, at least on this occasion, recklessness did not prove his undoing. "Five hours later the train slid into Newcastle and I brazenly marched past the throng of people, ticket men, policemen."

The end was almost in sight but still difficult to reach. Lacking money for a cab, Bunton lugged *The Duke* onto a trolley bus and rode the last three miles home—very close to home anyway; the nearest bus stop was actually eighty yards from his house. Arriving at 12 Yewcroft Avenue, Bunton rushed up the stairs and "Wellington was pushed under my bed. . . . I did not expect any complaint from him." He started downstairs, but his wife, emerging from the kitchen, stood on the stairway staring inquiringly.

Mrs. Bunton posed no major problem, however, because "nobody ever lied to his Mrs better than me at that period." Bunton felt guilty about keeping his wife in the dark about his amazing caper, but "one just can't trust gossipy old women." Exhausted but semitriumphant, Bunton went to sleep knowing that two immediate tasks lay ahead: finding a suitable "resting place" for *The Duke* and devising a plan for his successful ransom.

Task number one was accomplished the next day, as the ever-resourceful scofflaw placed a piece of hardboard over the canvas and fit it into the top cupboard in the smallest bedroom in his modest three-bedroom house. To guard against "the wife nosing around," he filled the cupboard with several pieces of junk and manuscripts of the various radio and television plays he had written in his spare time. "I knew my wife would not disturb these, and thus felt reasonably safe." Whereas once they had only gathered dust, now Bunton's works of fiction protected a more eminent work of art.

As for task number two, a plan to land the ransom, Bunton took stock. While his scheme was off to an inauspicious start, he still felt he was dealing from a position of strength: "My first 'Com' letter had brought no reaction as regards to a fund—well, best play a waiting game. The portrait was safely cached, and I could afford to play a waiting game—let the art world worry for a change."

In September Bunton took a job driving a taxi for a company in Byker, a suburb of Newcastle. All went smoothly enough for a few months, but Christmas Eve brought a life-changing event. Bunton experienced a close call on the road, the essence of and fallout from which he described as follows: "I was not hurt, but have never driven a car since that incident . . . because I shall never forget a bus that raced headlong for me, the night I thought I was about to die."

The incident connects to the kidnapping of *The Duke of Wellington* in two respects. First, under oath several years later, Bunton would offer a somewhat different version of events. It is not the only discrepancy between his memoirs and his trial testimony, and it suggests the need for skepticism toward both. Second, apropos of fate throwing near death in his face, he remarks (in his memoirs), "I wondered if that cursed Wellington had anything to do with it." He had *The Duke,* but perhaps we should say it had him.

In mid-February 1962, less than two months after the incident that ended his driving career, Bunton again took stock. Six months had elapsed since his first ransom letter to Reuters; it was time to try a second. He decided it would be safer to post from London than Newcastle, and he took the train there on a Saturday. In a quiet pub, he scrawled out his second note "in similar vein to number one," again using handwritten block letters. Bunton posted the letter and immediately returned to Newcastle because "London somehow was depressing to me." He had traveled six hundred miles in a day at nontrivial expense to post the ransom note. "I remember vowing to myself to find a better way if more letters were to be posted."

As days went by, the exorbitant effort gnawed at Bunton less than the lack of a return on the investment. Silence, rather than any sort of publicity, greeted the second ransom note, prompting him to make another resolution: "The letter I had taken so much trouble to post had been stifled, by whom I knew not, but blaming Reuters [I] decided there and then to transfer my custom to another agency."

Bunton ended up doing more than just boycotting Reuters. He put the custom of sending ransom notes in abeyance, deciding to take a page from the playbook of his adversaries: "Everyone it appeared, the Gallery included, was lying doggo, and I remember deciding to play the same game."

Bunton's memoirs communicate a righteous indignation toward the various parties that ignored him—police, media, National Gallery. How could everyone now be indifferent toward a painting for which the government had forked over substantial taxpayer money? "Worse still, not an article published taking my side." That may be Bunton's single-most puzzling assertion. Assuming for the sake of argument the validity of his belief that forcing the elderly to pay for television constituted a moral outrage, no one had any way of knowing that the painting had been stolen to support that cause. How could anyone take Bunton's side without knowing what side they were taking? He didn't see it that way. Rather he discerned in the nonresponse to his deed "a lack of feeling, [a] stone wall attitude that embittered me" but also shored up his resolve. "I vowed that in the end, Wellington would be the instrument for good."

Eventually the war of silence with the authorities wore Bunton down. He determined to write Com 3, albeit with a wrinkle. Perhaps Reuters and the police had ignored his previous letter because they did not believe it came from the actual thief. Com 3 would prove his possession of the Goya. And so, he writes in his memoirs, "releasing the Duke from his prison, [I] unpacked him and detached the small label [from] the back of the picture, after which I again re-packed and sealed in the hideaway."

To be sure, Com 1 described identifying marks and labels on the back of the painting. But now Bunton went further: Com 3 *included* a label. It wasn't the only tactical adjustment. Still livid at Reuters for ignoring Com 2, he sent Com 3 to the *Exchange Telegraph*. And this time he did not travel all the way to London to do the deed, though he remained prudent enough not to post the letter from Newcastle (for that "might well link me to 'that crackpot' who had worked the TV license affair"). A few bus trips and a hitched ride later, he found himself in Morecambe, where he deposited the letter. It took him a while to hitchhike home, "but nevertheless I was back in Newcastle before midnight, and not a query from wifey."

But, as it turned out, no success either. Com 3 elicited no more response than Com 2, prompting Bunton to renew his resolution to win a war of inaction: "I also would go to sleep—the next move would have to come from the enemy." However, in their dueling hibernations, the enemy again outlasted

Bunton. Come December 1963, "I decided to send Com 4. It was the only way to have any chance of succeeding." He took a lift from Newcastle to Birmingham, where he posted his latest effort to catch someone's attention.

Com 4 also failed to trigger any response. Shortly thereafter, however, something written by Bunton, albeit unrelated to both the theft and the BBC licensing fee, did capture someone's attention. On a whim he had written a seven-hundred-word reflection on the previous month's assassination of US president John F. Kennedy and sent it to the *Sunday Mirror*. According to Bunton, the newspaper promised to run the piece and make payment for it. The article never ran. That is a familiar tale for freelance writers and in Bunton's case notable only because it fueled his paranoia.

"The only reason I can think of [for the piece not running]," he writes in his memoirs, "is the fact that when the editor learned the article had been done by the chap who was known as a TV rebel, he had put his foot on it."

Bunton's growing frustration contributed to him lying low in 1964. The year "passed without any action from me. . . . The first dawnings of defeat had begun to glow." Admittedly he had in his possession only a "hunk of wood," but others valued it and yet made no effort to retrieve it. That was the inexplicable reality that became ever more apparent: England flipped over the prospect of losing this painting but refused to do anything to bring about its return.

Accordingly, in the spring of 1965, Bunton decided to make one last attempt—Com 5. This time he showed a greater ability to improvise. He lowered his demands from £140,000 to £30,000 and proposed that the money be raised by exhibiting the painting. But the new approach appeared to produce the same result—"total failure, the same inertia from the public and authorities alike, a blank."

Actually, the situation was even worse than Bunton realized. The initial response to Com 5 was not "blank"—it was an explicit rejection. Bunton apparently did not read the *London Times*, which reported that the authorities remained unwilling to negotiate a ransom. It is just as well that Bunton steered clear of the *Times*. Following Com 5, the paper assembled a team of handwriting experts and psychiatrists to analyze the letter and evaluate its author. Based on the experts' assessment, the newspaper declared that

the author of the various ransom notes was likely a "slightly built, well-educated man, probably over 35 years of age, living alone with his fear and mild paranoia."

Paranoia seems a plausible assessment, and Kempton Bunton was indeed over thirty-five, but otherwise the experts missed. He lived with his wife, had received little formal schooling, and tipped the scales at nearly 250 pounds.

Chapter 9: THE DUKE RETURNED

As the standoff continued throughout 1964, the thief made good on the threat in the December 31, 1963, letter (Com 4) to "sleep for a year"— fifteen months in fact. He awoke from his slumber to offer a final ransom note, a letter posted in Darlington on March 15, 1965, and (like the two previous ransom notes) sent to the *Exchange Telegraph*. Under the heading "5th & Final Com 5," it read as follows:

Goya's Wellington Is Still Safe.

I have looked upon this affair as an adventurous prank— must the authoritys [*sic*] refuse to see it that way? I know now that I am in the wrong, but I have gone too far to retreat.

Liberty was risked in what I mistakenly thought was a magnificent gesture—all to no purpose so far, and I feel the time has come to make a final effort.

I propose to return the painting anonymously if the following plan is agreed.

The portrait to be put on private exhibition at a 5[-shilling] view fee for 1 month, after which it would be returned to the Gallery. A collection box to be placed at side of picture for good people to give extra if so inclined. The effort to be conducted on a voluntary basis by Mr. Hendee-Wheeler or others having facilities for same. The affair to be a true charity, and all moneys collected, minus nothing for expenses, given to the place I name—a committee of 5 may redirect if they so wish. The matter to end there—no prosecutions. No police enquiries as to who has committed this awful deed.

I feel that many helpers would give their services free for such an exhibition, and that this troublesome episode Can end on a happy note.

I do not think the authorities need fear the feat being em-
ulated by others—the risk is great—the material reward nil.

This message gave the authorities hope. While calling this missive his "final
effort," the writer of the note made no threat to harm the painting. And not-
withstanding his impressive persistence, he sounded worn down, as if he fi-
nally recognized that his scheme had failed.

And it had failed, as was apparent from an article in the *Times* two days
later. Under the title "LD. ROBBINS SAYS GOYA OFFER AUTHENTIC," the
Times recorded a statement by the chairman of the gallery trustees, Lord Rob-
bins, replying to the latest ransom note. Robbins tried simultaneously to ap-
peal to the thief's ego and to reassure him that he could return the painting
without fear of repercussions: "I should have thought that a man of this de-
gree of ingenuity would have had the imagination to realize that, if the picture
were returned, the probability of further search for whoever temporarily ap-
propriated it would be virtually nil."

At the same time, Robbins wished to be unmistakably clear that the
man who had "temporarily appropriated" the painting should drop all his
demands. He urged the man to "do the sensible thing and return the picture
without trying to make a bargain." He explained that no bargain was possible
because it would "place all the treasures committed to our care at risk and cre-
ate an intolerable precedent." He might have added that negotiating with the
blackmailer was barred by law.

And yet, miraculously, if Com 5 could not and did not move the authori-
ties, its author had finally found a formula that moved *someone*. The *Daily
Mirror*, a brashly populist tabloid, saw an opportunity to exploit the thief's
apparent desperation.

A few years earlier, the *Mirror* had published its credo: "We believe in ordi-
nary people . . . so we strive to smash every artificial barrier to full expression of
the moral qualities of the British people." Now the *Mirror*, under the direction
of its charismatic new editor, Leon (Lee) Alexander Howard, and its longtime
chairman, Cecil Harmsworth King, would not so much smash as circumvent an
artificial barrier to recovering the Goya—the law banning ransom negotiations.

It is no surprise that King, the scion of an influential publishing family, would become the driving force behind the *Mirror*'s involvement in the search for *The Duke*. King tended toward megalomania—for example, long insisting that the *Mirror* had brought down Winston Churchill after World War II. He had joined the *Mirror* in 1926, as advertisement director, and worked his way up, becoming chairman in 1951. The paper prospered under King's tutelage, as his philosophy, succinctly described in his 1969 memoirs, dovetailed with the comparative advantage of a tabloid: "People buy the *Mirror* not for the day's news, but to be entertained. . . . Maybe you can insert in the sugar coating a pill of news. . . . But that is not what the paper is basically for." What was the paper for? In the words of the prominent Irish historian Ruth Dudley Edwards, who chronicled King's tenure at the *Mirror*, "bite-sized news, crime, sensationalism, astrology, sentiment, social conscience and sex."

While the *Mirror* showed only a mild and occasional interest in actual news, it craved *making* news. For some time King pushed for the paper to get directly involved in the story of the Goya theft, proposing that it offer a reward of £10,000 for return of the painting. But, as noted, the law precluded the payment of a ransom for pilfered art. The thief's latest letter, however, so-called Com 5, gave King a new idea for inducing the thief to return the painting without the *Mirror* violating the law.

On March 18, the *Daily Mirror* published the thief's letter on page 2 and urged him to turn back to page 1. There, he and other readers would find a long appeal under the bold heading "THE MISSING GOYA AND THE MIRROR. OUR SPORTING OFFER TO THE MYSTERY LETTER-WRITER." The article urged the man who possessed this "national art treasure" either to return it through a newsagent to the *Mirror* office in Holborn Circus or else "deposit it in any safe place of his choice," followed by informing the editor of its location. In either case, the *Mirror* would arrange to have the painting exhibited for a month "for the benefit of any charity nominated by the present possessor of the painting." The *Mirror* noted that it could not promise the thief immunity from prosecution, as that was a decision only the government was empowered to make. However, it reminded the thief that Lord Robbins, chairman of the National Gallery trustees, was on record as saying that if the painting were returned,

the probability of further search for the perpetrator would be "virtually nil." The *Mirror* included an inset quoting Robbins to that effect.

The *Mirror* acknowledged that, by law, Robbins "cannot bargain. Nor can the Mirror," but it added that "this newspaper can and does invite the letter-writer to return the Goya. This newspaper can and does promise that it will try to meet the writer's wishes in this affair." It concluded, "What matters most is that the historic painting by Goya should be speedily restored to the National Gallery and the nation."

A few days later, the *Daily Mirror* received a letter postmarked Birmingham, March 21, with the return address "Urgent." The letter began by noting, "My good friend and I are rather upset over the recent publicity concerning the missing Goya." This alleged good friend is "part owner of the 'Goya'" (presumably along with the letter writer) and the man who "wrote to you early in this week." This sequel sought to clarify his good friend's offer to return the painting if the requisite money was raised.

The author noted that his friend had "jumped the gun" in making the offer without contacting the author, a potentially fatal error since the author had "possession of the Goya at my home in Birmingham." The good news, however, was that "my good friend and I have sorted out our misunderstanding and I am willing to accept these terms offered. Rather reluctantly however!" The purpose of this letter? To assure the editors and the public that he and his repeatedly referenced "good friend" were "art lovers and wouldn't dream of damaging [the painting] in any way." He urged the *Mirror* to print this letter "so that the good people of Britain can see that although we committed this awful crime, we didn't mean any harm whatsoever." The letter expressed the hope that "no one will bear a grudge against my good friend or I" and gave the editors a heads-up: They could expect a letter "from my good friend in Darlington next week." It was signed: A.D.

The gratuitous nature of the letter, which did nothing to advance return of the painting, convinced the *Mirror* that it was a hoax, and the editors declined the offer to print it. They never heard from the author's "good friend" (or, at any rate, they received no relevant communication postmarked Darlington), which would seem to support their assessment and justify their inaction.

By contrast, the *Mirror* considered legitimate a letter also posted March 21 from Birmingham and marked "Confidential, For Mirror Editor Only." Inside, the letter began with one of the ransomer's characteristically puzzling assertions: "As no pardon has been offered, a deal can only be arranged if a guarantee is forthcoming." He proceeded to move the negotiation forward and propose another specific means for returning the painting:

> If you can assure me that £30,000 can be got from exhibition, or that you can get Gallery permission to continue exhibition until a minimum of £30,000 is taken—you will get the portrait.
>
> If in your power to promise such, you may wish to publicize openly, or I will accept an obvious message in personal column of Daily Mirror signed *Whitfield*.
>
> The morning after public or private message appears, you will receive a letter informing you to pick up Goya.

The ransomer added a second sheet with a cryptic message: "If collected, direct charity money on instructions from TYA." ("FHC" was legible but crossed out, with "TYA" replacing it.)

On March 23, the *Daily Mirror* printed in its personal column: "Personal —T.Y.A. (or F.H.C.) Your letter received and being considered—Whitfield." The next day, under the bold heading "THE MISSING GOYA: A LETTER TO THE MIRROR," the *Mirror* brought readers up to date ("The man with the Goya has been in touch with the Daily Mirror") and made a counteroffer to the ransomer. It essentially agreed to his terms, except it clarified, "Nobody can guarantee that £30,000 will be raised by public exhibition of the Goya portrait, but the Mirror offers to place the portrait on public exhibition (with acceptable arrangements over security and guards) or to endeavour to reach a similar arrangement with the National Gallery from which the Goya was stolen in August 1961."

The ransomer sat tight for two months. Then, on May 21, the *Daily Mirror* received some strange items in the mail: a cartoon with one corner missing cut out of the March 18 issue of the newspaper, a receipt for a parcel at the left

luggage station in Birmingham, and another cryptic message: "Some future wise guy may offer to tell you all. Ask him for references—a corner piece for enclosed cartoon."

The newspaper turned the ticket over to the police, and the next day Detective Constable Harold Stanley Reeves showed up at the left luggage office in Birmingham and asked for the parcel with ticket number F24458. He received a parcel secured by rope and wrapped in brown paper with two labels reading, "Glass: Handle With Care." Reeves found inside a wooden box with six screws securing the lid and inside that a pink polythene bag secured with Sellotape. He opened the bag and found another brown paper parcel secured with Sellotape and through an opening what looked like a piece of wood. When he turned it over, he saw a canvas covered with a piece of hardboard secured by more Sellotape. He further noted six pieces of pencil eraser positioned so as to protect the painting from rubbing against the hardboard. On removing the canvas, he saw Goya's *Portrait of the Duke of Wellington,* but without glass or frame.

Reeves learned from the luggage room attendant, Ronald Lawson, that the parcel had been left seventeen days earlier (May 5) by a tall, bushy-haired blond man in a blue duffel coat, appearing to be in his early twenties. This mystery man signed his name "Mr. Bloxham" and had urged the baggage clerk to "be very careful with this." He had paid one shilling and was given a ticket number. Lawson described the man as "well spoken and [having] sharp features" and claimed that he looked like an art student.

Reeves brought the painting down to West End Central Police Station and summoned Michael Levey, assistant keeper at the National Gallery, who inspected the painting and declared unequivocally that it was the real thing. (Levey would later explain his certainty to reporters: "The paint surface was right and because of a general thing I can't explain about recognizing paintings.") On May 24 the gallery held a press conference, where it displayed the painting to throngs of reporters. *The Duke* was missing his original seventeenth-century frame, but before long the gallery purchased a suitable imitation from Paris. As for the painting itself, it had suffered a few minor scratches, which took less than a day for conservators to fix. On May 27, the curators returned *The Duke* to an exhibition. But, perhaps spooked

by his disappearance four years earlier, this time the gallery kept him in good company—whereas he had been displayed solo before, now he was part of a larger exhibition devoted to Spanish paintings. (His neighbors included two less famous Goya portraits.)

The National Gallery had *The Duke,* but Scotland Yard wanted his kidnapper. That meant locating Mr. Bloxham, who may or may not have been the thief and in all likelihood was not in fact named Bloxham. It seemed improbable that someone would give his real name when dropping off a highly valued stolen painting. Something else also hinted at a pseudonym. In Oscar Wilde's play *The Importance of Being Earnest,* one Lady Bloxham rents the home of Jack Worthing, who as a baby had been found in a handbag in the cloakroom of a railway station. The new evidence suggested that some sleuths had been right all along: The thief was young and cultured and had a puckish sense of humor. But the only potentially meaningful lead to help the authorities pursue the self-styled Mr. Bloxham was his physical description by the baggage room attendant. Based on that, Scotland Yard artists composed and the police circulated an Identikit portrait, which leading newspapers published.

In the meantime, the *Daily Mirror* tried to make good on its offer to the ransomer, urging the National Gallery to exhibit *The Duke* for charity. The gallery, however, believed the public deserved to see their long-lost *Duke* without attaching strings for the benefit of a thief who had enjoyed sole and illegal possession of him for four years. Accordingly, the gallery declined to go along with the negotiated quasi-agreement between the *Mirror* and whoever returned the painting. Without the gallery's third-party assistance, the *Mirror* was powerless to assist the thief's charity operation. And so, as Milton Esterow would write in a book about art thefts published just a few months later, "the man who had once asked £140,000 for the portrait had ended by paying 14 cents to get rid of it."

The snubbed thief did not accept this result passively. He let loose two more letters, one postmarked May 25 and one May 26, both sent (for unclear reasons) to the *Exchange Telegraph.* The first one railed against what he considered a broken promise by the *Daily Mirror.*

Goya. Extra Com. Lost—one sporting offer. Property has
won—charity has lost. Indeed a black day for journalism. . . .
We took the Goya in a sporting endeavor—you, Mr. Editor
pinched it back by a broken promise. You furthermore have
the effrontery to pat yourself on the back in your triumph.
Animal—vegetable—or Idiot.

In the letter the next day, again sent to the *Exchange Telegraph* though addressed to Lord Robbins, he showed that he had still not given up hope:

When a certain influential gentleman offered to put Goya on
pay exhibition for charity, I take it that Lord Robbins must
have agreed.

I ask you to keep the agreement & withhold your plan of
free show.

I did not personally take the portrait, safeguarded it for
safe future return.

The Mirror is more intent on our arrest than keeping its
word, but I take it that you at least are a gentleman.

I am a man of no substance—but my word I do not break.

According to Times legal expert (May 24) we may have
no serious case to answer. Ask this gentleman to elaborate on
this affair, and give me some guidance on the matter.

In addition to the delusional ending (what motive could Lord Robbins possibly have for providing guidance to someone who had pilfered a gallery treasure?), the letter is noteworthy in two respects. First, the ransomer suggested for the first time that he did not personally take the painting. Second, he alluded for the first time, albeit elliptically, to something that would become central to his saga. The *Times* legal expert he referred to had opined that the man who had stolen the Goya might not be guilty of a crime since he had returned it.

Perhaps the expert expressed this view to lull the thief to come forward, but his suggestion actually had some legal basis. England's Larceny Act of

1916 defined a larcenist as one who without the consent of the owner steals something "with intent, at the time of such taking, *permanently to deprive the owner thereof*" (italics added). If the kidnapper intended to return the painting all along, he lacked the requisite intent to *permanently* deprive the National Gallery of its possession and therefore had committed no crime. On its face, this interpretation made little sense. It licensed "involuntary borrowing," such as taking your neighbor's car for a joy ride or, worse still, using it for a month or two, or even a few years, provided you eventually returned it. But however absurd the language of the Larceny Act, it looked unambiguous. You do not commit a crime when your action violates no criminal law, even if the void in the law produces manifest absurdity.

The legal nuances could wait. The nation was still absorbing the welcome return of *The Duke*, though *Newsweek* detected a sense of anticlimax. Whereas imaginative speculation had the painting taken by exotic people and turning up in crazy places (like Dr. No's lair), the reality turned out to be vastly less dramatic: "The man who defeated Napoleon at Waterloo was captured singlehandedly by a slightly crackers Robin Hood."

Not everyone felt let down. The *Daily Mirror* found the resolution of this caper deeply satisfying. On Sunday, May 23, the cover of the newspaper displayed a large picture of the gallery's Michael Levey inspecting *The Duke*, and on page 2 it ran a long article entitled "My Goya. The Mirror Found It." The newspaper indulged in major braggadocio:

> There are things which judges can do. There are things which Parliaments can do. But there are some things which only the newspapers can do. To be more factual: there are some things which only the Daily Mirror can do. Such as helping to restore to the nation the famous £140,000 Goya portrait of the Duke of Wellington. . . . The police searched in vain. The critics and connoisseurs wrung their hands and prayed that the painting would not be destroyed. Anonymous ransom demands were made to news agencies. But the missing Goya stayed missing. Then, on March 18 this year, the Mirror stepped in. . . . Today, little more than nine weeks later, the Goya is safely restored

. . . . The Mirror, in its own modest way, is proud of its role in rescuing a part of the national heritage. But we doubt if Mirror readers will be surprised. It's all part of the service.

The back of the newspaper carried an article titled "How the Goya Returned Home," which laid out the facts surrounding the negotiation and return of the painting. At the bottom was inset a wry comment by Lord Robbins: "I hope whoever had the Goya feels better now that he has sent it back."

As for the identity of that mystery man, speculation ran rampant. A letter to the *Guardian* proposed that, in a case of life imitating art, the thief took after the eminent rogues in John Buchan's novel *John MacNab*—a bored VIP looking for thrills. Because of the name Bloxham, the *Daily Telegraph* proposed that the thief had a literary or theatrical background.

Meanwhile, the *Daily Mirror* was not through tooting its own horn. The next day it featured a front-page article titled "How We Got Goya Back," and another article about the case, titled "The Man Who Got the Goya Back," which included the following self-congratulatory note:

It might have been some other newspaper, but it was, in fact, the Daily Mirror that brought the Goya portrait back to the nation. There are now many characters in the case. Success has a thousand fathers, but two men were responsible—and only two. One of them was the thin, well-spoken man who deposited the £140,000 picture in the parcel office at Birmingham New Street railway station—Mr. X. The other was Cecil H. King. For a long time King has believed that the Mirror could be instrumental in encouraging the thief to relent.

That day's *Mirror* also ran several other articles about the theft. One contained the opinion of a handwriting expert to whom the *Mirror* had turned over the letters that led to the painting's return. He announced that the thief "is probably an artist."

Just three days later (May 27), the *Mirror* offered yet another smug take on the affair, with a front-page headline story titled "Did the Mirror Pinch the Goya Back?" This was ostensibly a response to one of the thief's angry letters accusing the *Mirror* of welching on its alleged promise to exhibit the painting (and referring to the paper's editor as "Animal—vegetable—or Idiot"). This letter had been sent to the *Exchange Telegraph,* perhaps on the assumption that, whereas the *Mirror* would never publish an accusatory letter, the *Exchange Telegraph* would relish the opportunity to publish an attack on its rival. If so, the letter writer got things exactly backward: the *Telegraph* had dutifully turned the letter over to the *Daily Mirror,* which had published a photograph of the letter and was all too eager to quote from and discuss it.

The paper explained, "The man who returned the Goya is angry with this newspaper. In fact, he is very rude about its editor. . . . [But his] allegations are not true." The *Mirror* reminded readers that it always made clear that it could guarantee nothing and that it had kept its promise and approached the National Gallery for permission to put *The Duke* on exhibition. However, the gallery had vetoed the idea. The newspaper now met the thief's venom with venom, proposing that "perhaps the happiest ending of all would be for the man who stole the Goya . . . to choose this moment to vanish from contemporary history."

Whether or not recent developments would lead the thief to vanish, they had the opposite effect on others, bringing out of the woodwork various folks who wished to take credit for the now consummated deed. For example, the *Daily Mirror* received, in an envelope postmarked May 24, a five-page handwritten letter signed "Anon," stating that while "the actual theft of the Goya from the National Gallery can't be explained here," the author could at least offer a full account of all the ransom notes—written by himself and a mysterious accomplice referred to throughout as Mr. X. The letter ends on an incongruous note. After describing how Mr. X and Anon had jointly deposited the painting in the left luggage office in Birmingham, it continues: "Why we left the painting there for so long neither of us knows, but now that it is back, what does it matter?"

Perhaps because this letter was free of the rancor of the other letters to the *Daily Mirror,* and also lacked the flair of the ransom notes, it was dismissed as a hoax.

While the thief took a brief hiatus, he was not prepared to follow the *Mirror*'s advice and vanish from history. It wasn't long before the case took its strangest twist yet. With the painting returned, the police had little hope of apprehending the thief. Four years earlier, someone had risked his liberty to commit an outrageous, well-publicized felony. Then, on and off for four years, he had desperately tried to ensure that the risk was not in vain while expressing increasing anxiety that he would be punished for the deed. He wanted money but also repeatedly demanded assurances of a pardon. Clearly, the painting meant nothing to him except as a bargaining chip. Having failed to get anything out of the bargain, at least he managed to return the painting and extract himself from the mess. If nothing else, he had the satisfaction of having pulled off the perfect crime. The last letter venting to the *Daily Mirror* was presumably the storm before the calm, the last he would be heard from. This turned out to be true . . . for several weeks.

Chapter 10: DEFEAT

When his letter of March 15 (Com 5) initially met the same fate as his previous ransom notes, Kempton Bunton sunk into a funk. All that was needed for his plan to succeed was a single man to see the light. "Had there been such a man," he wrote mournfully in his memoirs, "television would have had 40 extra viewers every week, needy, lonely folk in the twilight of their lives. . . . Who would have worried at such a situation? I wonder if propriety be not a curse at times."

Faced with the world's irrationality, Bunton reached his nadir ("fed up, tired, disillusioned") in early 1965 and contemplated the unthinkable: surrender. "It would be heartrending to return the picture, but what else was there to do—destroy it? That would be the act of a mental idiot. I would have to retire beaten, just as I was over the TV campaign of 1960."

His depression did not last long. Just when despair brought him to the breaking point, someone actually responded to his last desperate appeal. And not just anyone but the influential *Daily Mirror*. Bunton claims to have learned of this development by way of a fluke. He kept up with the newspapers (ever hopeful that the theft, and especially his ransom notes, would be reported on) via libraries, which tended to carry "every paper excepting the *Mirror*." Serendipitously, one day a passenger seated in front of him on a bus pulled out a newspaper and "Goya" caught Bunton's eye. On closer inspection, Bunton saw the *Daily Mirror*'s front-page appeal to the thief to turn in the painting in exchange for an effort by the newspaper to help raise £30,000 by exhibiting it. "The headlines seemingly 10 feet high hit me full blast," Bunton recounted in his memoirs.

He thought the matter over for a few days, but, perhaps surprisingly, the sudden prospect of partial victory failed to bolster his spirits. Life taught Bunton to expect the worst, and now he found himself increasingly nervous that the *Mirror*'s choice of exhibition spot would be inadequate. "What if after having acquired the picture, they fobbed me off with a side street showing?"

Accordingly, he responded to the *Mirror*'s offer with the aforementioned letter of March 21, insisting on a *guarantee* that £30,000 would be raised. That letter set in motion the series of events described in the previous chapter, culminating in the return of the painting.

Bunton's memoirs convey his thought process throughout the tense exchange between himself and the *Daily Mirror*. The newspaper's refusal to guarantee the £30,000 naturally alarmed him, producing "another checkmate." He struggled to discern how the end game would play out.

"I felt reasonably certain that no committee of five would redirect the money, but what if the collection amounted to a paltry few thousand?" Because that possibility "would represent failure, and a failure cannot afford to be caught out," he decided to return to waiting mode. But just as the authorities had outwaited him for four years, the *Daily Mirror* also showed more patience than its negotiating partner. Finally, Bunton said "to hell with the 'thing'—I would return it to the Mirror."

A defeated Bunton "took the Duke from his 'prison,' opened him up, and examined the portrait carefully for possible damage. There he lay upon the bed looking contemptuously at me." Bunton had observed *The Duke*'s contempt the first time he had eyed him four years earlier, and *The Duke* apparently hadn't lightened up. Now Bunton felt compelled to treat the contemptuous stranger better than *The Duke* treated him. "He would have to be cared for a little longer. At all costs that sarcastic face must be protected."

Sarcastic seems a bizarre description of the countenance of Goya's *Duke of Wellington*, but Bunton, never a fan of the duke or his portrait, appears to have suffered from the inverse of the Stockholm syndrome—over time feeling increased disdain for his captive. Certainly he felt bitter about how everything was finally playing out.

"How the hell could society value such a thing at £140,000 when half the world was starving? . . . My small attempt to remedy the situation had failed."

Given his chronic failures, Bunton reckoned, "I would have to be careful at this last juncture." He wrapped and secured the painting with special care and decided to leave the parcel far away from his home in Newcastle. A plan took shape to take the train to Birmingham, drop the parcel off at the left luggage office, and post the ticket to the *Mirror*.

Bunton realized the obvious utility of having someone else physically return the painting. To the police, in court, and in his memoirs, he consistently maintained that he had recruited a "teddy boy" he happened to spot while milling around the left luggage office in Birmingham. The young man had willingly executed the errand, then handed Bunton the ticket. Why did this teddy boy give his name as Bloxham? In his memoirs, Bunton cryptically writes, "Somehow somewhere the name of Bloxham turns up as the name given by this teenager, but I was never aware that any name was necessary in the depositing of a package."

With good reason, Bunton does not claim that the name was fabricated by the luggage room attendant—what motive could the attendant possibly have for volunteering a name if he wasn't given one? Regardless of whether it was necessary in 1965 for someone to give his name when depositing a parcel in the Birmingham station, the young man (teddy boy or otherwise) who dropped off the painting *did* give his name as Mr. Bloxham. Here Bunton shows his ability to make a clever lawyerly diversion, culminating in his suggestion that the name "must remain a mystery." (One aspect of this case does indeed remain mysterious, but, as we shall see, the identity of Mr. Bloxham is not it.)

Bunton returned to Newcastle, where he waited a few days, clinging to the hope that the *Mirror* would reverse itself and guarantee the £30,000. Then he returned to Birmingham ("via the Hitch Hike method") and sent the ticket for the parcel to the *Mirror*. He did so from the outskirts of the city. "Feeling disgusted at the whole affair, [I] did not bother even to enter Birmingham, let alone check as to the parcel."

Disgusted, but before long also relieved. "Listlessly I read the headlines, [and] at least I was safe. No one could connect me with the affair, and one could breathe more freely now."

He remained curious how much money the exhibition of the Goya would fetch. "At least Wellington was going to do some good, even if only a trifle." He followed the newspapers closely in search of the outcome but found no mention of an exhibition of the painting. "I was shocked, astonished, and puzzled."

Things turned out even worse than Bunton had feared: Instead of *The Duke* being exhibited at a "side street showing" that might raise a "paltry few thousand," it would be exhibited nowhere, unless one counts the National

Gallery's exhibit of Spanish works, which of course raised not a penny for Kempton Bunton's charity of choice.

Bunton did not accept defeat graciously. He composed and sent off the angry letters to the *Daily Mirror* described in the previous chapter, and he seethed even more than those letters convey. In his memoirs, Bunton alleges that the *Mirror* was duped by gallery director Lord Robbins, whose behavior was inexcusable. "It is not a lawbreaker he is denying, but the people for whom this battle was fought."

As for the *Daily Mirror*'s response to his angry letters, its insistence that it had broken no promise, Bunton notes only that these "idiotic comments" merited no reply. He resolved to do exactly what the *Mirror* proposed—to vanish from history. "I was now finished with the whole affair."

At this point in his memoirs, Bunton digresses to describe "a very serious incident that happened at this time." As it turns out, this incident proved crucial to later events connected with *The Duke*. Bunton's son Kenneth was living in Newcastle with a woman named Pamela Smith. Bunton observes, "I am not what one would call a religious person, and the fact that my son was so to speak 'living in sin' did not in the least bother me." What did bother him, however, were the recurring "violent rows" between his son and the live-in girlfriend.

Like many an unwise parent before and after, Bunton chose not to keep a suitable distance from his child's messy relationship. Rather he visited the couple regularly, and "of course advice was freely given by me to both of them." But apparently his advice had no effect, or at least nothing helpful. The failed relationship (or perhaps his well-meaning meddling?) in turn helped produce "the shock of my life."

One day Bunton dropped in at the abode of his son and Pamela Smith but found no one home. He doesn't come out and say that he intended to visit Pamela rather than his son, but that can be inferred, since he notes that "my son would be at work and his 'wife' [was presumably] at some shop or maybe gossiping with a neighbor. . . . I sat down idly to await her return."

Both Kenneth Bunton and Pamela Smith have long since passed away, so we will never know why Kempton Bunton paid Smith daytime visits. No one has ever suggested anything illicit between them, although in his memoirs the unhappily married Bunton remarks in passing that "Pam and I were the

best of friends." At other times he expresses hostility toward Smith, which she would eventually return semipublicly. It is unfair to infer anything untoward about their relationship. Perhaps Bunton came by that fateful day simply to dispense some of his "freely given" advice about how Pamela might better get along with his son.

If there was indeed anything improper about this visit, what transpired may be considered condign punishment. By happenstance, Bunton noticed an old envelope on the mantelpiece. "It was no business of mine, but I did pick it up."

He was shocked to see his own address on the envelope. Inside, he found a copy of one of his letters to the *Daily Mirror* sent near the end of the Goya affair. It turns out (he reports for the first time in his memoirs) that he was in the habit of writing rough drafts of such letters in pencil before resorting to the block capitals that he would later draft and post. He intuited that he had accidently dropped this letter at his son's house and that Pamela Smith read it and placed it on the mantelpiece as a way of communicating as much to him. Whether this surmise makes sense, and for that matter why he carried around a rough draft of the letter in an envelope addressed to himself, are issues not easily adjudicated at this juncture. Regardless, Bunton concluded, "My secret is out."

He admonished himself not to panic. "It may be that the contents [of the letter] had not connected her conscious mind with Goya." He decided to "wait and observe her behavior" before deciding how to proceed. Fate gave him that opportunity forthwith—Pam showed up at her house. Kempton reported that he left an hour later but gives no account of what happened in the interim apart from a one-line description of what did *not* happen: "None of us had mentioned anything of the note in the old envelope." That silence failed to reassure Bunton. To the contrary, that "very fact alone gave me the firm impression that she knew everything."

The idea that Pam Smith was on to him made the next few weeks difficult for Bunton. He grew increasingly convinced that "Pam had me connected with Goya" and feared that "after the next argument with my son, she may come out into the open," especially because the offer of a reward for information about the missing painting remained outstanding and she would surely have found that prospect hard to resist. In sum, "I knew that she had

put two and two together, and only her regard for me had kept her silent." But he could not trust such virtue to last indefinitely, so "it was I who decided to come into the open."

Before doing so, Bunton wished "to make sure that Pam actually did know." That does not mean that he wished to ascertain with certainty her knowledge so as to avoid turning himself in unnecessarily. Rather he meant it literally. He would (for reasons he does not explain) *make sure* Pam knew the truth: "I at once told her everything." Pam pleaded with him not to come forward and assured him that she would not turn him in. But Bunton could not believe her. "Money is a strange master," and the reward now at Smith's disposal "had me frantic."

He decided to preempt Smith's recovery of the reward, going to the police to confess before she came forward to identify him as the thief. This solution came at a cost—"I shrank from coming forward as a two-time loser. . . . I would be called an out and out idiot," but a little reflection set his mind at rest. "Why should I be ashamed? There had been nothing dishonorable about my part of the case. [Lord] Robbins, by accepting all and giving nothing, was the real villain of the piece."

Bunton's resolve to turn himself in came too late to spare his own marriage. His irritability and panic over Smith's impending treachery led to "endless arguments with the wife over nothing in particular," until Bunton abruptly walked out on his spouse of forty years. In his memoirs, he tentatively attributes blame to his recurring whipping boy: "I wondered vaguely if Wellington had any hand in it."

A few days of aimless wandering and lamenting later, Bunton found himself in London prepared to give himself up. At one point he stumbled past the National Gallery and considered resuming the battle with his nemesis. "Was it worth taking a last look at Wellington—no—it would be better not to do so. Hadn't I had four years in which to gaze my fill?"

Instead he passed his last few hours of freedom in a pub, downing a pint of beer and drafting a written statement for the police about the entire affair. This included an explanation of why he was coming forward, "but [I] withheld the name of Pam, as I did not wish to implicate anyone. I had done this job—I would see it through."

Chapter 11: SURRENDER

On July 19, 1965, at roughly 8 P.M., a large bespectacled man with a round face and a gray crew cut, appearing to be roughly sixty years of age, showed up at the visitor's room on the ground floor at Back Hall, New Scotland Yard. The man, who wore a gray suit and top hat, claimed to have information about the Goya stolen from the National Gallery four years earlier and returned two months earlier.

Summoned to deal with the visitor, Detective Sergeant Frank Andrews said to him, "I understand you have information to give to police respecting the theft of the Goya portrait from the National Gallery in London."

"You don't have to look any further, I am the man who took it," the man calmly replied.

"Can you give me some more information which will enable me to decide that what you are saying is the truth?" Andrews asked.

"I am the man who took it and I am the man who sent it back. I can tell you exactly how it was packed. Will that do?"

"Tell me first how you came to take the picture," Andrews said.

"I am not saying anything more. Is the reward of £5,000 still available if I'm turned in by someone?"

Andrews said he did not know and again asked the man how he took the picture. The man again declined to respond but pulled from his pocket a small writing pad and said, "This is the actual pad I wrote the ransom notes on."

Andrews, familiar with the ransom notes, gave the man a piece of paper and requested that he "write me some words on this piece of paper in the same manner in which you wrote the ransom notes." The man removed a pencil from his pocket and wrote, "I have decided to turn myself in as I have reason to believe that somebody else is about to do so."

Andrews proceeded to summon his immediate superior, Detective Chief Inspector John Weisner, who then took the lead in interviewing the intriguing stranger.

"Who are you and what do you want?" Weisner asked.

The man replied, "I am turning myself in for the Goya."

"Are you saying that you stole it?"

"Of course. That's why I am here."

Weisner asked for the man's name and address but instead received a surprisingly aggressive response: "That can wait. As soon as you decide to charge me I'll tell you who I am but not before. Are you going to charge me?"

The above interaction took place more than two decades before a groundbreaking book, *Confessions in the Courtroom*, illuminated the surprisingly common phenomenon of false confessions. The authors, Professors Saul Kassin and Lawrence Wrightsman, divide false confessions into three categories, two of which result from aggressive interrogation tactics by police. The third category, the "voluntary false confession," involves someone coming forward of his own accord, often in high-profile cases, out of desire for notoriety or to protect the real culprit out of love or fear. While *Confessions in the Courtroom* sheds light on the voluntary false confession, it describes a phenomenon already familiar to law enforcement in 1965: Three decades earlier, the kidnapping of Charles Lindbergh's baby elicited more than two hundred people coming forward to take "credit."

Inspector John Weisner was no stranger to the voluntary false confession. He informed the man who claimed to have stolen Goya's *Portrait of the Duke of Wellington* that "numerous people come here and confess to crimes they have not committed. If you can satisfy me that you have committed the offense, then you may be charged."

It wasn't just his personal experience in sleuthing that contributed to Weisner's skepticism: The man in front of him seemed too old and too large to have stolen the Goya.

"Why have you waited all this time before coming forward?" Weisner asked him.

The man answered the question with a question, one he had already asked Weisner's underling. "Is there still a reward for the person giving information about this?"

When Weisner, like Andrews, responded that he did not know, the man let down his guard a bit. "I have let something drop and I believe someone

may turn me in to get the reward. If the reward still stands, I want to give myself up to stop them getting the reward. If there is no reward, then we can forget it, as the job is dead as a dodo. You make up your mind. Are you going to charge me or not?"

Weisner ignored the question and responded shrewdly. "Tell me about the parcel. How was it made up and what was used?"

The man described his use of India rubber, hardboard, and rope, and Weisner probed. The man had all the answers. When Weisner said, "Tell me more about the parcel," the man did not hesitate: "I wrapped it in brown paper and then cello-taped it. . . . It was all put in a wooden case, home made, made of plywood."

His knowledge was impressive, but something about the man's manner inspired skepticism.

"You have not convinced me you stole the painting," Weisner said. "If what you have told me about the parcel is correct, then you may have been present when the parcel was packed but that does not prove you stole the painting. Can you tell me how you took it?"

"I am not saying anything more. You have got enough there. If you tell me I am going to be charged, I'll tell you then."

The man did not realize that his eagerness to be charged was having the opposite of its intended effect.

Responding that he had to "make more inquiries," Weisner temporarily excused himself, phoned West End Central Police Station, and summoned Sergeant William Johnson. In Weisner's absence, and prior to Johnson's arrival, Detective Andrews resumed the questioning.

"Where did you prepare the parcel?"

"In London and then I took it to Birmingham and handed it to teddy boy who took it to the left luggage office."

Andrews remarked that the painting was obviously delicate, so "how have you kept it all these years?"

"You would never have found it in a hundred years. I put it in the back of my wardrobe and boarded it up."

"Whereabouts do you live?"

"Newcastle."

"Tell me your address."

"Not likely. Are you going to charge me?"

Andrews ignored the question and asked how the man had entered the gallery.

"It was ten to six in the morning and was a stroke of luck. The guards must have been playing cards."

"How did you get in?"

"By a ladder that had been left by some builders."

"You still have not explained fully how you took the painting and how you got into the Gallery."

The man's answer, while nonresponsive, was important. He explained *why* he had taken the painting.

"Well, I don't know whether you know but I have been fined three times for not paying my television license. The time I took the painting I was incensed that the government would not allow free television licenses to pensioners. That's why I took the painting."

Andrews found this answer too bizarre to take seriously. He determined that, as he would put it at a deposition some months later, "further questioning was not going to produce a great deal of information." He and the man sat in silence until a few minutes later, when Weisner returned, now accompanied by Sergeant Johnson.

Johnson resumed the questioning, which primarily covered the same ground, particularly details about the packaging of the parcel in which the painting had been returned. The man repeated the answers he had already given Johnson's colleagues, but Johnson said, "You have missed out one of the wrappings, what is it?"

"Oh yes," the man replied. "It was wrapped in a pink plastic coat cover."

Johnson asked whether the man used any metal in the packaging process.

"Yes, six screws to hold the lid down."

Johnson asked, "Would you like to tell me why you surrendered?"

"I didn't want someone to turn me in for the reward. Someone knows I did it."

Then the man let on that, notwithstanding their reluctance to charge him, he had already been working on his defense. "It will get thrown [out]

you know. The *Times* legal expert says that when there is no criminal intent there can be no conviction. My defense can demand an acquittal and get it. It's all in my statement." The man removed from a brown cardboard folder a typed but unsigned statement that read as follows:

I wrote all the Com letters, plus extras to the Mirror.

London is but 4.5 hours from Newcastle by train, and I have done it more than once without question.

The Com letters were posted generally by Lorry trips.

The case is as dead as a dodo with the exception that there is a price on my head.

I am turning myself in because—

(1) My secret has leaked—I wouldn't like a certain gentleman to benefit financially by speaking to the law.

(2) I am sick and tired of this whole affair.

(3) By surrendering in London I avoid the stigma of being brought here in "chains."

My only aid in this affair was a long haired teddy boy lolling in Birmingham station. Would he put a parcel in left luggage for me? Would he be careful as it was glass? I don't know whether he gave me a name or not, it isn't usual, but somewhere, somehow, somebody conjured up the name of Bloxham—the boy just gave me the ticket—I wouldn't know him again.

Why hasn't he come forward?—either he can't read, or doesn't or perhaps he doesn't wish to get mixed up.

I do not surrender with head down—I am ashamed of nothing—I ask no quarter, but demand my rights.

This generous country of mine grants bail to molesters of little children—so I want bail—furthermore, as without criminal intent there can be no crime—I reason I am only held on a technical charge, which any thinking judge will throw out.

The average man goes for wife and family—I am somehow different and trouble ensues.

My effort has been honest to goodness skullduggery—but evil—no.

On a separate paper, I have given intimate details of the Goya parcel and what it contained.

This is all I am prepared to say before seeing a solicitor—and now I ask you to charge me—or let me go.

Notwithstanding this detailed confession, the police still declined to charge the man. But nor did they let him go. At roughly 9:15 P.M., Detective Superintendent Ferguson McGregor Walker (also from West End Central Police) arrived, was briefed by Weisner and Johnson, and asked the man, "Who are you and where do you live?"

When the man replied, "I haven't said," the officers determined that Walker and Johnson would take him to their home base, the West End Station, for further questioning. He provided impressive details that indicated his involvement in the crime, but something still seemed off. He was disturbingly eager to be charged and resisted providing basic answers like his name and residence *unless* he was charged. What kind of game was he playing?

At West End, at roughly 9:45, the probe resumed. When Walker asked, "Are you going to tell me who you are?" the recalcitrant confessor made a most curious reply: "I don't see that's got anything to do with it."

They asked him to empty his pockets. When the man complied, Johnson spotted his driver's license, which gave them the information they had heretofore unsuccessfully sought. Name: Kempton Bunton; place of residence: Newcastle. Johnson read the information aloud, and the man conceded, "Yes, that's me."

Walker asked Bunton, "Do you want to make a statement so that I can have more detail regarding you confirming that you took this painting?"

Bunton replied, "No, I have made my statement."

"I'd like to ask you questions so that I can determine whether or not you are telling the truth."

"Please yourself."

Walker pointed to Bunton's typed statement. "I understand you have produced this statement. Is it yours and is it true?"

"I am not contradicting it."

"Will you sign it?"

Bunton agreed and signed the statement.

"Do you want me to inform anyone that you are here?"

"No. I don't know anyone who would be interested."

"You say you wrote all the Com letters including one to the Editor of the *Daily Mirror* which led to the recovery of the painting?"

"Yes."

"I would like you to print two examples at the dictation of Sergeant Ion."

John Ion, an officer who had just entered the room, dictated two of the thief's ransom notes, and Bunton handwrote them in print form.

Walker briefly questioned Bunton before finally crossing a major threshold: "Having read your statement and considering what you have told me and printed for me I have reasonable grounds for suspecting you of stealing the portrait and I must caution you."*

No doubt buoyed by this step in the right direction, Bunton replied, "Carry on. You will make a big blunder if you don't charge me."

"When did you steal the portrait?"

"1961, 21st of August."

"What day of the week was it?"

"Monday, Monday."

"What time?"

"5:30 or thereabouts."

"Was it dark at the time?"

"A bit."

"As far as I know, it wasn't dark at the time. Are you telling me the truth?"

"It's a long time ago. I'm fairly sure."

"Where did you take it from?"

"Opposite the main door entrance."

"How did you get in?"

* The "caution," the British equivalent of the US Miranda warning (the latter becoming officially required in 1966), is as follows: "You do not have to say anything. But it may harm your defense if you do not mention when questioned something which you later rely on in court. Anything you do say may be given in evidence."

"They were building at the back and I took a ladder when the guards were having a cup of tea or were asleep."

"How did you get round the back?"

"That was easy."

"But how?"

"I went through the open toilet window and along a passage and took it."

"Did you go up any stairs?"

"Only steps up to it."

"How did you get out?"

"The same way. Through the toilet and over a wall."

"How were you dressed?"

"I can't remember. Sometimes I wear a cap."

"Were you by yourself?"

"Yes."

"Did you go into the gallery for this particular painting?"

"I was not after this painting, no more than any other."

"Why did you steal it?"

"To ransom it. I thought there would be an immediate collection for it."

"When you left the gallery, how did you carry it and where did you go?"

"I went to the embankment with it under my arm. I destroyed the frame."

"Why?"

"It was too big. I broke it up and threw it in the river."

After several more questions and answers about the packaging of the parcel prior to its return, Walker asked, "Where has the portrait been all this time?"

"It was in the top cupboard in my bedroom at home."

Thus concluded the interview. Notes in the files of Bunton's lawyers indicate that the interrogation lasted between two and half and four hours. (Bunton sustained himself during this ordeal with several cups of tea.) The very fact that the lawyers made this observation suggests that they thought their client may have been fatigued.* The defense lawyers made several comments

* *Length of interrogation is indeed relevant to the reliability of statements to police, though knowledge of the appropriate contours remains murky. Few interrogations exceed two hours, and some interrogation manuals caution against going beyond four. In the most thorough study of proven-false confessions (published in* North Carolina Law Review *in 2004), in 84 percent of them, the interrogation lasted longer than six hours. However, the paradigm for all this is the coerced false confession. Kempton Bunton came in and confessed voluntarily.*

in the margins of the transcripts of Bunton's interrogation, the most intriguing coming in connection with Bunton's statement that he "was not after this painting, no more than any other." One of his lawyers scribbled tersely: "This may prove troublesome."

Surely the statement *was* troublesome, but in a way that ought to have been favorable to Bunton if his lawyers planned to attack the confession. The ransom notes left little doubt that the theft was triggered by the government's expenditure of a vast sum to keep Goya's *Portrait of the Duke* in England. Bunton's statement that he "was not after this painting, no more than any other" seemed at odds with the ransom notes that he claimed to have authored. Something did not add up.

But Bunton's lawyers did not wish to attack the confession, because their client told them it was true and he did not wish to retract it. The remark that he was not after the Goya in particular was troublesome to the defense because it called into question Bunton's motive. The defense case would rest on the notion that Bunton, peeved by the government's expenditure of substantial money to keep the Goya, stole it solely for the purpose of extracting ransom money for charity—not to deprive the gallery of it permanently. But if he was not in fact after the Goya ("no more than any other"), that story fell by the wayside.

In any event, at the conclusion of his long interrogation, Bunton was placed in a detention cell for the night. There, according to his memoirs, a little extra drama ensued. Although he acknowledges courteous treatment most of the night, at one point he was asked to surrender his spectacles. He protested against "the Gestapo like" gesture but eventually complied—after he "resolved on the spot to fight the issue when opportunity arose."

In the meantime, though, he had a bigger fight on his hands. Johnson and Walker rejoined Bunton the next day, July 20, at roughly 1 P.M. Walker said he would "like to continue where we left off" and again read Bunton his rights—the so-called caution. This time, Bunton invoked his right to remain silent. In the course of doing so he made a somewhat opaque remark.

"I am saying no more. I'm finished with everything. I'm not contradicting it. I shall fight this case on the goodness of it."

He was returned to his cell and formally charged with larceny. He remained silent while the charge was read to him. Bunton was then taken for fingerprinting and returned to his cell.

The next day he was brought before a magistrate at Bow Street Court, where he appealed to be let out on bail pending trial and to be provided the legal assistance due the indigent. The government did not oppose bail, and after a brief hearing Bunton was remanded on his own recognizance and a surety of £250. The magistrate promised a speedy decision on Bunton's application for legal aid, which was soon thereafter granted. The newly freed man found inexpensive lodging in Camden, where for some reason he gave his name as Mr. Clegg.

Bunton's court-appointed attorney was an inexperienced thirty-year-old solo practitioner, Hugh Courts, who fortuitously was an arts devotee and thus particularly interested in the case. Recognizing that the trial would be somewhat involved, not to mention high profile, Courts looked for assistance from his squash partner and friend Eric Crowther. Crowther, a rising forty-one-year-old barrister who would become a magistrate three years later, was in turn assisted by a pair of law students. One of them, a young man from Tanzania named Surendra Popat, made several trips to the Colindale newspaper library in search of everything ever written about the Goya theft. Hugh Courts found this digging so valuable that he applied for and received money for Popat from the legal aid fund. All told, Team Bunton, while young, enjoyed vastly more resources than the typical court-appointed attorney.

On August 11, Bunton and his legal team came before Bow Street Magistrates' Court for the initial proceeding, where the prosecution declared itself unprepared to proceed and was granted a continuance of six days. On August 17, both sides again appeared before the magistrate, Geraint Rees, and this time several issues were addressed. Taking the lead for the defense, Crowther noted that police had received numerous letters over the years from people purporting to have the painting, and he expressed concern about the admissibility of these letters at trial, since they would prejudice his client. The lead prosecuting attorney, Michael Evelyn, responded that he wished to introduce into evidence eight letters he believed were written by Bunton. Rees ruled, sensibly, that the letters would be inadmissible unless the prosecution could

establish a reasonable basis for believing that they had emanated from Bunton. As it happens, the question of which letters Bunton wrote would become a focal point of the trial.

The defense sought dismissal of all charges (a standard move at this stage, and almost always futile); Magistrate Rees rejected this motion as expected. With respect to the most tenuous charge, that of "uttering a menace" in a May 20, 1963, letter to Lord Robbins, prosecutor Evelyn cited a 1937 case that defined *menace* as "any action detrimental to or unpleasant to the person addressed." According to Evelyn, the May 20 letter, which demanded £5,000 for *The Duke*'s return, implicitly threatened not to return it otherwise—a development unpleasant and detrimental to Robbins, chairman of the gallery trustees. The magistrate provisionally accepted the argument. Determining that there was sufficient evidence for the case to go forward on all charges, he remanded the case for trial to Central Criminal Court. Rees did make one ruling favorable to the defense, allowing Bunton to remain out on bail pending the trial.

At the hearing, several of the police who had questioned Bunton when he turned himself in the previous month—Officers Walker, Johnson, and Weisner—briefly recounted their interrogation and his confession. Bunton did not testify at the hearing but did submit a written statement (read aloud in the courtroom by Crowther) describing his motives. It echoed the statement with which he had come armed when he confessed at Scotland Yard: "I had no intention of keeping the painting or depriving the Nation permanently of it I never wished to obtain anything for myself. My sole object in all this was to set up a charity to pay for television licenses for old and poor people who seem to be neglected in an affluent society."

Also present at the hearing was Goya's *Portrait of the Duke,* in a new frame and wooden case, accompanied by a security officer from the National Gallery. The painting was produced as an exhibit and held at shoulder height by a court usher. According to a contemporaneous account by the *Evening Standard,* for most of the hearing, "Bunton sat impassively with his arms folded. Only when the portrait was produced as an exhibit did he move slightly to get a better look." A more thorough account of the hearing by the *London Times* made the seemingly gratuitous observation that Bunton weighed seventeen stone (238 pounds), perhaps intuiting that his girth would become an issue at trial.

Toward the end of the hearing, Crowther offered an unusual statement on Bunton's behalf. Recognizing that the absence of the frame was a thorn in the defense's side, Crowther made a personal appeal to Bunton's old landlady (without naming her, lest he get her in trouble) to dig it out of the dusty cupboard where it had lain for four years and restore it to the nation. Apparently Bunton, who had told police that he had thrown the frame in the Thames, had told his lawyers a different story. But, as Crowther lamented years later in his memoirs, "the plea [to the landlady] went unheeded and the Duke stood unadorned in the Old Bailey" courthouse when the case went to trial two months later. His memory was faulty: *The Duke* stood in its new frame, not unadorned.

With trial scheduled for late October (though it ended up continued until early November), the defense found itself with more than two additional months to develop a strategy. During this time, Bunton was assigned a far more experienced attorney, Jeremy Hutchinson (aka Baron Hutchinson of Lullington), an art lover himself who later became chairman of the trustees of the Tate Gallery. Eric Crowther and Hugh Courts were relegated to supporting roles, which suited the young attorneys fine.

Hutchinson, who had been practicing law for twenty-six years and had been involved in the ballyhooed Lady Chatterley Trial (over censorship of the D. H. Lawrence novel) five years earlier, was in the process of getting divorced from actress Dame Peggy Ashcroft. Despite or perhaps because of the personal turmoil, he threw himself into Bunton's defense. Bunton took an immediate liking to Hutchinson, whom he perceived as "like myself a fighter." The admiration was reciprocated. In an interview in 2011, the ninety-seven-year-old Hutchinson recalled Bunton as "just rather a darling. I had an affection for him." Bunton told his fellow warrior his incongruous plan: "I am pleading not guilty to all charges, even though I have already admitted to taking the picture."

He was, at least in this sense, the ideal client for an ambitious defense attorney—factually guilty and wishing to raise a creative defense. For Hutchinson, such a situation created a welcome challenge and a no-lose proposition. In other respects, Bunton was a defense attorney's nightmare. He had trouble keeping quiet, except on those occasions when he stubbornly refused to provide basic information, and his story changed somewhat with each telling.

Chapter 12: PRETRIAL

In the United Kingdom, as in many jurisdictions in the United States for civil cases (but less so in criminal cases), the actual trial is largely the playing out of a drama well rehearsed in advance, albeit with an uncertain outcome. Prospective witnesses give offers of proof—sworn statements that begin, "John Doe will say"—and proceed to explain exactly what information they will offer at trial. If what a witness has to say is significant, the opposing attorney calls him in for a deposition, during which he is questioned about his statement. By virtue of this procedure, lawyers can better determine whether to call witnesses for trial and can know in advance of a trial what the other side's witnesses will say. Should a witness change his story once on the stand, opposing counsel can confront him with his deposition testimony.

In the Bunton trial, two dozen witnesses gave offers of proof. They included the foreman in charge of the construction project taking place in the gallery yard during August 1961; a police constable who had taken measurements of the gallery and produced a plan to the scale of eight feet to one inch; the warders who had first noticed the painting missing; the assistant keeper at the gallery who had verified *The Duke*'s authenticity upon its return; the warehouse manager whose company had stored the painting for the Duchess of Leeds in 1958; a handwriting expert who had analyzed the ransom notes; the policeman called to the scene at the National Gallery on the morning of August 22, 1961, when the painting was reported missing; the luggage room attendant who had taken the painting from "Mr. Bloxham"; and, most importantly, the various police officers who had questioned Bunton at different times. Their testimony suggested that the government had done a thorough job putting together a case that hardly required the effort. Most of its case went toward establishing what the defense did not dispute: Kempton Bunton had stolen and attempted to ransom off Goya's *Portrait of the Duke of Wellington* and, when that failed, had returned it minus its frame.

The most important witness pretrial, as well as at the eventual trial, was Bunton himself. On four separate occasions, he either offered written responses to questions submitted in advance or sat for depositions in which he responded to questions in person. The various written documents and oral sessions (which were transcribed) covered his entire life as well as the specific events that gave rise to his prosecution.

In a written document, Bunton set forth, in narrative form, a summary of his life and his commitment to free television licenses for the elderly. For the most part, this statement gave facts described in earlier chapters, though it also included a strange and noteworthy summary of his attitude toward charity in general and more specifically his commitment to the cause that ended up driving his life:

> I do not believe in charitable organizations, but when I was a taxi driver I never took tips from old people. I never had anything myself to give to any charity.
>
> My first important charitable endeavor was connected with my campaign for free television licenses for the aged. . . .
>
> I got the idea of defying the Post Office hoping that another couple of thousand people would follow my lead. Undoubtedly about 100,000 people did, but they only did it secretly. This didn't help my campaign. . . .
>
> I don't believe in organized charity, because I think more money goes in expenses than goes to the people who ought to receive the charity. Before my television campaign, I had not been concerned in any important charitable enterprise.

Bunton was asked at a subsequent deposition to elaborate on his involvement with his charity of choice, as well as on how it led him to take and eventually return the Goya. His characterization of his various acts of civil disobedience with respect to the BBC licensing fee was uncharacteristically succinct: "My campaign which lasted from April 1960 until January 1961 was unfortunately not successful, although it achieved considerable publicity for my idea." He added, "Since this campaign had not been successful, I had a chip on my shoulder about this."

He had told the police that he "took the Goya for a reason I am not prepared to state at this moment." Now he was ready to disclose his motives. He recited the story described in chapter 6, explaining how he had learned about the auctioning of *The Duke* and contrived to steal the painting and ransom it for the auction amount. Only one detail differed from his prior accounts. Now he claimed that he had expected the money, and interest from its investment, to yield "forty-six licenses each week," an increase of six over the estimate he had given on many other occasions.

While again acknowledging that he had taken the painting, for unspecified reasons he remained "not prepared to provide any details for my solicitor or counsel of the precise details of the actual taking." At this point, one of Bunton's attorneys pointed out to him that this refusal might place the defense at a disadvantage, "because the manner and mode of taking may throw some light on the question of intention at the time of taking." Nevertheless, Bunton "refused to take the matter any further."

In a final deposition, when asked at the outset to describe all relevant events, starting with his arrival in London two days prior to the theft, he readily acknowledged what he had pointedly denied when he had turned himself in—"the intention of taking this particular painting." But he still avoided discussing the details of the actual taking. The day he arrived in London, he did now disclose, he visited the gallery and looked *The Duke* over. Ditto the next day, though he was suffering from the flu. He "drank a certain amount of rum to sweat it off." He apparently was itinerant those two days, or maybe too nervous to think straight, because "I cannot remember exactly how many places I stayed at during the time that I was in London."

Most of the deposition was devoted to the aftermath of the theft, with an emphasis on the various letters and ransom notes Bunton had written. As for the theft itself, he said only: "I took the painting between five and six o'clock in the morning. I took the picture and the frame with me straight back to the lodging."

He addressed at some length the first ransom note, sent shortly after the theft. He stated, "I went out of my way to post this letter on 30th August," but he failed to explain why. He "did not post it in the area in which I was staying in London," a notion that made more sense. He emphasized (likely at the behest of

his attorneys) that although he used the word *ransom* in his note, that terminology was "not a threat to harm the picture."

There were other instances in the depositions where precise word choice assumed importance. Bunton tied himself in knots trying to explain why he had used the word *culprits* in the initial ransom note while now denying criminal wrongdoing: "I knew that I had done wrong. I believed that what I had done had been wrong in the eyes of the law, but not in my own eyes. I thought that what I had done was not a crime, but that I would get charged with a crime. I felt that it had been wrong to borrow an article which was not mine." He explained that the plural (*culprits*), as well as references to the *group, we,* and *us* throughout, was a "red herring," and he insisted, "I was the only person involved in the whole affair." The red herring apparently had multiple causes, since he went on to explain that *we* and *us* are "Newcastle colloquial expressions for 'I.' At times I forgot the red herring."

At one point he was asked what he meant by the phrase *red herring,* which he also had used repeatedly when questioned by the police. He replied that a red herring was something "which any criminal will say [he] is entitled to place as an obstacle in the way of the police." This response was doubly odd, both a weird sense of entitlement and an implicit concession that he was a criminal—not exactly what you would expect from someone who had pleaded not guilty.

When asked about his statement "On the night of the 'borrowing' I was hooded with a silk stocking," Bunton replied, "I was not hooded with a silk stocking. This is only theatrical." Asked about the elaborate scheme (outlined in Com 4) for turning over *The Duke* on some "dark street in London," he explained, "The proposals I put forward for the handing over of the Goya in this letter are entirely serious." The proposals included the sending of a check to an establishment of "national repute"—he meant the post office, Bunton now explained.

Bunton was asked about his personal appeal to Lord Robbins to "assert thyself and get the [painting] on view again." He expressed annoyance with the chairman of the board of trustees of the National Gallery and acquitted himself: "I was suggesting in this sentence that Lord Robbins was asleep. I do not regard it as an indirect threat, because I had always intended to return the

painting to the Gallery but he would not have had it back just then without the money being raised." Here, at least, Bunton remained on message, hewing the defense line that he had committed no crime because he always intended to return the painting.

Bunton was asked about his final ransom note, Com 5, dated March 15, 1965, the one in which he sounded forlorn, more or less admitting failure while making one last-ditch effort to induce a ransom payment. What had he meant when writing in Com 5, "I know that I am in the wrong"? As before, he expressed a confusing ambivalence: "I knew all along that I was wrong. . . . I never felt that I was committing a sin—on the contrary." Regardless, he had pretty much realized that the jig was up: "I was prepared to hang on a while longer, to think up a way of getting the money, although I was thinking of giving up the picture after this letter if it didn't produce a result."

The Com 5 reference to a fund-raising effort by "Hendee-Wheeler" gave rise to this explanation at his deposition: "Mr. Hendee and Mr. Wheeler are two separate people who were often mentioned in the press as being connected with the Gallery."*

Finally, at the deposition Bunton made cryptic remarks about his general circumstance at the time he returned the painting: "At the beginning of March 1965 I found myself in a trap, and instead of lying low, I could have been stopped at any time. It was only later, when £30,000 was offered (considered) that I thought that I had succeeded. This sum would have provided seven free licenses per week." But in almost the same breath he contradicted himself, saying that, at least from the time he conceived Com 5, he was optimistic: "I thought they'd jump at the idea of an exhibition for one month."

They did jump after a fashion, or at least the *Daily Mirror* responded with its "sporting offer" of March 18, prompting Bunton's follow-up letter of March 21. At the deposition, he explained the contents of that letter, sprinkling in Latin in the process: "This letter [was] in reply to Daily Mirror's 'sporting offer' of 18th March, 1965. In the sporting offer, the Daily Mirror said—*inter alia* 'In return the Daily Mirror will at once hire a hall.'" Bunton

* Hendee" was Philip Hendy, director of the gallery, and "Wheeler" was Sir Charles Wheeler, then president of the Royal Academy of Art, who in January 1964 had written a letter to the London Times *urging the thief to turn over* The Duke *to the academy.*

explained his cryptic stipulation that money collected from the exhibition be directed to charities "on instructions from TYA." TYA referred to 12 Yewcroft Avenue, Bunton's home address in Newcastle, though it is unclear how he expected the *Mirror* to know that. FHC, which he had written but crossed out (in favor of TYA), stood for "Faith, Hope, and Charity."

Someone had also written a letter from Birmingham to the *Daily Mirror* on March 19, and Bunton was asked about that. (This was the letter, described in chapter 9, signed A.D. and claiming that the author's "good friend" had jumped the gun in accepting the *Daily Mirror's* sporting offer.) Bunton said he had nothing to do with that letter, which was actually written by "a crackpot," someone "who knew of a letter previously sent from Birmingham" and "got his clue from what the *Daily Mirror* had published." On this, he was almost certainly correct.

When asked about the return of the painting by a Mr. Bloxham, Bunton gave the same explanation he had given the police. He had traveled to Birmingham with *The Duke* on May 5, 1965, "and asked a teddy boy to put it into the left luggage office for me." The teddy boy had obliged and given Bunton the counterfoil of the ticket, which on May 20 Bunton mailed to the *Daily Mirror*. In his letter, he had also included a cartoon from the March 18 issue of the newspaper (the edition that included the "sporting offer" that had led to the painting's return) and cautioned the *Mirror* that "some future wise guy may offer to tell you all. Ask him for references."

At his deposition Bunton explained both the cartoon and the admonition as follows: "I anticipated that on the return of the painting, many people would get in touch with the *Daily Mirror* and ask for the money for all sorts of charities. I enclosed the corner of the cartoon because I wanted to retain my identity as the person who had actually returned the painting so that I could specify the charity to which the money was to be donated."

Bunton was also asked about his bitter May 25 missive to the *Daily Mirror* and his appeal to Lord Robbins on May 26. The former was the one that had declared a "black day for journalism" and had ended, memorably, "Animal—vegetable—or Idiot." Bunton clarified the obvious: "I was referring to the editor of the *Daily Mirror* who had broken his word." In the same letter Bunton also said of the editor, "I wonder if he is worthy of £2,500 reward or should be

drummed out." Bunton explained that "the paper has said a few days previously that it had got back the Goya painting, and wondered whether it would be entitled to the £2,500 reward, i.e., half of the £5,000 for the return of the painting, even if not for the capture."

In his May 26 letter to Lord Robbins, Bunton stated, "I personally did not take the portrait, I safeguarded it for future return." At his deposition, though, he said, "This is not strictly correct, and I am here guilty of a white lie." However, at that point one of his lawyers chimed in to observe, "None of the letters says expressly that the writer actually took the painting."

Such is the world of the criminal defense lawyer. Bunton insisted on taking sole responsibility for the theft, but his resourceful defense team wished to preserve the argument that he wasn't in fact the thief. Where necessary, lawyers argue in the alternative: "My client did not take the painting, and if he did take it he intended to return it." Besides, Bunton had already shown the proclivity for changing his story. Who knew when or how he might do so again?

Asked about his statement to police that "the case is as dead as a dodo with the exception that there is a price on my head," he explained that he had in mind his reason for coming forward—to prevent someone from claiming the reward money for his capture. "In the last few weeks, the later stages of the affair, a friend of mine knew that I had the painting. . . . I had told him in a pub in Newcastle after I'd had a bit to drink. Rightly or wrongly, and I couldn't be sure, I was afraid that he might offer to turn me in."

As the police would learn a few months later, this account of why Bunton came forward was largely true but involved another of his red herrings. The "friend" he mentioned was not exactly a friend and certainly not a "him" but rather Pamela Smith, the girlfriend of Bunton's son Kenneth. Bunton never explained, to the police or in his memoirs, why he was so determined to deprive Smith of the £5,000 reward. (The real reason for his aversion to Smith coming forward would eventually emerge, but not for decades.)

In the written statement he gave police when he had turned himself in, he also cited two other reasons for coming forward: "I am sick and tired of this whole affair" and "by surrendering in London I avoid the stigma of being brought here in 'chains.'" At his deposition, he said that the first of these

additional reasons "explains itself" and that the comment about chains was "just in fact a flippant remark."

In that written statement he said, "I do not surrender with my head down—I am ashamed of nothing," but at the deposition he walked back that defiance somewhat: "I only wish to say that I want to dispute this case on a fighting basis. I regarded the affair as skullduggery—not wicked, but something that I didn't ought to have done."

Why had he complained in the written statement that "this generous country of mine grants bail to molesters of little children"? Because, he explained at his deposition, "These latter I regard as the worst kind of criminals. I feel that this is a fairly average reaction and nothing unusual."

What about his statement that "without criminal intent, there can be no crime"? Here, not for the first time, he said he was relying on the opinion of the *London Times* legal expert. "What I had read had given me reason to believe that a judge would throw the case out." As noted, shortly after the painting's return, the *Times* indeed quoted a barrister declaring that, under a straightforward reading of the Larceny Act of 1916, a man was not guilty of larceny if he intended to return the goods.

Perhaps Bunton's strangest response at his deposition came when he was asked to explain his earlier statement that "the average man goes for wife and family—I am somehow different and trouble ensues." He clarified what he had meant: "I did not regard myself as the average person, but regard myself as a social worker."

Having dealt with all his own prior statements, at the end of his deposition Bunton was given the opportunity to respond to the prior depositions of all the prospective witnesses in the case. With respect to most of them, he opted for "I have no comment," but with a few noteworthy exceptions. Apropos of testimony by gallery warder Sydney Settles Cadman, he said: "I disagree with the evidence of this witness when he says that the picture was missing between midnight and 12:30 A.M." And apropos of testimony by Sergeant William Johnson, he offered a key clarification: "It says I replied to a question, 'I was not after this painting, no more than any other.' I made this reply because I did not think it was relevant at that time to say that I was after this particular painting. However, at the time I really was not after any other painting, only this one."

This cleared up Bunton's strangest response to the questioning when he turned himself in, a remark that his lawyers considered troubling. The ransom notes clearly implied that the Goya had been pilfered because of the extreme measures taken by the government to keep it in England. By denying that he was after the Goya in particular, Bunton created at least some doubt as to whether he was the author of those notes. Now, his acknowledgment that he was in fact after the Goya provided clarity to the prosecution and defense alike. But the explanation itself—that he had made a false statement because he "did not think [the truth] relevant"—underscored his sometimes cavalier approach to the truth. He said things because they were "theatrical" or justifiable "red herrings" or based on his assessments of relevancy, among other considerations.

In any event, with the depositions in place, Bunton and the other prospective witnesses were largely locked into their stories. The attorneys could now review the evidence and determine which witnesses to call and which points to emphasize at the criminal trial. As it approached, Kempton Bunton felt rickety. As he explained in one of his depositions, "I have been married for 40 years and although we have had rows from time to time and have not spoken to one another, the marriage has not been brought to an end. At the moment my relations with my wife are rather strained, due entirely to this case."

But Bunton's marital problems were nothing new and were perhaps the least of his troubles. He faced prolonged prison time, which for a sixty-one-year-old man could amount to a death sentence.

The police had originally charged Bunton with just one count of larceny. When the prosecution got involved, however, a more ambitious charging document emerged:

FOR THAT HE, in the said Area and District and within the jurisdiction of the Central Criminal Court did:

1) On or about the 21st day of August, 1961 at the National Gallery, Trafalgar Square, LONDON. W.C.2., feloniously stole a painting of the Duke of Wellington, vested in the Trustees of the National Gallery.
CONTRARY TO SECTION 2 OF THE LARCENY ACT, 1916

2) On or about the 21st day of August, 1961 in the Greater London Area, feloniously stole one picture frame valued at £100, the property of the National Gallery.
<u>CONTRARY TO SECTION 2 OF THE LARCENY ACT, 1916</u>

and

3) On a day between the 19th and 22nd days of May 1963. At 10 Headway Close, London, N.W. II, utter, knowing the contents thereof, a letter demanding money from Lord ROBBINS, with menaces and without any reasonable or probable cause.
<u>CONTRARY TO SECTION 29 (X) (1) OF THE LARCENY ACT, 1916</u>

Later the document was amended to add two more charges: a second count of sending a letter "with menaces," stemming from the letter to the *Daily Mirror* posted on March 21, 1965 (during Bunton's final effort to have the painting exhibited to raise money for charity); and a charge of "public nuisance," which alleged that "Her Majesty's subjects were desirous of viewing the said painting [and] were obstructed in the exercise of their rights and deprived of the enjoyment of the same." Thus in the case of *Regina v. Kempton Bunton,* the defendant faced five charges.

It has long been common for prosecutors to squeeze as many charges as possible from a single criminal act, for several reasons: to enhance leverage in plea bargaining, to achieve a greater sentence upon conviction, or to give jurors the option of compromising and finding the defendant guilty of a lesser charge if they have misgivings about convicting on the most serious charge. Accordingly, it is not surprising that the prosecution charged Kempton Bunton with writing ransom notes (albeit only two of them) as well as stealing the painting.

What might seem surprising was the government separately charging Bunton with stealing the frame, which is akin to charging someone with theft of an automobile while drafting a separate charge for stealing items inside the car. Or, to use the analogy Bunton himself invoked in his memoirs, it was "like

charging a bandit who had admitted stealing thousands of pounds in cash with also stealing the tin box it was held in." He added, rhetorically, "but who was I to question the mysterious ways of the prosecution?"

Actually, there was nothing mysterious about the extra charge, and Bunton himself triggered it through his gratuitous comments to police. He indicated to the officers at Scotland Yard, as well as in the written statement he offered them, that he planned to argue that he lacked the requisite criminal intent because he had intended to return the painting all along. Notwithstanding the language of the Larceny Act that, read literally, seemed to authorize it, such a defense was unorthodox and seemed unlikely to succeed. But the prosecution saw no need to take chances. If jurors felt they should not convict a thief for a painting eventually returned, well, the same could not be said of the frame, which was never returned. Bunton's lawyer Eric Crowther later acknowledged that the separate charge of stealing the frame was "cunning."*

The public nuisance charge, on the other hand, seemed a bit of a stretch, one the Bunton team planned to protest. But that, like the entire case from the defense standpoint, figured to be an uphill climb.

* Surendra Popat, who assisted the defense, recalls running into Sergeant William Johnson (one of the lead investigators in the case) at a social event a year after the trial. Johnson claimed that he had convinced the prosecutors to charge separately theft of the frame.

Chapter 13: **BEFORE THE BOMBSHELL**

The long-awaited case went to trial on November 4 in Central Criminal Court (better known as Old Bailey) in London. The august Old Bailey, named after the street where it is located, was completed in 1907 and officially opened for court business by King Edward VII. A gold leaf statue of Lady Justice stands atop the imposing, sixty-seven-foot neo-Baroque dome, and above the main entrance are inscribed two of the court's principal roles: "Defend the children of the poor and punish the wrongdoer." Lady Justice holds the customary sword in one hand and the scales of justice in the other but, for whatever reason, is not blindfolded, unlike the usual iconic Lady Justice.

The inside of Old Bailey features Sicilian marble floors and ornate mosaic arches as well as four spacious oak-paneled courtrooms. In one of these courtrooms, Kempton Bunton stood trial before a jury of ten men and two women, presided over by Judge Carl Aarvold (the "recorder," as judges in England are called), a former professional rugby player once oddly described by a journalist as "not only gracious in defeat but fluent in French, a rare combination." First appointed to the bench in 1951, Aarvold was promoted to senior judge at Old Bailey in 1964, the year before the Bunton trial, and he would become knighted in 1968.

The first day and a half of the trial witnessed perfunctory prosecution testimony recounting nondisputed circumstances surrounding the theft of the painting and its return. In the middle of the second day, the trial took its first surprising turn. Defense counsel Jeremy Hutchinson requested a hearing to seek dismissal of three of the five charges against his client. (Defense attorneys usually await completion of the prosecution's case before making such a motion.) The judge said, half-smiling, 'I have no doubt that Mr. Hutchinson

is going to throw the books at me,' to which the quick-witted solicitor replied, 'With all due respect, M'Lord, I shall *present* the books to you.'"

So he did, during a two-hour hearing held outside the presence of the jury.

Hutchinson urged the court to dismiss all but the two larceny charges, arguing that (1) the government had failed to present evidence from which a jury could convict with respect to the two counts of sending a letter "with menaces"; and (2) the public nuisance charge was simply inappropriate in this type of case.

He devoted most of his argument to the public nuisance charge, an hour-long presentation that would have done any trial lawyer proud. Hutchinson discussed dozens of cases going back centuries, summarized learned commentaries (especially those of the revered legal historians Blackstone and Stephen), and responded sharply but sycophantically to the judge's requests for clarifications ("No, my Lord, with great respect"). His introduction of some of the cases left laypeople in the courtroom scratching their heads, as these cases involved circumstances bearing little resemblance to the theft of a painting. For example, Hutchinson quoted at length from a nineteenth-century opinion holding that "burning rather than burying a body" does not constitute a public nuisance under the law.

While such cases would strike some as far afield, it is common for attorneys to dig up any cases from which favorable language can be extracted, especially court opinions authored by famous or well-regarded judges. The burning versus burying case, for example, was decided by a well-known judge, whose notion that the public nuisance language should be construed narrowly served Hutchinson's purposes. Indeed, Hutchinson actually turned to his advantage the fact that the cases he cited seemed unrelated to the present case: The disconnect, he explained, was precisely because no one ever thought to prosecute as a public nuisance a mere act of theft. Courts, especially British courts steeped in the common law (legal doctrines established by judges in previous cases), rely heavily on precedent, and Hutchinson emphasized the unprecedented nature of the application of the public nuisance charge to cases like the present one.

A public nuisance charge usually involved damage to the public health and safety. Hutchinson claimed to have plowed through all the relevant law books and "been unable to find any case . . . where an individual has been indicted

for depriving a section of the public of the enjoyment, or the satisfaction of contemplating a work of art." To allow the charge to stand, Hutchinson insisted, would "enlarge the scope of criminal law quite enormously."

Hutchinson buttressed his argument from precedent with a more technical argument: Depriving members of the public of some pleasure constitutes a public nuisance only if they have the right to that pleasure. Thus, for example, "digging a hole or blocking the entrance to the Gallery" might constitute a public nuisance because people have the right to enter the gallery and view paintings. They do not, however, have the right to view any *particular* painting. Indeed, which paintings are viewable is a function of many arbitrary factors, such as the curators' whims. It was a matter of happenstance that Goya's *Portrait of the Duke* had been exhibited in the first place. Accordingly, depriving people of seeing it could not constitute an independent crime.

Hutchinson also advanced the related argument that Bunton's thievery had deprived the public of seeing only a single painting. This was, in the words of the law, de minimis—too trivial to rise to something legally actionable. By analogy, someone might commit a public nuisance by bombing a library and destroying its collection, but a person who "took a book from a public library and retained it for a long time to the great annoyance of any other members of the public who wanted to read it"—while surely causing a nuisance in lay terms—did not create a public nuisance as a matter of criminal law.

This latter argument gave the prosecutor (or counsel for the crown, as he was called) an opening, and, in his best moment in response to Hutchinson's long argument, Edward Cussen exploited it. Playing to the nation's pride in the Duke of Wellington, Cussen acknowledged that one overdue library book would not amount to a public nuisance but that the matter was different with respect to a "national treasure." Suppose, he said, someone removed the Magna Carta—surely that would support a charge of public nuisance.

Otherwise, the prosecutor did not shine during the hearing. Since Cussen maintained that deprivation of the pleasure of looking at the painting constituted a public nuisance, the judge posed an analogy that also involved viewing pleasure: "If somebody stopped on a highway to enjoy a scene or a view, and somebody puts up a post to prevent them stopping there, would it be committing a public nuisance?"

The best response would have been either "yes" or "no, but," followed by an explanation of why the present case was different. Instead, Cussen did what shrewd lawyers generally avoid—he thought out loud. His meandering response involved musing, "If, for some purpose of his own, a man saw fit in these astonishing scientific days to cause an artificial cloud perpetually to hang over Box Hill so Her Majesty's subjects could never see it at all," it might indeed constitute a public nuisance. Except Cussen lacked conviction with respect to his own far-flung hypothetical, saying only that "the first thought which would come to mind would be that thereby he was bringing himself within the purview" of the criminal law.

Cussen did a better job responding to the fact that decades of cases applying the public nuisance offense included none resembling this one. That, he said, is precisely the beauty of the common law: It involves the evolution of doctrine in response to new scenarios not previously envisioned or encountered. Precedent is nice, it may even be the lifeblood of the law, but it has limits. It must be supplemented with new doctrines, or new applications of old doctrines, when unanticipated or changed circumstances arise.

But in the course of making that reasonable argument, Cussen committed what for lawyers is sometimes (and may have been here) a fatal mistake: the sin of candor. Unprompted, he explained at length why he added the charge of public nuisance to the four earlier charges against Bunton. He confessed that the other charges made him nervous. He knew that the defense planned to argue that Bunton always intended to return the painting and that the Larceny Act on its face required that the thief intend to "permanently deprive" the owner of his possession. He feared that a jury would accept that argument. So too the two charges of "uttering a threat" left him uneasy—"My Lord, supposing this is not supported. Supposing that counts three and four are not supported?"

Having fretted that the first four charges might fail, yet knowing that a man could not be allowed to steal a valued painting without suffering criminal consequences, Cussen racked his brain to find "any other offense of law" that just might be deemed applicable to the defendant's acts. And, he concluded in his confession, "That is the reason for the inclusion of count five in this indictment."

There is, of course, nothing unusual about prosecutors doing exactly what Cussen did during the charging process: scouring the criminal code for all relevant charges that might plausibly be applied to wrongful behavior. What is extremely unusual is to *acknowledge* that they have done so, all the more so to admit that they have done so because of insecurity about the more straightforward charges.

Not surprisingly, in rebuttal Hutchinson jumped on his adversary's admission. He noted the observation of a famed jurist that "nothing is a crime in this country unless it is expressly forbidden by law." Adapting the common law to changed circumstances may be fine in civil cases, but in the criminal law it is anathema—an ex post facto law, or punishment of behavior deemed criminal only after the fact. Ex post facto laws are not forbidden in Great Britain (unlike the United States, where the Constitution expressly prohibits them) but have always been frowned upon.

Here, Hutchinson maintained, the government was frustrated that (because of the loophole in the Larceny Act that seemed to allow theft-as-borrowing) the defendant's actions did not constitute a crime on the books. Accordingly, the prosecution's thought process, as revealed by Cussen's own confession, was (in Hutchinson's characterization) as follows: "Here is something which requires condemnation and, therefore, if the larceny count does not succeed I must see to it that there is something that covers it." Though not in so many words, Hutchinson essentially accused Cussen of creating an ex post facto law of his own.

Having heard the competing positions at some length, Judge Aarvold decided the matter with striking brevity. He declared the issue one "I would very much prefer to reserve for the decision of a higher court" but one he simply could not avoid deciding. Therefore, though "the evidence shows an irritating and frustrating act . . . I can only rule that the facts adduced in evidence so far cannot amount in my opinion to a public nuisance." Accordingly, "I shall direct the jury that a verdict of not guilty must be returned on Count Five."

As noted, Hutchinson also urged Judge Aarvold to direct a verdict in Bunton's favor with respect to counts three and four—the two charges of uttering a menace. Here, his argument was much more brief: The letter of March 21, 1965, to the editor of the *Daily Mirror* did not constitute a threat or menace

for two reasons. First, the prosecution had not called (and did not plan to) the editor as a witness, so there was no evidence that he was menaced. Second, what possible threat could there have been to him and his newspaper? If the *Mirror* failed to agree to exhibit the painting and raise money for his charity, Bunton would not return it . . . but so what? The newspaper did not own the painting, so it could hardly be menaced by its nonreturn. Similarly, the letter to Lord Robbins on May 20, 1963 (which Bunton denied writing but for the purposes of this motion the defense had to assume he had written), involved no direct threats to Robbins and there was no evidence that he felt threatened.

Here, counsel for the crown had the stronger argument. Whether Robbins or the editor of the *Mirror* felt threatened was irrelevant: For legal purposes, the question was whether the author of the letters *intended* his missives as a threat. Just read the letters, Cussen urged the court, and their intent is unmistakable: If you do not comply with my demands, I will not return the painting. The fact that the *Daily Mirror* did not own the painting was also irrelevant, since case law established that a threat affecting a third party can constitute an unlawful menace.

Judge Aarvold agreed. Indeed, he did not seem to regard this issue as a close call, rejecting the defense motion with a single conclusory sentence: "I need say no more than that in my opinion there is evidence which calls for the jury on each of these counts."

It is doubtful that Hutchinson expected to prevail in his efforts to get these two counts dismissed (he spent less than ten minutes addressing them), but it is understandable why he felt the need to try. With respect to the two letters, Bunton's lawyers faced a tricky balancing act. Their handwritten notes in the case file include items like the following: "Could a simple man have done this alone? If not, [we] can establish doubt as to whether Bunton did this alone, it might go some way towards establishing his non-responsibility for the 2 threatening letters."

Therein lay a central dilemma for the defense. The idea that a large, nonathletic fifty-seven-year-old man could have pulled off the physically demanding theft seemed improbable. And, exactly as the defense team's notes suggest, if Bunton had accomplices, why assume that he (rather than they) had written the ransom notes? And if the defense could establish doubt about

his authorship of those letters, that could knock out two of the charges. The problem was that Bunton himself insisted that he had no accomplices. If defense counsel raised doubts on that score, they were effectively calling their own client a liar. For that matter, Bunton directly admitted authorship of one of the two letters in question—the one to the *Daily Mirror*. The defense was at war with itself: It could make a strong case that Bunton hadn't written these letters but only by discrediting the defendant. Faced with that dilemma, it emphasized that, whether or not he had written them, none of them constituted a legal "threat" or "menace." But Judge Aarvold rejected this argument.

Following Judge Aarvold's ruling throwing out the public nuisance charge but allowing the two charges of uttering a threat to be decided by the jury, the case went forward with the four remaining charges: stealing the painting, stealing the frame, and writing the two allegedly threatening letters.

In support of those charges, the government introduced forty formal exhibits, including the painting, a plan of the National Gallery, the various ransom notes and other letters allegedly written by Bunton, the written statement he had handed the police when he turned himself in, and assorted physical items, such as the material used to secure the painting and the left luggage ticket given to him when he returned it. The government also called a raft of witnesses, twenty-three in all, a few of whom were particularly important.

These included the scientific experts. Detective Superintendent Harold Squires of New Scotland Yard's fingerprint department had conducted fingerprint analysis on more than fifty documents (mostly letters sent by people claiming to be the thief) and compared any discernible prints to Bunton's. He would testify that he found Bunton's fingerprints on one important and contested letter. Roland Alfred Page, a senior forensic science officer in Cardiff, had compared Bunton's handwriting samples with various letters and testified that in his expert opinion, Bunton had written several of the ransom notes.

Michael Vincent Levey, assistant keeper at the gallery, clarified, lest there be any doubt, that on August 21, 1961, "No one had permission to remove the portrait from the gallery." He verified that the returned painting was the original Goya and estimated the value of the missing frame at £100. Under cross-examination, Levey acknowledged, "I don't think I can clearly describe the frame," but he quickly added, "I recollect it was a gold frame—a fairly plain—

gold in color with no other color. I do not recollect the frame in detail." He also conceded that "very little damage has been suffered by the portrait in the period it has been away from the Gallery since August 1961."

The various detectives who had interrogated Bunton after he turned himself in—Officers Andrews, Weisner, Johnson, and Walker—all testified about the encounters, somewhat redundantly. They were cross-examined, Johnson at some length, but the thrust of their accounts survived intact.

Taken together, the prosecution's various witnesses and exhibits convincingly established Bunton's involvement in taking the Goya and writing various ransom letters and other letters related to the theft.

But the prosecution presentation was not flawless. Major problems emerged with respect to the May 20, 1963, letter to Lord Robbins, one that formed the basis for an independent charge. Scotland Yard's forensics testing had found no observable fingerprints on the letter to Robbins but had identified Bunton's fingerprints on the one to Lord Rothermere written the same day and undoubtedly by the same person (since the one to Robbins referenced Rothermere and they bore consecutive registration numbers from the Darlington post office). The government expert, Scotland Yard's Harold Squires, testified with certainty that Bunton's fingerprints were on the letter to Rothermere, patiently explaining the science of fingerprinting and the basis of his conclusion. Squires, a fingerprint analyst for thirty-four years, was a respected authority in the field, but defense counsel Hutchinson shredded him on cross-examination—partly for reasons outside the witness's control.

On direct examination, prosecutor Cussen asked Squires to explain the science of fingerprinting "not in great detail" and may have been displeased when the witness launched a lengthy response. Squires started by observing how "the hands are covered with a thick type of skin in ridge formation, and these ridges are studded by sweat pores" and then grew increasingly technical. But the biggest problem wasn't the esoteric nature of Squires's testimony. He did explain, comprehensibly enough, that whereas eight points of similarity between fingerprints suffice to establish a match, he had identified sixteen points of similarity between prints found on the letter and envelope sent to Rothermere and the fingerprint sample provided by Kempton Bunton.

The problem was less a matter of substance than process. Squires testified how the letter to Rothermere was given chemical treatment (which makes invisible prints visible), brought to a forensic laboratory, analyzed, photographed, and taken back to West End Police Station, where it somehow . . . disappeared. The photographs survived, but the missing letter gave Hutchinson an opening on cross-examination that he wasted little time in exploiting. After a few perfunctory questions, he said to Squires: "You appreciate, do you not, that Mr. Bunton and those of us who appear for him have never been able to see this document, ever. You appreciate that?"

After Squires assented, the alert Judge Aarvold interjected that "whether Mr. Bunton has been able to see [the original letter] is perhaps still in issue." But the point had been made. And Hutchinson was not satisfied to allege negligence; he subtly implied corruption. He drew from Squires that, of the fifty-three documents Squires had examined, evidence of Bunton's fingerprints was identified on only this one letter—the single letter to disappear. Rather convenient? Hutchinson made his implication sufficiently clear that at one point the angry Squires protested, "The fingerprint department of Scotland Yard is one that has built up over many, many years a reputation of the highest integrity."

Hutchinson stressed the fact that the fifty-two items that had been examined and failed to yield a fingerprint match for Bunton included several letters that Bunton acknowledged writing. He seemed to be calling into question the competence of Squires and his department as well as their integrity. At other times, he not-so-subtly implied that fingerprint analysis in general was a junk science, prompting the witness to proclaim that his methodology "is accepted throughout the world and in all the courts of this country" and that it supplied, in this case as in others, "proof beyond all reasonable doubt."

Such protests by the witness may have played into the defense's hands, evincing an off-putting arrogance that Hutchinson sought to highlight. When he asked, "You would not hold out the view that your opinion should always be accepted without any question?" Squires actually replied, "With regard to fingerprints, yes, sir." At another point, when Hutchinson provoked Squires by saying, "It is extremely difficult to ask you questions because you stand there and say you cannot understand," the witness cut in to say, "No, sir, I understand it all."

While we cannot be sure how Squires's cocksureness played with the jury, it clearly failed to intimidate his inquisitor. Hutchinson argued with Squires as much as questioning him, at one point declaring him "completely wrong" and at another noting, "You keep saying that, Mr. Squires, but to the ordinary person's eyes that just is not so."

At times Hutchinson elicited what seemed like damning admissions, as when he identified an apparent "fork" in a fingerprint that Squires had not so identified. "Is that an optical illusion?" he asked, and the flustered witness replied, "It must be." On other occasions, he deliberately dragged Squires into the weeds, where the discussion could only leave jurors befuddled—if they remained awake. At one point, as he probed the finer points of a certain print, he elicited this mind-numbing analysis from the witness: "I was looking at the two lines which form the ridges of the fork. Now I realize you are talking about the dark ridge which goes slightly to the left at 11 O Clock, or the dark mark that is not a ridge at all. It is something foreign in between the two."

Something foreign indeed—that is surely how the jurors, by the end, regarded the entire process of fingerprint analysis. At turns riveting and deadly dull, the interplay between Hutchinson and Squires muddied the waters sufficiently that jurors were unlikely to trust that Kempton Bunton's fingerprints were indeed on the missing letter to Rothermere. The charge that Bunton "uttered a menace" in his May 20 letter to Robbins obviously could not stand unless Bunton wrote those letters. Accordingly, by the time Squires descended the witness stand, that charge seemed shaky at best.

The other charges remained on firmer ground. The defense could not dispute most of the government's narrative because it came from Bunton himself. He was largely locked into the fundamentals of his account of the theft and its aftermath, as he had already given versions of it several times, including under oath (during his depositions). While his multiple accounts differed in many particulars, they converged in his acknowledgment that he had taken the painting and written most of the ransom notes. Accordingly, the defense did not aggressively cross-examine most of the government witnesses who corroborated (or, in the case of the officers who had interrogated him, passed along) Bunton's own accounts of events. As Bunton accurately if acerbically remarked in his memoirs, "Witnesses for the prosecution were

brought hundreds of miles to personally give evidence which was not to be disputed by the defense."

But if the government was overly fastidious about establishing undisputed facts, the defense erred in the opposite direction, raising frivolous issues—apparently on the theory that if you throw enough mud against the wall, some will stick. When the first prosecution witness, National Gallery employee Michael Levey, identified the portrait (brought into court in a wooden box), on cross-examination Hutchinson suggested that the painting might be inauthentic—that is, not a legitimate Goya. Levey acknowledged a brief brouhaha over its authenticity earlier that year, sparked by Sir Gerald Kelly, former president of the Royal Academy. Hutchinson asked whether Kelly had called the gallery's alleged Goya "slick, incompetent and vulgar." Levey could not vouch for those exact words but agreed that Kelly had indeed disparaged the painting.

Prosecutor Cussen rose and objected, demanding to know the relevance of this line of questioning. Hutchinson replied that surely it was significant whether Bunton had taken "an old bit of canvas with a piece of paint slapped on it . . . [or] a painting worth £140,000." Those with a sense of history heard echoes of the historic slander suit brought by artist James McNeill Whistler against leading critic John Ruskin for writing, apropos of a Whistler exhibit, that he "never expected a coxcomb to ask 200 guineas for flinging a pot of paint in the public's face."

Judge Aarvold sustained Cussen's objection, because "whether it was a genuine picture or rubbish, I think it would still be a picture of interest." For that reason, he added (incoherently) to Hutchinson, "If you are going to prove during this trial that the picture is a fake, I shall be interested. But I doubt whether I shall allow it." To clean up whatever little mess Hutchinson may have stirred up, Cussen used re-direct examination to ask Levey whether he personally ever doubted the authenticity of the painting. Levey said he did not.

Like many a stubborn and effective defense attorney, Hutchinson insisted on pursuing this questionable angle. When the next day the prosecution called Lord Robbins to testify, primarily about his receipt of the May 20, 1963, ransom note, Hutchinson again used cross-examination to insinuate that *The Portrait of the Duke* might be inauthentic.

A distinguished-looking sixty-seven-year-old gentleman, Robbins was somewhat of a celebrity—an accomplished economist who had also authored the influential *Robbins Report* on higher education, commissioned by the government and published just two years prior to the trial. Robbins combed back his thick white hair, leaving his prominent forehead exposed. Confident and outspoken, he had a commanding presence and figured to be a compelling witness.

Prosecutor Cussen wasted no time with niceties. After just a few questions to establish Robbins's connection to the National Gallery, he turned to the letter sent to him on May 20, 1963, which Cussen read aloud. This was the short typed letter that began by assuring Robbins that "I have the missing painting of the Duke of Wellington—you may have it back at £5,000—this can be arranged providing you work quietly" and that suggested that Lord Rothermere (who was sent a long letter that same day) of the *Daily Mail* serve as intermediary. Robbins confirmed receipt of the letter and explained that he had immediately contacted the police and turned the letter over to them. And that was that for his direct testimony. Although the prosecution charged Bunton with "uttering a menace" by way of this letter to Robbins, Cussen chose to let the letter speak for itself rather than ask Robbins about it. He questioned Robbins for just five minutes before turning him over for cross-examination.

Hutchinson began cross-examination by attempting to cast doubt on the notion that Bunton had even written the letter in question. Noting that other letters (the various Com ransom notes) included labels and other physical information to identify the painting, whereas the letter to Robbins had not, Hutchinson proposed that the latter "did not appear to you to have any connection, on the face of it, with the other letters." But Robbins emphatically rejected that suggestion: "Oh no, I wouldn't say that, sir." Robbins explained that while the letter to him lacked "the same objective hallmark of authenticity" as the other letters, he felt certain that it came from the same hand. He observed that it "had the same dottiness of broad style, the rather wild idea of some intermediary who should negotiate a ransom It is the same sort of, what shall I say, ideology." Robbins went so far as to say that "it didn't occur to me to doubt that it came from the same author."

Hutchinson would have been better off ignoring this line of inquiry alto-gether. He was free to emphasize to the jury (in closing argument) the differences between this letter and the others and to argue that it had originated from someone different. Why invite Robbins to give the jury the opposite conclusion from a neutral source? Hutchinson compounded this rare mistake by pursuing the matter after Robbins had forcefully stated his position.

"I wonder whether you could tell me why you thought that?" he asked.

Robbins replied, "The style has a truculence which suggested to me a common origin."

"Anything else?" Hutchinson persisted.

Robbins responded that the letter to him seemed "very authentic"—meaning not a hoax, which thus linked it to the letters whose authenticity was borne out by the description of details on the back of the painting.

"I am afraid I must press you about this," Hutchinson insisted. He asked Robbins to look at two of the Com letters concededly written by his client, elicit-ing from Robbins that "they are as alike as one sonnet by Shakespeare to another."

"The sonnet in the typewritten one [to Robbins] is very different," Hutchinson interjected, noting that it did not specifically mention charity, asked for just £5,000 as opposed to the £140,000 requested in the two other letters, and was typed rather than handwritten.

"That is true," Robbins conceded, while maintaining that these differences "didn't raise in my mind that the object of the request was any different from the request in the other letters." Try as he may, Hutchinson could not shake Robbins's conviction that the May 20 letter was written by Kempton Bunton. Eventually Hutchinson changed course and elicited opinions more helpful to his client, starting with the fact that the painting, in Robbins's words, "had been packed [by Bunton] with care and solicitude for its condition."

"You did not ever get the impression that the person who had it in his care was going to harm the picture on purpose?" Hutchinson asked.

"No, I always refused to believe that."

Hutchinson then turned to the rumors that the painting was inauthentic, even though Judge Aarvold had declared the issue irrelevant just the day be-fore. He asked Robbins to acknowledge that there was a controversy not only about whether the painting was worth £140,000 but also about "was it really

by Goya at all." Robbins replied that the question of authenticity "never worried me much," since the gallery's experts, who vouched for the painting, are "the best in the world." Robbins conceded that the painting could be seen as overpriced (its value had been dictated by Charles Wrightsman's auction bid, not any action by the gallery), but "it was a portrait of Britain's most famous nineteenth century soldier by the most important painter of the time," and thus its value transcended its aesthetic merit.

Judge Aarvold interjected to refocus Robbins's attention on the issue of the painting's authenticity—somewhat surprisingly given the judge's previous ruling that the matter was out of bounds. Robbins replied that he thought the controversy was frivolous, prompting Hutchinson to jump in to observe that the original doubts about authenticity had been voiced by the estimable artist Sir Gerald Kelly, not some crank. Robbins snapped, "It would never occur to me to read Sir Gerald Kelly's casual observations on art matters." Hutchinson asked whether he was aware that Kelly had called the portrait "a very poor specimen of a picture." (Though unremarked by Hutchinson, Kelly had also publicly declared, "If that's a Goya, I'm a virgin.")

Before Robbins could reply, Judge Aarvold again decided that he had heard enough of this side issue. He declared the matter "completely and utterly irrelevant" and told Robbins he need not answer. Robbins said, "I have got something I would like to tell learned counsel very much," but this time Aarvold was steadfast and declared debate over the quality of the picture off-limits once and for all. Thus concluded Hutchinson's mostly unsuccessful cross-examination of the witness.

On re-direct-examination, Cussen sought to establish the painting's bona fides. He couldn't do so directly, given the judge's emphatic determination that the issue was off-limits, so Cussen cleverly asked Robbins to verify that the gallery had again exhibited the painting following its return. Robbins replied that it had, following a brief interval for slight repairs, procurement of a new frame, "and [provision of] a Perspex shade in case any member of the public should misbehave."

Apart from the curious diversion concerning the painting's authenticity, most of the trial proceeded smoothly enough, if only because few knew about the bombshell dropped behind the scenes.

Chapter 14: BOMBSHELL

On November 11, 1965, one week into the trial, a woman named Pamela Smith of Newcastle dropped in at West End Central Station and asked to speak to the officers who had conducted the investigation into the stolen Goya painting. When Detectives William Johnson and Ferguson McGregor Walker emerged, she told them that she had information about the case and, at their request, proceeded to give an oral statement. Johnson typed it up and Smith signed it. Her story, covering five double-spaced pages, included substantial material about her various encounters with Kempton Bunton, which for the most part conformed to his account of their relationship in his memoirs (described in chapter 10). But Smith contradicted Bunton on the single-most important point, offering evidence that called into question the central claim of not only Bunton's memoirs but also his numerous versions of events told to the police, at his depositions, and before long at trial. According to Smith, Bunton had not stolen the painting.

Smith told the officers that she had separated from her husband in 1961 and in late September 1963 met Kenneth Bunton, Kempton's oldest son. They hit it off, and a week later she moved in with Kenneth in Birmingham. In June 1964 the couple moved to Newcastle, where Kenneth had grown up and his parents still lived. They briefly stayed with his parents, Kempton Bunton and his wife, before finding a flat of their own. (Pamela and Kenneth had split up by the time this statement was given, and she was living in Stoke.)

According to Smith, Kenneth Bunton often talked about the Goya theft but had never associated himself or his family with it until the latter part of June 1964, after she and Kenneth had been living in Newcastle roughly three weeks. At that point, Kenneth shared a family secret: The Goya had actually been stolen by John Bunton, Kenneth's younger brother and Kempton's youngest son, with assistance from another man Kenneth did not name. John kept the painting hidden behind a wall "in a cottage on the coast" where an old lady lived by herself.

That, at least, is what Kenneth told Smith *at first*. A few days later, he admitted to Smith that while his brother John was in fact the thief, the rest of the story was "a pack of lies." There had been no accomplice, and the painting was in fact in Newcastle, though he did not disclose the precise location. Smith asked him how the painting had been transported north from London and also how Kenneth knew so much. It turns out the answers to the two questions were intimately related.

Kenneth claimed that, following the theft, he loaned his father £70 so that the latter could travel to London, along with Kenneth, to assist John. And so they did. Kenneth and Kempton wrapped the painting in hardboard, transported it to Kempton's home in Newcastle, and put it in the cupboard in an upstairs room. They covered the hardboard with wallpaper "in order to disguise the fact that there was a cupboard. It was supposed to be walled in." Smith hastened to add, "All this is what Kenneth was telling me. I did not see it for myself."

Meanwhile, the father and two sons formulated a plan. If money could be raised from the National Gallery to reclaim the painting, Kempton, Kenneth, and John planned to split the proceeds—50 percent to John, 25 percent each to Kempton and Kenneth.

That was the initial bare-bones story, but, according to Smith, "Over a few weeks I heard the story many times and Ken kept adding details." She eventually learned that John had not gone to the National Gallery in search of the Goya. He was after any painting, intending to extract money from the insurer. After the heist, he wrote to his father to tell him he was in unspecified trouble and to request his father's presence in London. When Kempton (not accompanied by Kenneth) arrived in Kings Cross, where John was staying, John told him about the theft and asked Kempton to take the painting off his hands.

After Kempton did so, they learned that John had miscalculated: "They found out [the painting] was not insured." Trouble between the collaborators ensued. "According to Kenneth, John and his father were at loggerheads over the next few years over what to do with it. . . . They argued for a long time." John wanted to burn the painting, an idea Kempton considered unthinkable. "Kempton eventually convinced John to do it the father's way"—which meant keeping the painting "so they would eventually get money from a story."

While Kempton's story and Pamela's diverged on who stole the painting, they converged on one key fact: "About a week before he gave himself up, Kempton told me that he had stolen the Goya." (A little later in her statement to the police, she offered a crucial clarification: "The old man never said to me that he was the one who had stolen it—he just said that he had it.") She added, "He did not know that Kenneth had already told me and I did not want Kempton to know what I knew already." Accordingly, she said to him, "Pop, you're living in a fool's paradise and there's no fool like an old fool."

According to Smith, Kenneth told her that Kempton and John had arranged the return of the painting to the left luggage office at the Birmingham railway station. John had personally returned it there (which would make him "Mr. Bloxham," though Smith shed no light on that choice of name). They had cooked up some elaborate plan involving a letter that would mention television licenses to get Kempton arrested, but the plan fell through. ("Ken thought that John had been afraid to keep to the plan.") Accordingly, "The old man had to give himself up," though Pamela failed to explain why in fact that was necessary. However, later in her statement she remarked, "His idea is to carry on as he has been doing at his trial, go to prison if he has to, then sell his story to the highest bidder."

Smith cleared other members of the Bunton family: Kempton's other sons, Tommy and Harry, knew nothing about the theft except what they read in the newspapers, and Bunton's wife "thinks it's all a publicity stunt by the old man to get his plays published."

In his memoirs, Kempton portrays Pamela Smith unflatteringly. Whether he knew it or not, he was returning fire. Pamela Smith told the detectives, "Kempton himself is not interested in old age pensioners, he is just looking after himself."

Her signed statement was the only time Pamela Smith (who died in 1974) would ever go on the record about her relationship with the Buntons and the kidnapping of *The Duke of Wellington*. Smith gave no explanation for coming forward then rather than before the trial began. Though her motives must forever remain a mystery, with the benefit of hindsight we can make several safe statements related to Smith's involvement in the case.

First, when Kempton Bunton had told police that he came forward because he worried about someone identifying him as the culprit and claiming

the reward money, he was telling the truth, and he had in mind Pamela Smith (not, as he would testify, some drinking buddy). She was clearly telling the truth when she said that Kempton Bunton told her he had the painting. He told the authorities in no uncertain terms, and reiterated in his memoirs, that he returned the Goya because he had blurted out his involvement and did not want the recipient of his confession to get the reward. Kenneth Bunton and John Bunton would later confirm that Pamela Smith was the person Kempton wished to keep from receiving the reward.

Beyond that, it is difficult to determine how much of her story is true. (Falsity could have emerged either from Kenneth Bunton dissembling to Smith or from she to the police.) Some of what she said was manifestly untrue, such as the claim that Kempton did not care about old age pensioners. That alone could justify suspicion that she was indulging a grudge rather than simply sharing relevant information. Smith could have been motivated to come forward by the reward money (as Kempton obviously feared), since she was naming a new suspect, but she never mentioned the prospect of a reward to the police.

Whatever impelled Smith to share information would lead her only so far. Toward the end of her statement she said: "I have told the truth in this statement but I do not wish to go to Court and give evidence." The reason for her resistance was straightforward: "I am afraid of Kenneth—he is violent and has struck me before. Since he told me about the Goya he has kept a close eye on me. He will come to Stoke and assault me I am sure." She also claimed to fear for the safety of her husband and children, claiming that Kenneth threatened to harm them if she ever divulged the secret. (As it happens, Smith and Kenneth Bunton later reconciled and lived together until he died of a heart attack in 1973 at the age of forty-two.)

Later that day, the police shared Smith's statement with the prosecution, and the following morning, Friday, November 12, Cussen brought her statement to the attention of lead defense counsel Hutchinson. Hugh Courts, who assisted Hutchinson, recalls discovering that morning that the trial had taken a curious turn. The prosecution had finished its case, and Courts expected the defense to begin calling its witnesses.

But when I arrived in the morning at the usual hour, between half an hour and three quarters of an hour before commencement of the day's trial, to my astonishment I found an empty chamber. Upon my enquiries I was told that all the barristers in the case were in the judge's room, and no-one else was to enter, so that they could discuss that which—at that time I knew not. All I knew then . . . was that one of Kempton's sons may have done that which, given Kempton's girth and age, would have been very difficult indeed. Consequently there was obviously an extraordinarily difficult legal question to answer.

In his memoirs, Kempton Bunton gives a similar account of what transpired when the bombshell was dropped in the middle of the trial, though he leaves his sons out of it:

This morning there seemed to be an unusual delay, and I could hear the distant voices of the lawyers conversing. Some 15 minutes later I was ushered into the dock and the Judge addressed the jury to the effect that some fresh evidence had been submitted which the prosecution would be talking over with the defense.

Indeed, the judge adjourned the trial until Monday, sending the jury home for the weekend and informing them that the two sides were engaged in "private consultation." Plea bargaining can take place during a trial, and occasionally agreements are reached mid-trial. The more savvy jurors probably guessed that such talks had progressed to the point that the trial might be derailed. The continuation of the trial was indeed up in the air, though the commotion and interruption had nothing to do with efforts to settle the case.

After the adjournment, when his attorneys explained the situation to Kempton Bunton, he informed them that he indeed knew Smith and "knew her to be a dangerous lunatic." He insisted that she was simply looking for the £5,000 reward. He neglected to tell them that the threat of her coming forward

was precisely what led him to come forward—in other words, that she was the one he feared would turn him in. (It was just as well, as Bunton would shortly perjure himself with respect to this matter and would have made his lawyers accomplices to his perjury if he told them the truth.)

The parties and the judge faced what Hugh Courts called an "extraordinarily difficult legal question"—how to handle this new information.

Pamela Smith declared herself unwilling to talk, and in any event, her most relevant information (Kenneth Bunton's claim that his brother, not his father, had stolen the painting) was probably inadmissible hearsay.* Still, the prosecution was wise to apprise the defense of her statement. Had it not done so, if the defense ever learned about her statement it could have asked for a mistrial—or, if an unfavorable verdict had already been reached, a vacating of the conviction. Starting in 1946, seventeen years before the United States followed suit, Great Britain's Court of Appeals imposed a duty on prosecutors to disclose to the defense the names of anyone who might provide exonerating information.†

But, as it happens, the defense did not wish to utilize this potentially exonerating information. Smith's statement cleared Bunton only by suggesting that his son was the actual culprit. The last thing Kempton Bunton would have authorized his attorneys to do was to make John the fall guy. Besides, the defense team felt that the evidence had gone favorably to this point (and they hadn't begun putting on their own witnesses) and expected an acquittal. They

* *Hearsay is a statement made to the witness by someone else. The problem comes from the inability of the adversely affected side to cross-examine the person who allegedly made the statement. Had Pamela Smith been allowed to testify that Kenneth Bunton had told her that his brother had committed the crime, the prosecution would have been unable to probe Kenneth Bunton's story. If either party had wished to present Kenneth Bunton's story, they would have had to call him as a witness. But, as it happens, he was merely reporting what his brother had told him—which was itself hearsay. In other words, Pamela Smith's prospective testimony would have been double hearsay ("Someone told me what someone told him") and clearly inadmissible. Although Great Britain has substantially loosened its restrictions on hearsay, back in 1965 it had strict rules limiting such testimony.*

† *England's Court of Appeals went further in 1965, in a case decided shortly before the Bunton trial. The court held that if the prosecution "knows of a credible witness who can speak to material facts which tend to show the prisoner to be innocent, [it] must either call that witness himself or make his statement available to the defense."*

didn't need or even want evidence that someone other than the defendant had taken the painting. They would stick to the original plan and argue that he had taken the painting but was nevertheless not guilty.

The government, for its part, could conceivably have asked for a mistrial based on crucial and late-arriving information and could have initiated a complete investigation into the possibility that it was prosecuting the wrong Bunton. But, as Hugh Courts observes, that was unlikely: "The only possible road to follow is to have closed the trial; to have dismissed the jury; then to convene a new trial; collect a new jury; require the police to dismiss from their minds all the trails that they had followed and to pursue an entirely new case against another person, who might *not* have been the thief." He doubts that the prosecution seriously considered this option.

Human nature, and experience with the justice system, supports Courts's conjecture. As a parallel in the United States, consider that DNA testing has led to the exoneration of several hundred people convicted of crimes. Typically, the wrongly convicted remain incarcerated unless and until the prosecution agrees to their release (or until a judge orders it over the prosecutor's objections). In a staggering number of cases, prosecutors have refused to relent—insisting that the DNA evidence is inexplicably unreliable or that the person may have been an accomplice even if not the primary culprit. They cannot admit to themselves or the public that they got the wrong guy. Moreover, in this case, even in Pamela Smith's account, Bunton *was* guilty—not of having taken the painting himself but as an accomplice after the fact.

Given all the circumstances, it is understandable that neither side wanted Pamela Smith to derail the trial. While she brought forward potentially important new information, she (a) did not wish to testify; (b) was offering double hearsay; (c) gave an account that was manifestly false in some respects; and (d) came forward with the trial well under way. And, even if she was right, the person on trial was guilty of some offense.

After the weekend break, the hullabaloo passed and the trial proceeded as if Pamela Smith did not exist. Her information amounted to a rather large dog that had failed to bark—or better, a dog that *had* barked but was ignored. Even so, Smith's intervention may have been relevant to the outcome of Bunton's trial by virtue of her influence on the judge.

Chapter 15: **KEMPTON BUNTON TAKES THE STAND**

T he principal dispute at trial concerned Kempton Bunton's motives. The defense argued that Bunton, motivated solely by his devotion to a charitable cause, always intended to return the painting—and therefore that his action did not amount to a crime under British law. The prosecution insisted that Bunton's adopted cause concealed a power complex, that he enjoyed toying with police and would have done so indefinitely but for running out of steam and will.

The defense argument rested entirely on the testimony of the defendant himself. Criminal defense attorneys say that the most difficult decision they face is whether to recommend that their client take the witness stand (the decision ultimately rests with the defendant) or to take advantage of his privilege against self-incrimination. On the one hand, even innocent defendants will likely suffer from anxiety and can be made to look bad by a trained prosecutor. Moreover, if he can convince the judge to allow it, the prosecutor will bring out unsavory aspects of the defendant's background about which the jury would otherwise not be aware. On the other hand, juries want to hear from the defendant. And while the Anglo-American rule prohibits a jury from drawing an "adverse inference" from a defendant's choice not to testify, it is doubtful that jurors will honor the admonition to ignore the fact that the defendant is unwilling to give his side of the story and subject himself to questioning. A judge's instruction cannot easily overcome the powerful intuition that the innocent have nothing to hide. Consciously or unconsciously, jurors look askance at the defendant who declines to testify.

While in many cases these competing considerations create a conundrum for the defense, there was never any doubt that Kempton Bunton would take the witness stand. For one thing, without his testimony the government case regarding theft was close to airtight: The notion that Bunton intended

to return the painting no matter what was counterintuitive and appeared to be contradicted by his ransom notes. But Bunton's desire to take the witness stand transcended tactical considerations. After spending four years desperately trying to advance a cause, how could he resist a national audience? Closely related, a major consideration that normally cuts against a defendant testifying had no force in this case. If Bunton took the stand, the prosecution would be able to cross-examine him about his criminal record. But the defense *wanted* the jury to know about his refusal to pay the BBC licensing fee. That established his motive for the theft and thus indirectly supported the notion that he intended to return the painting. He was a man on a mission, not your ordinary thief out for criminal gain.

Almost immediately after Bunton lumbered to the witness stand, any doubt about the defense strategy dissolved. Defense attorney Hutchinson began with what has always been standard practice, asking the defendant to state his name and address. Under normal circumstances, he would have followed that formality with several more background questions, slowly leading up to the events related to the charged offense. But Hutchinson wanted to make a quick impression on jurors while their attention was fresh. His third and fourth questions went to the heart of the matter:

"Mr. Bunton, did you ever intend to steal this picture in the sense of permanently depriving the Gallery of it?"

"No, sir."

"Did you ever intend and make any menaces, demand any money by menaces from anybody?"

"No, sir."

Six months earlier, when he had read the *London Times* legal expert's opinion that whoever had stolen the painting had not committed theft (because he intended to return it), Bunton immediately grasped that this would in fact be his defense. Now his lawyers wanted this idea lodged in jurors' minds before they got in the weeds of the case. Having planted it, Hutchinson resumed the usual tack of establishing background, asking a dozen questions about Bunton's personal life, everything from his age to his place of birth to his father's occupation. He sought to establish sympathy for his client in a clever way that would hook up with Bunton's lifelong crusade. He elicited that Bunton's father had come back

from World War I "a complete invalid" and was thereafter "a one hundred per cent pensioner," whom teenage Kempton "pushed around in his chair."

Such background questions tend to put a witness at ease, but here that effort failed. The stress of at long last testifying, or perhaps recalling his father's condition, may have unnerved Bunton. Whatever the cause, he became confused when Hutchinson asked him about the car accident that had ended his career as a driver.

"Did you have an accident at some time?"

"I had an accident in 1942, sir."

"In 1942?"

"Forty-two."

"Was there some reason why you have not been able to follow your occupation of driving in the sixties?"

"Yes, a taxi accident in 1942 when a bus practically overturned us."

"Do you mean 1942?"

"Forty-two, yes."

"That was 20 years ago."

"No, 1962."

In his memoirs, Bunton claims that the accident occurred on Christmas Eve 1961. Six days off is inconsequential. But in his memoirs he also claims that his car *almost* collided with a truck (not a bus). His trial testimony that he was unable to drive after an accident seemed to suggest that he had suffered an injury. In reality, he was physically unscathed but the near miss had left him feeling too skittish to get behind a wheel.

Details aside, it was unclear why Hutchinson asked about the incident/ accident. While it theoretically could have been used to cast doubt about Bunton's ability to pull off the theft of *The Duke*, the defense did not deny that he had done so. The discussion about the incident established only that Bunton was an unreliable witness (confusing even his own attorney when he got the date wrong by two decades), which presumably would not help when it came to more consequential matters. But perhaps Bunton's lawyers were doing what lawyers often do, trying to play on the jury's sympathies. Even an irrelevant accident, at least one that caused the defendant to give up his occupation, could help in that regard.

So might the fact that in general Bunton came across more as an amiable bumbler than a hard-core criminal. At various points, his responses to Hutchinson's questions were inadvertently humorous. When Hutchinson asked about the identity of the "Committee of 5" proposed in some of his ransom notes, Bunton replied: "They would be selected. Not by me, but by some responsible person." He also delightfully mixed metaphors, at one point explaining that "I often threw red herrings about and I tried to put the police on to some gang instead of a lone wolf."

The 1942 or '61 or '62 accident out of the way, Hutchinson turned to the all-important issue of motivation, questioning Bunton at some length about his cause célèbre—television licenses for the elderly. He asked no fewer than twenty-one questions about Bunton's objections to the BBC licensing fee and the criminal penalties he suffered as a result of his civil disobedience. He then seemed to transition, asking, "Did you read about the paying of £140,000 for a picture?" When Bunton answered in the affirmative, Hutchinson connected the dots.

"What was it that you felt about it?"

"That the government could afford such money, yet they couldn't afford to let the old age pensioners have television."

Hutchinson then elicited from Bunton the latter's now familiar calculation that the £140,000, properly invested, would subsidize forty television licenses weekly forevermore. That established, he asked Bunton to describe briefly ("not going into detail") his plan to steal the painting and his execution of that plan, including taking *The Duke* 450 miles north to Newcastle. After Bunton complied, Hutchinson raised a potentially crucial issue.

"What happened to the frame?"

"The frame was too large to take north, and I left it in a lumber cupboard in the second lodgings [in London]."

"Did the frame appear to you to have any great value?"

"It certainly did not, sir."

Hutchinson asked whether Bunton, after deciding to return the painting, made an effort to locate his old lodgings in order to recover and return the frame as well.

"I certainly looked for it, but all the streets seemed to be a maze to me."

Bunton also explained that, during preliminary proceedings in Magistrates' Court, he had publicly (but unsuccessfully) appealed to his old landlady to return the frame. Hutchinson followed up with what the defense hoped would be the decisive series of questions.

"Now Mr. Bunton, when you took this picture away from the National Gallery, what did you intend to do, what was your intention?"

"I intended to try and get a collection up to the sum of £140,000 for the reason that has been already stated, and if it failed, I would just return the picture."

"Did you want to get the picture for yourself?"

"I didn't want it."

"Did you want to harm the picture?"

"Certainly not."

"Did that apply equally to the frame as well?"

"Well, I never gave the frame much thought."

"When you took the picture and the frame at that time, did you have any intention when you took it of depriving the National Gallery of either the frame or the picture?"

"Just temporarily."

Hutchinson turned to the other crucial issue: the ransom notes. Bunton acknowledged writing Com 1 a week after the theft and sending it to Reuters to attract, in his words, "maximum publicity." In that context, Hutchinson returned to the all-important issue of motivation. Apropos of the ransom demand of £140,000 in Com 1, he asked, "Did you want any of this money for yourself?"

"I could never have got any," Bunton replied.

"Did you ever ask for any for yourself?"

"No."

The defense faced a potential problem here. Of course Bunton did not say in the ransom notes that he wanted the money for himself. What ransomer ever bothers to say such a thing? Absent some reason to think otherwise, it is assumed that ransoms serve personal gain. Significantly, Bunton's ransom notes did not mention any *other* reason (or intended beneficiary), at least not directly, for wanting the money. Hutchinson sought to defuse that problem.

"Why did you never say in these letters the actual purpose for which you wanted the money?"

"I daren't say at that period that I wanted the money for television licenses because that would have been like signing my signature to the taking of the picture."

"Had there been a certain amount of publicity when you took your stand about not paying the license?"

"There had been a lot of publicity."

Establishing Bunton's charitable intentions would not suffice for the defense. It had to show that Bunton intended to return the painting *even if his ransom attempt failed.* Otherwise, jurors could conclude that, when he took the painting, Bunton at least entertained the possibility of permanently depriving the gallery of it. He did in fact return the painting but only because the *Daily Mirror* led him to believe that he would gain some money for his cause. The notes—starting with the very word *ransom*—seemed to imply that only the payment of £140,000 would bring back the painting. Hutchinson struggled to overcome that potentially fatal perception.

"What did you mean by 'It is for ransom, £140,000'?"

"Well, I could have put for collection, £140,000, just as well."

"It has been suggested or put forward that you were implying that you would do injury of some kind to the picture if a fund was not started, or money was not forthcoming. Did you ever mean to imply that?"

"I never implied it, I never wrote it, and I never meant it."

Adamant though he was, Bunton's position required an unusual interpretation of his original intention and his ransom notes. He seemed to be suggesting that he had undertaken this daring theft in the hope that the government would fork over £140,000 if asked and that he would return the painting if the government refused. Quite apart from the inherent improbability of such a plan, he did *not* return the painting for four years, long after it became apparent that the government was ignoring his "request." Moreover, some of the language in his letters comes close to threatening not to return *The Duke* unless his demands are met. For example, in Com 3 Bunton said of *The Duke*, "his future uncertain." In Com 5 he noted that the art world had done nothing to meet his demands and asked, "Will they rescue the Duke?" *Rescue* seems an odd word if Bunton intended to return *The Duke* no matter what.

Yet whatever the difficulty of their position, Hutchinson and Bunton doubled down.

"It has also been suggested that you meant to say that you will never get your picture back unless you do what I tell you or what I ask you to do."

"That was never stated in any of my letters."

"Did you ever intend that to be your thought?"

"Absolutely not."

Hutchinson turned to Com 3, the letter dated July 3, 1962, and addressed to the *Exchange Telegraph* in London. Bunton acknowledged authorship of it and explained that he called it Com 3 because Com 2, a letter to Reuters in February, had been "suppressed." Hutchinson asked Bunton what he meant by the phrase "his future uncertain."

"Well, just that he may be returned any time, but he may have to wait awhile."

Hutchinson turned to the all-important letters of May 20, 1963, to Robbins and Rothermere, both of which Bunton denied writing and the former being the basis of a criminal charge. Handing Bunton those letters (the original of the one to Robbins, a copy of the one to Rothermere, the original having disappeared when it was sent for fingerprinting), he asked, "Did you have anything to do with writing these two letters?"

"Absolutely nothing."

"Those were the letters you had written, the Com Letters?"

"Just the Com Letters."

Noting the fourteen-month period that elapsed between Com 4 and Com 5, Hutchinson asked, "What happened during this interim period? What did you feel about having the picture and the publicity and so on?"

"I felt that I wasn't going to get a collection, and I began to study how to return the picture."

"Did you want to bring the matter to an end?"

"Yes, I was thoroughly sick of the whole affair."

"Were you worried about it by this time?"

"I was worried, and disgusted at the way things had turned out."

"You say [in Com 5] that you know now that you were in the wrong 'but I have gone too far to retreat.' Was that true when you wrote that?"

"Well, I know I was in the wrong, and this was my last letter. If this didn't get a collection, that was the end."

Hutchinson then turned to the event that in fact precipitated the end, the *Daily Mirror* entering the fray. He noted the newspaper's "sporting offer" to encourage an exhibition if the painting were returned and asked Bunton whether he believed that such an exhibition would result if he returned the painting.

"I certainly did."

In response to the offer, why did Bunton lower his demand to £30,000?

"Well, my price is coming down now, and £30,000 would mean seven licenses each and every week for evermore."

Next came a crucial question and cheeky answer.

"What is suggested is—this is one of the charges against you—that you uttered that letter demanding money from the editor with menaces. . . . Were you trying to frighten the editor of the *Daily Mirror* into—"

Bunton was so outraged by the suggestion that he cut off his own attorney. "Well, I think it is the most ridiculous suggestion that ever has been made."

"I take it your answer is no, is it?"

"Absolutely."

Hutchinson elicited that Bunton had wrapped the painting carefully before returning it and asked: "Did you ever from the time the picture was in your care, did you ever want to do it any damage at all?"

"Well, I wouldn't dream of doing such a thing."

That claim seems borne out by Bunton's behavior. An underrated aspect of the whole affair was that *The Duke* had barely suffered a scratch. One of Bunton's attorneys, Eric Crowther, later observed, "How Mr. Bunton managed to keep the picture undamaged during its travels around the country was little short of a miracle."

Hutchinson turned to Bunton's May 25 and May 26 letters, both sent to the *Exchange Telegraph* but with a different target audience: The former railed against the *Daily Mirror;* the latter pleaded with Lord Robbins. Why did Bunton send these letters to the *Exchange Telegraph* rather than the *Mirror* and Robbins, respectively? Bunton explained that the *Mirror* would have suppressed his letter and that he lacked Lord Robbins's address.

The *Exchange Telegraph* had passed along the letters, and the *Mirror* had responded (in print) by justifying its failure to exhibit the Goya to raise money. At that point, Bunton testified, he regarded "the matter as now closed."

Why, then, did he turn himself in seven weeks later? Here he repeated the story he told consistently, starting that day, July 19, when he arrived at New Scotland Yard identifying himself as the thief. He had come forward "for the simple reason that by that time other people knew that I was the person. . . . I thought eventually with the reward still on my head, that somebody would squeal, and to stop that I decided to come south and give myself up."

Hutchinson next sought to turn the government's witnesses into his own.

"You heard the police officers giving evidence?"

"Yes."

"Broadly, do you agree with their account of the things that you said [after he gave himself up]?"

"Yes."

"Did you, as they have agreed, try to help them in every way that you could to convince them that you really were the person?"

"Yes."

"You told them all about how it was packed and so on and so forth?"

"Yes."

Hutchinson read aloud the written statement Bunton had given police, pausing to emphasize Bunton's declaration that he had acted "without criminal intent." Then Hutchinson asked him to reflect on the statement.

"Did you have any criminal intent at the time?"

"None whatsoever."

He asked Bunton to explain what he meant, in the written statement, when he said that "the average man goes for wife and family—I am somehow different and trouble ensues." Bunton welcomed the opportunity to elaborate about his altruism, saying, "The average man is in the rat race, and looks after himself. I seem to get into trouble looking after other folk."

Hutchinson read aloud Bunton's written statement that "my effort has been honest to goodness skullduggery."

"I do not know what your definition of skullduggery is, and what you meant," Hutchinson said.

"Well, neither do I," Bunton replied.

Such moments were greeted with raucous laughter in the courtroom. Bunton's son John, who was present at the trial, recalls, "The whole case was like a Steptoe and Son comedy, unbelievable really, judge and jury laughing their heads off."

Hutchinson next asked several questions about Bunton's comments to police (both in his written statement and orally) that, on account of the opinion rendered by a legal expert in the *London Times,* he believed he lacked criminal intent and would be acquitted if he came forward and was brought to trial. This could have no relevance to Bunton's state of mind when he had stolen the painting four years earlier or returned it a few months prior, but Hutchinson sought every vehicle possible to emphasize that legal opinion—which, after all, formed the basis of the defense theory of the case.

Then he returned to the crucial May 20, 1963, letter to Lord Robbins. Once again, as he had all along, Bunton claimed that he had "nothing whatsoever" to do with that letter. Hutchinson noted that this letter stated £5,000 as the price for the painting's return and asked, "Did you ever throughout this period ask anybody for £5,000?"

"Never at all."

"Is that a figure that came into your head at all ever?"

"No."

"It appears to be a registered letter. Did you ever register any of the Com letters at all?"

"No."

"Have you ever throughout this business wanted to ask for money for your own sake at all?"

"Never at all."

Hutchinson turned to the letter to Lord Rothermere written the same day as the one to Robbins.

"The copy of a letter, Exhibit 3, did you have anything to do with writing that, the foolscap one?"

"No."

"There has been evidence about finger marks which the police say were on the original of that letter. Have you ever handled that letter to your knowledge?"

"Not at all."

Hutchinson next elicited that Bunton had turned over to his solicitors his typewriter of twenty years, for examination. He showed Bunton the typewriter, which Bunton identified, and then placed it into evidence as a trial exhibit.

With that, Hutchinson announced his questioning complete and turned the witness over to prosecutor Cussen.

Chapter 16: **THE MAIN EVENT**

The well-regarded Edward Cussen was a queen's counsel, meaning in the top echelons of barristers, and his more than three decades as a prosecutor included participation at the Nuremberg Trials. It can safely be said that Cussen's performance at Bunton's trial, especially his cross-examination of the defendant, failed to advance his formidable reputation.

He started, sensibly enough, by asking whether Bunton's testimony amounted to "the whole of the story." When Bunton assented, Cussen asked whether Bunton had an accomplice at any point, from the conception of the theft to the time when he had turned himself in.

"No one at all."

A series of questions established that no one knew Bunton had the painting through the end of 1964.

"What about 1965?"

"Well, someone knew then."

"Who?"

"I am not prepared to say."

"Why not?"

"I am not involving anyone else in this affair."

"Do you wish the Court to know the whole of the truth in this matter in every particular?"

"Yes."

"Then if that is your wish, will you be good enough to inform the Court on the matter about which I am asking you, Mr. Bunton?"

"I am not prepared to say, sir."

A regular witness might be held in contempt by a judge for refusing to answer questions, but the situation is different with respect to a criminal defendant. Since the defendant is allowed to maintain silence altogether, he typically won't be punished for maintaining silence selectively. But it doesn't

follow that he can do so with complete impunity. In 1965, at the time of Bunton's trial, jurors were routinely instructed that they should not draw an adverse inference from the defendant exercising his right not to testify. (This remains the case in the United States but was changed in the UK in 1994.) However, that protection was removed when a defendant took the witness stand—the jury could draw adverse inferences from him taking the stand but refusing to answer certain questions.

That posed a problem for many defendants, but not for Bunton. Here, as with much in his trial, the usual rules went out the window. The jury could infer whatever it wanted from Bunton's refusal to discuss his accomplice; any such assumptions would hardly harm him, since he admitted his own involvement in taking the painting. Moreover, the identity of anyone who had learned about Bunton's theft in 1965 seemed beside the point. The pertinent question concerned Bunton's state of mind on August 21, 1961, when he allegedly sneaked inside the National Gallery and emerged with *The Duke of Wellington.* Did he intend to return it or not? The issue of who had learned about Bunton's possession of the painting four years later was far afield. Hutchinson could have objected to this line of questioning as irrelevant, but he had no reason to interrupt Cussen as the prosecutor went down a fruitless path. For whatever reason, Cussen relentlessly pursued the question of who knew Bunton's secret years after the fact.

"Mr. Bunton, I am going to give you every opportunity to deal with this matter in your own way, you understand?"

"Yes."

But Bunton's way of dealing with the issue was to stonewall, leading Cussen to grow increasingly frustrated.

"As far as you are concerned, you are not going to answer the question I put to you?"

"Well, that would get someone into the wrong, wouldn't it?"

Here the prosecutor missed an opportunity. By seeming to acknowledge that he was protecting someone from a criminal charge, Bunton was implicitly admitting to a crime himself. You cannot be a criminal accomplice to a noncrime. But instead of identifying that flaw in Bunton's position, Cussen actually became apologetic.

"Please do not think I am being persnickety or critical or anything."

"No."

"If you want to develop that matter I will give you the opportunity by putting the question to you."

"No."

Finally giving up on the *who*, Cussen asked *when* Bunton let someone in on his possession of the painting. Bunton replied that it was "when the £30,000 success was at hand. After I had the *Mirror* guarantee."

Actually, he was never given such a guarantee, proving only the durability of Bunton's delusions and resentments.

Cussen followed up with several questions trying to pin Bunton down on the date when he shared his secret. (It is unclear why he pursued this matter at all, much less so relentlessly.) They meandered for some time until Bunton, not responding to any particular question, again vented about how he had been double-crossed.

"I was led into a trap by the *Daily Mirror*. They not only got the picture, but they trapped me also at the same period." He paused and with undisguised bitterness added, "And now they are fully entitled to the full £5,000 reward."

The frustrated barrister replied, "I am going to keep you to this conversation with the person whose name you say you will not tell me."

"Yes."

"You have dealt with—and I am obliged to you—you have dealt as much as you can with the date when it happened. Where did it happen, what place?"

"Well, a pub."

"A public house in Newcastle?"

"Yes."

The oddly persistent barrister elicited that the conversation had taken place in the evening. He then asked Bunton to report the substance of it, "not word for word. Do it in any way you would like."

"Well, I told him I was responsible for the whole affair. He had heard of it, but he had never connected it with me, and I told him what it meant if £30,000 could be guaranteed. That would be eight, approximately eight free licenses each and every week. I told him that was like signing my signature, but that I thought I would get away with it."

Bunton did not explain, nor was he asked to, the apparent contradiction in his last sentence. Instead, the barrister finally moved on to new ground—at least temporarily.

"Up to this time had you revealed at all in any of your communications that it was going to be used, when the money was raised, in connection with TV licenses?"

"No."

But Cussen failed to pursue this potentially promising path. Instead he returned to the question of the accomplice, about which no detail was too small.

"Were you sitting down with him at a table or were you and your friend at the bar, or what?"

"Sitting down."

He further elicited that the conversation was with someone Bunton had drinks with "twice, thrice a week." The questioning became increasingly irrelevant, something the barrister even acknowledged.

"Which of you got there first?"

"Well, this is a question—"

"If you can remember. It does not matter if you cannot."

"No."

But the barrister *still* would not let go of the subject. He wanted to know why Bunton had divulged his secret ("I thought I was on the verge of success, and possibly a few drinks loosened my tongue") and how his friend had reacted to the news ("He was amazed"). For some reason, Cussen felt the need to probe Bunton's friend's amazement.

"Did he show every sign of being amazed? . . . For example, did he say, 'Don't try and have me on like this' or anything of that sort?"

When that inquiry yielded nothing fruitful, Cussen at last appeared to drop the subject, but after a few innocuous questions about other matters, he returned to it.

"Did your friend ask questions about it?"

"No, I told him to keep quiet about it."

"What did he address you as, how do you call each other?"

If this was a trick question asked in the hope that Bunton would blurt out his friend's name, the ploy failed.

"Well, Christian names," Bunton replied.

"What name does he use for you?"

"Kemp."

"After he had been amazed and incredulous, did he say 'Kemp, tell me how you got away with it, how did you do it?'"

"I gave him a rough idea how I did it."

"Did you tell him what you have been telling this Court as to why you had had this idea and all about the letters and so on? You told him the whole thing?"

"Roughly speaking, yes."

"How did it end, this conversation?"

"Well, it just ended. The next day I rued telling him, but nevertheless, if the £30,000 had been forthcoming it wouldn't have made any difference by telling him."

"Was this friend a close friend?"

"Yes."

"How many years have you known each other?"

"Oh, fifteen to twenty?"

Perhaps Cussen was laying groundwork that would help the police determine the identity of the mystery man. After all, how many people could have drunk with Bunton twice a week for fifteen years? A little sleuthing would surely unearth his accomplice. Of course, the police could have asked Bunton these questions months before. The courtroom is not usually the place to identify for future prosecution someone not on trial. Trials do sometimes serve this purpose as a collateral benefit, but Cussen seemed to be seeking this result at the expense of focusing on the issue at hand. And it's not as if he were honing in on some dangerous felon: His probe, if successful, would merely identify someone who learned about Bunton's theft four years after the fact.

Any effort by Cussen to use the courtroom for investigative purposes ran headlong into another problem: Bunton's answers were not truthful. As we shall see, a great deal of Bunton's testimony, under both direct examination and cross-examination, was false. But his story about the drinking buddy who learned his secret was particularly revealing about his willingness to engage in elaborate perjury with what seemed like minimal angst or effort.

Perhaps in part because he sensed as much, and was offended by the witness's brazenness, Cussen persisted in probing the accomplice after-the-fact angle.

"You trusted him and he you?"

"Yes."

"So he was the first person to know that it was you, and he was the first person to know how you had done it? Is that right?"

"Yes."

"And the first person to know why you had done it, is that right?"

"Yes."

"How did you part from this, having made this revelation to him? Did you say anything about keeping it quiet?"

"I certainly did."

"What did you say to him?"

"I said, 'Now, not a word until it breaks.'"

There was an apparent absurdity to Bunton's story. Though his account with respect to many particulars (such as what he did with the painting's frame) changed over many tellings, he consistently maintained that he had come forward because he had divulged the secret and did not want the recipient of his secret to claim the reward. But now, on the witness stand, he insisted that the person he had told was a trusted old friend sworn to secrecy. Moreover, his confidant had kept the secret for months before Bunton had turned himself in.

Under Cussen's prodding, Bunton did his best to explain away the absurdity.

"He would be all right, but who would he talk to? That was the danger. He wouldn't talk to the police, but he might talk to another friend, and therein lay the danger."

"Did you have any knowledge whether he had in fact told others about it?"

"No, just strong suspicions."

"Why?"

"Well, just the human failing. Very few people can keep a secret."

After some more give and take along those lines, the prosecutor sensed the witness's vulnerability.

"When you were giving your evidence a little time ago, you told the Court that your reason for surrendering yourself was because you thought somebody would squeal?"

"Yes."

"Did you think your friend was going to squeal?"

"No, I did not."

"Did you know whether he told anybody else?"

"I did not."

"Did you really fear at all at that time that somebody might give you away?"

"Very much so."

"Did you tell your friend that you were going to go down to London and go to Scotland Yard and reveal it?"

"No."

"Now, you have told the Court how that came about, have you not?"

"Yes."

At this point Judge Aarvold interjected, "Are you moving on to another matter, Mr. Cussen?"

Undaunted, Cussen responded, "My Lord, if I could put perhaps two or three further questions, it may well be I shall be moving then to another matter." Aarvold granted permission. And now, having asked some thirty-five questions that seemed irrelevant to the matter of Bunton's innocence or guilt, Cussen posed *the* question that perhaps revealed his underlying strategy.

"Mr. Bunton, do you agree that your telling your friend in the way you described . . . is an important feature in the account you have given the Court?"

Bunton would have been justified in saying no, but he rose to the bait and agreed that this long diversion was in fact "important."

Judges sometimes instruct jurors that if they find a witness demonstrably dishonest with respect to any issue, they are justified in doubting his entire testimony. Whether or not he could procure such an instruction, Cussen seemed to be tapping into that sensibility. He was surely right to think that Bunton's account of why he came forward was dubious. But the jury might well infer that he had come forward for some other reason, or that he was protecting someone by dissembling, without necessarily concluding that everything else in his testimony was false. Surely, the barrister would have benefited by showing more salient aspects of Bunton's account to be false. That would not have been difficult. (To take just one example, why had Bunton failed to maintain a consistent story of what he had done with the painting's frame?)

Cussen apparently felt that Bunton was protecting a significant accomplice, someone who had done more than learn about the theft four years after the fact, and that the jury would realize as much and therefore reject the more important aspects of Bunton's testimony, such as whether he wrote the disputed May 20, 1963, letters and whether he intended to return the painting all along.

"Apart from your friend being told by you what had happened, which you say is all truthful as you have told the Court, apart from that, did he give you any assistance of any kind?"

"None whatever."

"Either before you told him or after?"

"No."

"He is the first person to have been given the account which in effect you have given to the Court today?"

"That is so."

"Let me ask you again: Will you tell the Court his name and, if you know it, his address?"

"I am not involving anybody in this affair."

Cussen turned to Judge Aarvold: "This would be a convenient moment [for a recess]."

The judge ordered a brief adjournment.

Chapter 17: THE DEFENDANT ON POINTS

When the trial resumed, it took another curious turn. Judge Aarvold announced, "I have a note from the jury that they are anxious to see the Goya portrait again." Though it is hard to fathom why that anxiety manifested now, Cussen assured the judge that he would arrange for *The Duke's* return to the courtroom the following morning. Then he turned toward the witness and resumed his questioning, promising, "just one more question on the matter" of the man Bunton had told about the theft.

"What is the name of the public house where this conversation took place?"

Bunton replied, "The Howlett Holt Hotel," and at last the issue was put to rest.

Cussen turned to Bunton's motive, asking a series of questions rehearsing Bunton's protests and punishments over the BBC fee and the fact that he had stolen the Goya as a combination reprisal (for the government making a substantial expenditure on a painting while short-changing old folks) and solution to a pressing social problem. Bunton took the opportunity to preach the old gospel and claim partial victory. "Television is the greatest time killer for lonely old folk and television is denied to them because of a £4 pound license, and the things that I have done have at least brought some light on that fact."

Cussen pounded away at Bunton's motivation for taking the painting, and Bunton seized the opportunity to reinforce the defense narrative: "If the collection failed, the portrait was no earthly good to me, and it would just have to be returned."

Cussen asked whether Bunton had ever considered that the authorities might ignore his ransom notes.

"Never for one moment."

"Did you make any plan at all as to what you would do if you did not get anything out of them by way of agreement to your orders?"

"No plan whatever."

During this portion of the questioning, Bunton stayed on message, even when it meant ignoring a question and instead reciting a defense talking point. In response to a long question about whether he planned to hold on to the painting indefinitely if his demands were not met, he replied, "Well, I would never have done any harm to the picture," leading the frustrated Cussen to reply, "I was not touching on the question of harm to the picture."

Over and over Cussen tried to elicit that Bunton would have kept the painting if his plan had failed, and over and over Bunton insisted otherwise. "The picture was no good to me and there was never any thought of keeping it for evermore."

Bunton's lawyers thought he was doing fine, although he occasionally forgot that their strategy included contrition. When Cussen suggested that Bunton was "punishing the authorities very effectively for what you thought was their gross error in relation to licenses for old age pensioners," Bunton took the bait: "I still think it was the thing to do."

As such honest but improvident boasts illustrate, the effectiveness of Bunton's testimony tended to vary inversely with his candor.

Cussen turned to an issue that seemed irrelevant for his purposes but would prove important to the judge—Bunton's claim to have had "very bad influenza" during the two weeks prior to the theft. He asked how Bunton had been feeling on the night he took the painting.

"Very bad."

Cussen sought to discredit the defendant by bringing up one of Bunton's oddest utterances—his statement to the police that "I wasn't after this paint-ing, no more than any other." It was a remark that, in handwritten notes in their case file, Bunton's lawyers called "troublesome," but Bunton had already clarified at his deposition that "I made this reply because I did not think it was relevant at that time to say that I was after this particular painting. However, at the time I really was not after any other painting, only this one."

At trial, he offered a different explanation for the odd statement: "What I meant was if that painting had not been handy I would have took another."

"You have not mentioned the possibility that if the Goya was not there you would take any other picture."

"No. I fully expected it would be there," Bunton replied.

Cussen again sensed weakness. The entire defense narrative was that the expenditure of £140,000 on a single painting infuriated Bunton and inspired him to take that very painting to raise that very amount in service of his pet cause.

"Mr. Bunton, if in fact you could not have taken the Goya and you were really down in London to take the Goya to help the old age pensioners as you have explained, there would not be any question of taking something else, would there?"

"Yes."

"Whatever for?"

"Because all the pictures were valuable, and it was money I was after."

Cussen proposed that Bunton's motive was not in fact to raise money for charity but rather "revenge for the way you had been treated about the T.V. license." Bunton denied the suggestion.

Cussen next asked a question whose answer should have raised alarms, notwithstanding the fact that Bunton had given it before: "What time did you go into the National Gallery on the 21st of August?"

"Well, it would be between five and six in the morning."

Technically that would have made it August 22, but the date was hardly the issue. The problem was that his time frame seemed at odds with conclusive evidence that the painting had been taken hours earlier: Two different security personnel reported noticing it missing by midnight. Indeed, in defense counsel's copy of the deposition of warder Sydney Settles Cadman, next to Cadman's comment that he noticed the painting's absence between midnight and 12:30 A.M., one of the defense lawyers scribbled in the margins: "The difference in timing between this and Bunton's statement (5:20 or 5:50 A.M.) may be significant."

Significant indeed, and yet neither side called Cadman as a witness. Instead his deposition was read aloud to the jury, accompanied by the judge's explanation that it was "accepted by the prosecution and by the defense." Because of the weird posture of this case, neither side wished to probe the time of the theft.

Cussen changed the subject, inviting Bunton to offer details about how he had gotten the painting out the lavatory window and safely to the ground. In response, Bunton offered more elaboration on this specific point (albeit in a single sentence) than at any prior time.

"I got a box, I had a box, an empty beer bottle crate box, and I had a bit of a clothes line, and I lowered it, pulled it up and lowered it down."

Cussen did not ask where these materials (never before mentioned) had come from. Instead he expressed understandable surprise that Bunton had managed all this by himself and then walked with the painting to his car, all the while suffering from influenza.

"If I walked slowly there was no fatigue," Bunton replied.

"When you walked from the back of the National Gallery to the wall, over which you had to climb, carrying the portrait with you, are you saying at that time you always intended to return it?"

"Absolutely. It was no good to me otherwise. I wouldn't hang it on my own kitchen if it was my own picture."

This response by Bunton prompted the courtroom to burst into laughter. When it subsided, Cussen asked whether, having gone to all that trouble to attain the painting, Bunton then intended "to bring pressure to bear on the authorities to do what I want."

"No, I was going to *request* the authorities," Bunton said, avoiding the trap.

Cussen asked whether Bunton enjoyed the ensuing publicity over the theft.

"Well, I thought the publicity would make some spirited minded chap get up and say, 'Yes, I will start a collection.' That was the only benefit from the publicity that would do me any good."

Cussen returned to Bunton's whereabouts and activities in the immediate aftermath of the theft; and asked a half dozen questions about Bunton's knowledge of the geography in the Kings Cross area, where he had been staying at the time. Cussen then pivoted from questions of space back to questions of time, finally asking Bunton about the biggest hole in his story: the timing of the theft. He noted testimony by the warder that he personally noticed the painting's absence around midnight.

"You are telling the Court that you had taken it in the early hours of the morning, of the morning after?"

"Yes."

Having at last raised this key issue, Cussen now said, oddly, "For the moment I will leave that matter because I do not want there to be any confusion in your mind about it."

Once again, Cussen occupied a curious position in a weird dance between the two sides. On the one hand, he had powerful evidence that Bunton had misstated the timing of the theft—a falsehood central enough that it would cast doubt upon Bunton's entire account. On the other hand, Cussen did not want to destroy Bunton's entire account. After all, Bunton's confession constituted the case against him. If he got the timing of the theft wrong, might that be because he wasn't the thief? Prosecutors are supposed to prioritize truth over victory, but few wish to torpedo their own case—even if it seems flawed.

Cussen turned to the crucial question of the frame. The prosecution's clever decision to draft a separate charge accusing Bunton of stealing the frame posed a major problem for the defense. The defense argument that Bunton did not intend to permanently deprive the gallery of the painting was a harder sell with respect to the frame. After all, he *had* returned the painting; he had *not* returned the frame.

The defense could make a plausible argument: Notwithstanding what Bunton had and had not returned, or precisely what he did with the frame, why in the world would he wish to keep the frame without the painting? But the prosecution could counter: Maybe he entertained no specific wish to keep the frame but nor did he plan to return it. Perhaps he had destroyed and/or discarded it (as he initially claimed). While that would not necessarily prove that, at the time of the theft, he intended to deprive the gallery of the frame permanently, at a minimum it complicated the claim that he intended to return the frame. And, regardless of speculation about his intentions, if jurors believed that Bunton had discarded or destroyed the frame, they might be less inclined to acquit him based on speculation about his state of mind.

He had testified that he had removed the painting from the frame to make it easier to handle. He had further testified that he had left the frame at a Kings Cross apartment where he had taken up lodging shortly after the theft and that he had recently tried unsuccessfully to locate that apartment for the purpose of retrieving the frame. Cussens probed this claim.

"[You] put [the frame] in the cupboard under the stairs?"

"Yes."

"Do I understand you to tell the Court that you have never been able to find the house where you left the frame?"

"Well, I have been looking around, but all the streets of this city seem to me to be all alike."

"You are quite used, I suppose, to finding your way about streets with which you are not too familiar?"

"Well, you mean the taxi work in Newcastle?"

"Exactly."

"If you know the city 50 or 60 years, you naturally can find your way around, but not London."

"Your profession led you at all events to having to find the way even though it was not your own City?"

"Yes."

"You found your way in the early hours of the morning when you were walking from the National Gallery to your first lodgings?"

"Yes."

Cussen asked whether Bunton had sought help in finding the apartment where he had stored the painting and left the frame.

"We made an appeal for the landlady to come forward if she had a frame in her lumber cupboard," Bunton replied.

"Have you ever been up there on foot looking for it, or have you been in a car looking for it?"

"Yes, I have had several walks around, but the districts are pretty much the same to me. . . . Four and a half years is a long time."

"Did you want to find your second lodgings where you say you left the frame?"

"Well, it would be interesting to see if it was still there."

Cussen did not probe this strange response but did continue probing about the landlady and the frame.

"Did it occur to you to ask the police to help?"

"No, it didn't."

Judge Aarvold interjected, asking Bunton, "Why not?"

"I never thought of it, my Lord."

Aarvold followed up, "Who else would know the district better than the local police?" which elicited a cryptic response.

"I imagine shops are the same kind of shops one year, and the next year they are fruit shops."

The judge persisted. "Maybe. Who would know that better than the local police? That must be obvious to a taxi driver."

"Well, it never crossed my mind, my Lord."

Aarvold gave up, and Cussen resumed questioning. He reminded Bunton that he had initially told the police that he had destroyed the frame and thrown it in the Thames. Bunton declared that he had dissembled at the time but was now telling the truth. Cussen insinuated that Bunton had changed his story about the frame when and because the prosecution had added "stealing the frame" as a separate charge. If Bunton had deposited the frame in the Thames, he had intended to "permanently deprive" the gallery of it. If, instead, he had left it in his apartment and hoped to retrieve and return it at some point, as he now conveniently claimed, he had lacked criminal intent. Bunton stood his ground. He claimed that he had initially concocted the story about the Thames to protect his landlady.

"It is very important indeed, and vital, is it not, to find [the frame] if possible?" Cussen asked, prompting a bizarre response from the unfazed defendant.

"Well, it could turn up any day."

Cussen then came as close as he would to calling Bunton a liar, albeit in his own genteel fashion.

"Is not the real truth, Mr. Bunton, that this cupboard under the stairs is an afterthought on your part because you realized that you might be in a difficulty if it had been destroyed on the embankment by being put in the river?"

"That is quite wrong."

Cussen dropped the frame and turned to the portrait itself, which Bunton claimed to have kept in his Newcastle house from September 1961 through May 1965.

"Did you ever look at it?"

"I never looked at it. Yes, I did, I'm telling a lie there. I took it out to take the label off."

"Did you tell your wife it was there?"

"No, the world would have knew if I told her."

Cussen pressed ahead about the decisive matter of Bunton's intentions. When pushed by his skeptical interrogator, Bunton played his trump card.

"Are you sure you really ever had any intention of returning it at all?" Cussen asked.

"Well, I did return it, didn't I?"

Cussen elicited that no one but Bunton had known the whereabouts of the painting and then suggested the problematic implications.

"What was going to happen if by some misfortune you were run over and killed by a bus?"

"Well, I nearly was. It would have been just unfortunate, that's all. Well, I never gave it a thought really."

"How comes it that you made no arrangements of any kind to cover [the painting's] return in the event of your death?"

"Well, one doesn't think of death over a short period."

Cussen asked several more questions designed to show that Bunton had not planned all along to return the painting. But Bunton insisted that the painting "wouldn't do me any good in the cupboard" and rejected out of hand the prosecutor's suggestion that he derived "mental satisfaction from knowing what nobody else knew."

Cussen turned to the ransom notes. Had Bunton given careful thought to the first note, the quirky August 30, 1961, ransom note (Com 1) penned ten days after the theft?

"I just took a pencil and wrote it at random. . . . It just came naturally."

Cussen took him through the letter line by line, asking for Bunton's interpretations.

"Are you really saying you expected any result at all to come out of that letter?"

"Well, I still think a result should have come, if people were half-humane at all."

"Had you really expected there would be [results]?"

"I was absolutely confident there would be."

Cussen took Bunton through other Com notes more quickly, before turn-

ing to the all-important typed letter to Lord Robbins dated May 20, 1963, which formed the basis of a separate charge of "uttering a threat." Bunton denied having anything to do with that letter, but Cussen reminded him that his fingerprints had been identified on the pendant letter sent that same day to Lord Rothermere. Cussen implied that Bunton had grown "angry and bitter" at the silence that had greeted his previous letters and hence had written directly to Robbins. Bunton insisted that he was only "disgusted," not angry or bitter, and adamantly maintained that he knew "nothing whatever" about those two letters.

Cussen pressed as to why, when Bunton received no response from the authorities throughout 1963 and 1964, he still chose not to return the painting. Bunton replied that he had held out hope. Cussen made one final attempt to break through.

"Was not the real reason why you kept it in the cupboard of your home because it was going to stay there so far as you were concerned at that time forever?"

"Well, I did give it up."

Cussen fired back: "Is not the real truth this: You knew there was no hope, and this idea you have put to the Court that you always intended to return it is not the correct one?"

"Well, I say that you are completely wrong."

The frustrated barrister turned to the judge and asked if it would be a good time to adjourn. Court was adjourned until 10:30 the following morning.

Before cross-examination could resume, other matters had to be taken up. First, Cussen informed the Court that the portrait had been brought back to the courthouse and placed in the jury room. However, the painting was now in a new frame—the original lying in pieces in the Thames or in some apartment in Kings Cross or God-knows-where. Judge Aarvold expressed concern that the new frame would confuse the jury and proposed that the government "call a witness to give some idea of the [original] frame."

The judge next asked when they wished the jury to view the painting, noting that "it is not a portrait we want to keep in the central Criminal Court." For every minute *The Duke* spent in court, visitors to the National Gallery would find an empty space where he belonged.

Cussen replied that now would be a good time for the jury to see the work of art at the heart of the trial. Aarvold called in the jurors and informed them

that they would be taken to see the painting and would find a gentleman in charge of it who "will remain completely and utterly silent. He is not there for you to ask questions of, he is only there as custodian; not that we do not trust you, of course." The jury was ushered into a back room for a close-up look at *The Duke of Wellington.*

With the jury again gone, the judge and counsel for both sides resumed discussion about the frame. They agreed that Philip Hendy, the director of the gallery, who was present in court, would make the ideal witness as to the frame. Court was adjourned so that the attorneys themselves could look at the painting. It is unclear how viewing the portrait could affect either side's approach to anything, especially since the judge had rebuffed defense efforts to question the painting's quality or authenticity, but perhaps the lawyers simply wanted another look at the object whose purchase had set everything in motion. Goya's *Portrait of the Duke,* like the Maltese falcon in Dashiell Hammett's famous detective novel, had become the stuff dreams are made of.

At last everyone returned to the courtroom and Cussen resumed cross-examination of Bunton, picking up as promised in 1965, when a depressed and disgusted Bunton continued to get no response to his ransom notes. Cussen pounced on Bunton's description of the theft (in Com 5) as "an adventurous prank." Pressed on that language, Bunton conceded that "it was serious, but I considered charity much more important."

The prosecutor turned to the March 21, 1965, letter to the *Daily Mirror,* which said that if £30,000 were raised, "you will get the portrait." Cussen placed on this language the obvious construction: Unless the money were raised, the *Mirror* would *not* get the portrait. Bunton rejected that interpretation, insisting that under no circumstances did he intend to keep the portrait.

Cussen turned to the typed letter to Rothermere, which Bunton denied having authored. He went through it line by line, eliciting that various parts expressed views similar to those held by Bunton. The unfazed witness remarked with a straight face, "There must be thousands of people who hold my views."

Reprising an old line of questioning, Cussen demanded to know whether the taking of the painting was "in order to revenge yourself on authority in

general?" Here, somewhat surprisingly, the usually unyielding witness replied, "You could put it like that to some extent."

Cussen took a last stab at getting Bunton to acknowledge authorship of the disputed letters to Robbins and Rothermere and his having in fact tossed the frame in the Thames. Failing at that, he finally turned the witness over to Hutchinson for re-direct-examination.

Defense attorney Eric Crowther later recalled that Cussen's cross-examination of Bunton consisted of "two charming old gentlemen having a sparring match." If so, Bunton won the match on points. Parts of his story made no sense, and he'd been caught in contradictions, but he had more or less successfully stuck to his story with respect to what were emerging as the key points of contention: He always intended to return the painting and had not written the May 20, 1963, letter to Robbins.

Chapter 18: FINAL ROUNDS

Notwithstanding Bunton's success in fending off Cussen, the defense was sufficiently worried about certain vulnerabilities that Hutchinson engaged in a fairly extensive re-direct-examination. He got Bunton to retract the suggestion that he was motivated by revenge; he was, of course, motivated only by charity. He also asked a series of questions to drive home what was obviously becoming the main defense theme.

"You have told the jury on numbers and numbers of occasions that if a collection was started you would have sent the picture back?"

"Yes."

"You have also said that if there was not a collection, well, then you intended to send it back?"

"Yes."

"When you took [the painting] . . . did you ever intend to keep it forever?"

"Not at any moment."

"Or destroy it?"

"No, sir."

"Or sell it?"

"No."

"Or injure it?"

"No."

He turned to what was emerging as a serious problem for the defense: the frame. Hutchinson asked whether, at the time of the theft, Bunton envisioned treating the frame any differently from the painting.

"No. Just the same," Bunton said.

As for the disputed letters to Robbins and Rothermere, Hutchinson elicited that these, unlike the letters indisputably written by Bunton, had been registered as well as typed. He also elicited that Bunton could not have sent letters to Robbins and Rothermere even if he had wanted to: he did not know

their addresses. Cussen had brought out that the disputed letters, like several of the others, were postmarked Darlington. Under Hutchinson's gentle prodding, Bunton dismissed this as "pure coincidence."

Hutchinson asked whether there was any threat or menace implied in the March 21, 1965, letter to the *Daily Mirror*, and Bunton responded, "None whatsoever."

"Did you have any intention to try and frighten, threaten or menace the editor of that newspaper?"

"Well, the suggestion is ridiculous."

At this point, the judge intervened, wishing to ask about a matter "I am interested in and I daresay the jury is interested in—the reasons for the return of this picture." Aarvold asked a series of factual background questions, establishing the precise sequence of the various letters, culminating in the painting's return. He specifically wanted to know why, after two months in which the *Daily Mirror* would not guarantee the £30,000 Bunton wanted, he nevertheless returned the painting on May 20.

"I said I may as well get the best deal I can. They will get something. They will put it on exhibition, and if they don't raise £30,000, they will raise £3,000."

"You do not say that in your letter [accompanying the left luggage office ticket]."

"No, but that was the only deal I could get, so I took it."

"You said 'Some future wise guy may offer to tell you all.' That is all you sent in to the *Daily Mirror*?"

This straightforward question elicited another one of Bunton's head-scratching replies.

"Yes, my Lord, but the idea was to keep my identity because even on the *Daily Mirror* exhibition it could have been any amount, and I wanted if possible to transfer the money for licenses if the sum was large enough. If it wasn't large enough, they could have put the money to any charity."

Having hit a wall, the judge proceeded to advance his own theory as to why Bunton returned the painting.

"Round about the 23rd of March your tongue was loosened a bit with a few drinks, and as you described it, you got a bit careless and you told your friend?"

"Yes."

"The suggestion is—you might as well deal with it—that you, having told your friend, gradually worked up feelings of worry and anxiety, saying to yourself, 'Good gracious, my friend may tell the police, I had better get rid of the picture,' and with that feeling you put it into the Birmingham left luggage office on the 5th of May."

The defendant, never shy in the face of authority, responded as follows: "That is completely wrong, my Lord."

Ignoring the blanket rejection of his theory, Aarvold resumed his account of what had led Bunton to return the painting.

"And having put it in the Birmingham left luggage office on the 5th of May, you did not take any action to send the ticket to the *Daily Mirror* until the 20th of May because your anxiety was getting greater. You were more worried about the whole thing, and you thought, 'there is a £5,000 reward out for people to give me away. My friend may have mentioned it to somebody else and they may try to get the £5,000 reward. The best thing I can do is to remove the incentive and return the picture, and then perhaps they won't give me away.' That is the suggestion made as to the reason why you returned the picture."

Bunton reiterated that "that suggestion is completely wrong," without explaining why.

At this point, Judge Aarvold, having done the prosecutor's job, backed off. He said, "Mr. Hutchinson, I put that as the suggestion which has been made about that matter. If you want to deal with it by further questioning, now is the time."

Hutchinson protested that the judge's theory "is a completely new suggestion to me." The judge had presented him a mess he had no choice but to try to clean up. In fact, Bunton had said that the fear of his friend blabbing and someone coming forward for the reward had caused *him* to come forward in August, two months after the painting had already been returned. He had not given this as his reason for returning the painting. If that was in fact why he had returned the painting, as Aarvold suggested, the notion that he always intended to return it suffered a severe blow.

Hutchinson elicited from Bunton that he had returned the painting because his negotiations with the *Mirror* had given him some hope, not because he had feared someone coming forward for the reward. Sounding weary and

perhaps discouraged by the judge's intervention, Hutchinson declared his questioning complete. Cussen waived re-cross-examination, and Bunton was finally done. The large man descended the witness stand, perhaps sensing that his brief period of celebrity was winding down.

Hutchinson called the second witness for the defense: Julius Grant, a forensic scientist with expertise in typewriters. Grant had examined the typewriter Bunton turned over to his attorneys and concluded that it was not the typewriter on which the disputed letters to Lord Robbins and Lord Rothermere had been produced. He was on and off the stand in just a few minutes, with Cussen declining to cross-examine.

Hutchinson next called Bunton's twenty-three-year-old son John, for the sole purpose of confirming that the typewriter in question was his father's. John Bunton stated that he had lived in his father's Newcastle house from November 1962 through February or March 1964 and that he recognized the typewriter, which was normally kept under a table. It was definitely the typewriter he was now looking at, and there were no other typewriters in the house. Cussen again declined cross-examination. The judge chimed in to ask John Bunton who used the typewriter. "My father, your honor," he replied, before stepping down and resuming his accustomed seat in the courtroom as a spectator. He was on and off the witness stand even quicker than Julius Grant.

Their combined testimony about the typewriter was potentially important. Significantly, all his Com letters, and the subsequent letters to the *Daily Mirror,* were handwritten, bolstering the defense claim that Kempton had nothing to do with the typed May 20 letters.

John Bunton's brief testimony also caused the memory of one trial participant to play tricks. In his memoirs, defense attorney Eric Crowther recalls Kempton Bunton telling him that he did not know how to use a typewriter— a surer way to debunk the notion that he had sent the typed letters. Crowther proposed calling Bunton's wife as a witness about his incompetence at the keyboard, prompting Bunton to snap, "Do you want to ruin everything?" He proposed, instead, that a different family member, his son John, testify about his nonfamiliarity with typewriters. When the defense summoned John for that purpose, Crowther noticed that John was a dead ringer for the widely circulated Identikit of the Mr. Bloxham who had returned the painting to the left

luggage office in Birmingham. Crowther recalled advising Kempton Bunton to get his son out of there, "unless you want him arrested too," and the defense choosing not to call John Bunton to the witness stand.

Crowther had no reason to dissemble, but his memory must have been faulty, because his account is demonstrably false: The trial transcripts verify what John Bunton himself vividly recalls: He *did* testify (and not about his father's inability to type—to the contrary, he identified his father's typewriter and said that his father used it). Apparently no one in the courtroom remarked a resemblance between the witness and the Identikit version of Mr. Bloxham, or at least no one thought to raise the matter.

One more witness remained to complete the presentation of evidence. As promised, Philip Hendy, director of the National Gallery, took the stand to discuss the frame of the purloined painting. Hendy was questioned by Judge Aarvold rather than by the attorneys. Aarvold directed Hendy's attention to the painting, which had been brought before him in the courtroom, and asked him how the original frame compared to the current frame. Hendy replied that the two were "virtually identical." However, under further questioning, Hendy acknowledged, "The frame of the stolen painting had a rather better gold leaf, which was actually original. I don't think that one is."

"I dare say you would not choose a poor frame to put round the Goya?" Aarvold asked.

"The other frame was bought for that purpose. I went out and bought it on the day the picture came to the National Gallery. It cost £100."

Aarvold asked a court attendant to remove the frame so that the jury could handle it, remarking that it was heavy and admonishing, "Try not to drop it, members of the jury."

The witness stepped down, and Judge Aarvold asked Cussen whether he wanted the frame kept as a trial exhibit or returned to the National Gallery. Cussen shrewdly opted for it to be exhibited, where it could remind the jury that Bunton's "adventurous prank" had permanent consequences, however small.

Now only closing arguments and the judge's instructions remained. The closing arguments suggested what had increasingly become the focal point in the eyes of the attorneys: the quirky aspect of the Larceny Act that permitted,

even required, Bunton's acquittal if he had not intended to "permanently deprive" the National Gallery of the painting. The defense would again play its ace card: Bunton *had* returned the painting.

During his questioning of Bunton, prosecutor Cussen seemed flummoxed by that stubborn fact. On several occasions, when Cussen proposed to Bunton that he planned to keep the painting if his ransom demands were not met, Bunton reminded him that he had not kept it, even though his demands were not met. But Cussen, in closing argument, seized on Judge Aarvold's suggestion that Bunton returned the painting to prevent someone from receiving the £5,000 reward, a risk that arose only because Bunton had indiscreetly told someone about the theft. Were it not for that indiscretion, he would have kept the painting, defeating his legal defense that he always intended to return it. Cussen leaned on that argument in his final address to the jury.

Defense attorney Hutchinson, for his part, dismissed this argument as a new theory trotted out "in the 59th minute" by a desperate prosecution (though the argument he so stigmatized had in fact originated with the judge). As noted, he had a point: Bunton had claimed that preventing someone from receiving the reward was why he had come forward, but that was two months after he had returned the painting. Hutchinson urged jurors to apply the letter of the law, even if they found absurd the idea that you can be innocent of theft solely because the theft was not intended to be permanent.

"You may think the law is stupid about this," he acknowledged, "but the law is the law." Like it or not, "if someone goes into your house and takes your television set because he wants to watch a football match and then keeps it, it is extremely irritating and annoying but it is not stealing."

Even on its own terms, the analogy was strained. Bunton's act was more like someone taking your television set and watching football for four years while sending you ransom notes offering to return the set if you met his extravagant demands.

On Tuesday, November 16, Judge Aarvold gave highly unusual final instructions to the jurors before sending them out to deliberate. Although the jury finds facts, and thus determines innocence or guilt in a criminal case, a judge's instructions on the law provide the context for the jury's decision and

can influence the outcome enormously. For this reason, alleged impropriety of a judge's instructions is often cited (sometimes successfully) as a basis for overturning a verdict on appeal.

In this case, Judge Aarvold's interpretation of the Larceny Act (specifically his belief that Bunton could not be convicted if he had not intended to keep the painting) virtually dictated the jury's verdict on the main larceny charge. Aarvold had every right to make that determination—it involved a question of legal interpretation clearly lying within the province of the Court rather than the jury. Moreover, as a matter of plain English, his interpretation was correct. But in the course of his instructions, he did something that transgressed the normal authority of a judge.

First, Aarvold did what judges and lawyers call marshaling the facts—summarizing the evidence that each side had presented and what it purported to show. This too is an unobjectionable and time-honored judicial function, which for the most part the judge performed ably—except that in the course of describing the evidence, Aarvold not so subtly injected his own opinion of it. After recapping the government's theory (not disputed by the defense) about how the thief had entered the National Gallery, Aarvold pivoted:

> It was a reasonably simple way in you may think, but how would he get out carrying a picture of this size? You have seen a copy of the frame leaning against the dock, so it was you may think quite an athletic feat.
>
> The defendant tells you that he managed to get in and he managed to get out. You have seen him, you know his age, and you have also heard him say that he was suffering from a bad attack of influenza at the time. But somehow he managed to achieve that remarkable athletic feat, as you may well think it was. So far as we know there was only one person involved in this, and the defendant tells you he was there doing it himself with no one else helping him at all. As I say, you may think it was a remarkable athletic feat by the defendant.

In the course of this brief description, Judge Aarvold managed to refer to the criminal's "athletic feat" three times, twice adding the adjective *remarkable*. The jurors had only to look across the courtroom to see that the hefty defendant was probably incapable of even a nonremarkable athletic feat, but Judge Aarvold went out of his way to focus attention on this issue and to remind them of Bunton's claim to being ill at the time of the theft. Significantly, the government and the defense, which shared the assumption that Bunton was the culprit, had barely mentioned any of this. The judge effectively made his own closing argument.

To be sure, Aarvold qualified his overbearing instruction. Instead of overtly telling the jury his opinion, he repeatedly added "you may think"—as if he were just giving the jury one among several options. Aarvold wished to eat his cake and have it too: to influence the jury but in a way that would survive a Court of Appeals review. He didn't stop with his repeated invocations of the "remarkable athletic feat" in question. There were other aspects of Bunton's story that he regarded with skepticism—to put it mildly.

> The method, when you look at the plan, you may well feel must have required some very, very careful reconnaissance. The defendant tells you that all he did was to look out of the window of the gents' lavatory, and from that window he could make up his mind as to how to get in. It looks as if it was perhaps a remarkable piece of intuition on his part when you see the actual route an intruder must have taken. He would have to go through the Chemistry department, through another building and into the courtyard, none of which it would appear to be possible to see according to the plan at any rate, from that window.
>
> Well, it may have been a casual reconnaissance, or it may have been that he carried out a much more careful reconnaissance than he would have you know about. It may be it was just an amazing piece of good fortune, but that appears to have been the method by which that picture was taken out of the National Gallery.

The judge had only begun to express his doubts about whether Bunton had accurately described the theft. He proceeded to muse about how fortunate Bunton must have been to find guards off duty and to be seen by no one, and how bizarre it was that Bunton had gratuitously lied (by his own account) to the police in claiming to have disposed of the frame in the Thames. Further, Judge Aarvold expressed incredulity that "off he went to Newcastle with the painting." Aarvold instructed the jury: "Again, you will ask yourselves, do you really accept that? Do you believe that? Do you think that would be the sort of risk he would be prepared to take at that stage?"

Having expressed major doubts about every aspect of Bunton's story, the judge explicitly told the jury that the various incredible claims "may cast considerable doubt as to his reliability as a witness." Then, perhaps saying what he thought the Court of Appeals would need to hear if it was to forgive all his editorializing, he added the following—ostensibly for the jury's benefit: "That is a matter entirely for you."

And so it was, in the sense that jurors could do as they pleased without fear of reversal, much less reprisal. Still, the judge had in no uncertain terms communicated his own view of the evidence, a professional jurist's impermissible intervention likely to influence the lay decision makers who necessarily looked to him for guidance.

Aarvold's summation, unusual in many respects, was perhaps unique in one, reflecting the surreal nature of this trial. Though the judge had all but told the jury that he believed the defendant to be a massive liar, one could interpret his doubts as suggesting the defendant's innocence. Indeed, Aarvold was disagreeing with both the defense and the prosecution. The two sides differed about Bunton's motives, but they each claimed that he had seized the painting in the manner he described. Since Aarvold found Bunton's story absurd, he felt the need to enlighten the jury. And lest he leave any doubt that he did not believe Bunton's account of the theft, when Aarvold turned his attention to the ransom notes, he emphasized that Bunton used the term *culprits,* seeing fit to add, "Culprits is in the plural there."

Judge Aarvold marched through the various ransom notes, and here he at first maintained neutrality. He repeatedly told the jury that "it is for you" to determine Bunton's mind-set, and with respect to that issue he seemed

sincere. And on the question of whether Bunton had written the May 20 letter to Lord Robbins, the judge marshaled the evidence fairly. On the one hand, he noted, an expert had testified that Bunton's fingerprints were on the pendant letter to Lord Rothermere. On the other hand, he observed, there were various discrepancies between those two letters and the ones Bunton had indisputably written.

With respect to the technical and scientific process of fingerprint analysis, the judge observed, "Luckily, you and I do not have to understand or go into" these details. However, apropos of the original letter to Rothermere having disappeared, he said, "Somehow [it has] disappeared, and it is a matter for you to take into account. It means that the defense has not been able to study and scrutinize the original document and you must make all due allowance for that."

The judge parsed the letters to help focus the jury's decision as to what they said about Bunton's plan: Was he in fact threatening damage to the painting? Did he in fact plan to return it no matter what? In language that surely pleased the defense, Judge Aarvold informed the jury that to find Bunton guilty of uttering a threat, it must find "a very definite threat."

With respect to the March 21 letter to the *Mirror* in particular, the basis for count four of the indictment, Judge Aarvold again offered an analysis that infuriated the government and delighted the defense. While declaring the matter "entirely for the jury to decide," he noted that "you may well come to the conclusion that [the letter] was really only part of the negotiations with the editor of the *Daily Mirror* in clarifying the 'sporting offer' they made. If you think that might be so, then you acquit on count four straight away." Oddly, the judge gratuitously gave his imprimatur to a kidnapper engaging in "negotiations."

Having offered thinly concealed opinions about many of the factual issues, Aarvold turned to his legitimate task of instructing jurors on the law and the scope of their determination. He emphasized that if the jury found that Bunton had intended to return the painting and frame, it *must* acquit on the charges of theft.

So instructed, the jury retired to deliberate at 12:10 P.M.

Chapter 19: VERDICT

A fter seventy-five minutes of deliberation, the jury sent a note to the judge, asking for clarification of the law on theft. In keeping with standard procedure, Judge Aarvold summoned the jurors into the courtroom and answered their question—which, as it happens, meant reiterating what he had already made clear but what they were understandably struggling to accept:

"As I say, the real issue you have got to decide there is whether it has been proven that in the defendant's mind there was the intention when he took the portrait out of the National Gallery to permanently deprive the owners of that portrait." He continued in that vein for five minutes, before asking, "Does that help you any further, members of the jury?"

The foreman responded: "Yes, thank you," and the jurors resumed deliberations at 1:40 P.M. They returned with their verdict two hours later.

The jury acquitted Kempton Bunton on three of the four charges: stealing the painting and the two "uttering a menace" charges stemming from letters to Lord Robbins and the *Daily Mirror*. But the jury found Bunton guilty of stealing the frame.

After the verdict was announced, assistant prosecutor Thomas Leary informed Judge Aarvold that defense counsel Hutchinson was not present. (Somewhat oddly, the defense assented to the reading of the verdict in his absence.) Aarvold asked Leary, "Has [Hutchinson] been notified?" and the prosecutor replied, "I hope so, my Lord."

Leary also informed the Court that Detective Ferguson McGregor Walker, a prosecution witness, was present to answer the usual sentencing-related questions. Judge Aarvold said, "I think I better hear Mr. Walker." Under Leary's questioning, Walker relayed Bunton's age, previous convictions, and current employment status (unemployed).

Hutchinson, who returned to the courtroom during this brief interval, declined to ask questions of Walker but opted to make a very brief statement prior to sentencing, urging the Court to "take into account the fact that perhaps no one could possibly have imagined a frame would have the value this one is alleged to have had, and that on the face of it did not seem perhaps to him to be of any great value."

The court clerk than asked Bunton whether he wished to make a statement, and the newly minted convict replied without emotion, "Nothing at all, sir."

The sentencing remained for Judge Aarvold, who began somewhat informally: "Well, Kempton Bunton, the jury have accepted that at the material time you intended to return the picture, and they have accepted that you made no demands for money with menaces . . . and of course I accept the jury's verdict on those matters."

Hutchinson would later recall that at the outset of the trial, Judge Aarvold had been shocked to learn that the defendant would plead not guilty; he was "absolutely furious" about the defense argument that it is legal to take and keep someone else's property for four years. He came to accept that the perverse larceny law required such an interpretation, but now, at sentencing, he took the opportunity to offer a moral judgment. He scolded Bunton, explaining that "temporarily" depriving the National Gallery of the painting, while technically legal, was nothing to be proud of—notwithstanding the fact that he had acted to support charity: "Motives, even if they are good, cannot justify theft, and creeping into public galleries in order to extract pictures of value so you can use them for your own purposes has got to be discouraged." But having announced the law's need to deter such behavior, Aarvold immediately added: "Taking all those matters into account, I can only sentence you to a short term of imprisonment of three months."

The mismatch between the judge's strong rhetoric and weak sentence echoed a Bob Dylan song recorded two years earlier. "The Lonesome Death of Hattie Carroll," a ballad about a murder, climaxes with the judge's decision at the end of the trial: "And he spoke through his cloak, most deep and distinguished / And handed out strongly, for penalty and repentance / William Zanzinger with a six-month sentence."

Six years later, Judge Aarvold was asked to contribute a few paragraphs

to the *American Bar Association Journal* (under the title "A Note from the Recorder of London"). He concluded his benign remarks by declaring that the judiciary must "fulfill its function of administering justice with mercy and understanding." Certainly the slap on the wrist he had given Kempton Bunton accorded with that sentiment.

The next day's *Reading Eagle* served up the obvious pun, titling its article on Bunton's conviction "Defendant Can Say He Was Framed." The *London Times*'s ostensibly straightforward headline better captured the oddity of the verdict. In bold letters it proclaimed, "MAN ACQUITTED OF STEALING GOYA"; then in smaller letters: "Guilty of Stealing Frame."

———

Kempton Bunton received a minimal sentence while maximizing attention to his pet cause. Many thought that he had gotten off ridiculously easy. A National Gallery publication that appeared in 1967, while the wound was still fresh, acidly observed that "to most of the world it was a shock to read that it is not against English law to climb into a public gallery at dead of night, remove a national treasure, keep it hidden for several years and meanwhile attempt to extort ransom from the public for whom it had just been acquired." In fairness, though, the jury found that it *was* against English law to engage in such behavior if you did not return the frame.

It is impossible to know what bothered National Gallery officials more: that Bunton was actually acquitted of most charges (including stealing the painting) or that he received such a light sentence for the count on which he was convicted. Perhaps the combination. But not surprisingly, Bunton's lawyers saw the outcome differently. Hugh Courts, Bunton's original court-appointed attorney, who ended up assisting Jeremy Hutchinson, recalls that "three months of prison we thought was harsh." Fellow defense attorney Eric Crowther agreed, stating in his memoirs that Judge Aarvold, "normally a kindly and understanding judge," probably would have given Bunton a suspended sentence, except that option did not exist in 1965.

For his part, the defendant pronounced himself "intrigued by the verdict." He also joked that prison wouldn't be so bad, because "I'll get free television there." In his memoirs, he complains about the outcome of the case in

only the mildest terms: "I do not argue with the result of the trial—the judge was fair—but maybe if I had been in his shoes, after the jury had said that I was guilty only on the frame charge, I would have said to myself . . . 'he is aging, and maybe his motives were good—the jury apparently thinks so—[this is] a case for probation.'"

Was the sentence in fact harsh? One can easily make the opposite case. Stealing a highly valued work of art, and holding on to it for four years while taunting the authorities and trying to extract a ransom, presumably merits a sentence heftier than three months in prison. But putting aside the judge's lenient sentence, did the jury get things right? The answer requires consideration of the verdict with respect to each of the four charges.

NOT GUILTY OF STEALING THE PAINTING; GUILTY OF STEALING THE FRAME

The finding of not guilty of stealing the painting might seem absurd given that Kempton Bunton had taken the witness stand and acknowledged taking the painting, just as he had when he had turned himself in months earlier and on several occasions thereafter. His sundry confessions, however, did not constitute proof of guilt, because he did *not* admit to intending to deprive the gallery of the painting permanently.

The jury presumably followed Judge Aarvold's instruction to acquit if Bunton always intended to return the painting. That said, the determination that Bunton intended to return the painting was arguably unjustified. Several of the ransom notes implied that he would not return the painting unless his demands were met. (Then again, to acknowledge otherwise would defeat the purpose of a ransom demand. A ransom "request" seems unlikely to succeed.) Still, the judge's instructions, involving a straightforward interpretation of the Larceny Act, gave jurors a way out. The defendant was obviously not a conventional criminal out for personal gain. To the contrary, his motives were charitable. On top of that, he was a bit . . . off. Why not seize on any plausible justification to acquit him of the principal charge?

As in so many respects, here the case may have presented a strange twist on the normal functioning of the law. Jury nullification involves jurors disregarding the facts or law in order to produce a result they consider just. While controversial (some celebrate nullification as an indispensable democratic weapon, while others lament that it gives jurors unfettered power), it indisputably occurs—and probably always will, since jurors are not required to give reasons for their decisions and acquittals cannot be appealed. The case of Kempton Bunton might seem like a great candidate for nullification, as it involved a defendant who had seemingly committed a crime but, for idiosyncratic reasons, was not someone the jury wished to punish. However, if jurors felt that way, they did not have to nullify. The weird Larceny Act did their work for them. The notion that theft is not theft if not intended to be permanent allowed the jury to *follow* the instructions of the law and acquit someone who seemed clearly guilty. One might say that the Larceny Act itself nullified common sense and Bunton's guilt.

But having acquitted Bunton of stealing the painting, why did the jury convict him of stealing the frame? There were three ways of looking at the frame in relation to the theft of the actual painting. From the government's perspective, the fact that Bunton failed to return the frame undercut his claim that he always intended to return the painting. The defense, of course, argued the opposite: The fact that Bunton had returned the painting showed that he intended to return the frame (even though he failed to do so). The jury quite reasonably split the difference. Whenever prosecutor Cussen suggested that Bunton had intended to keep the painting indefinitely, Bunton made the show-stopping reply that he had in fact returned it. Turnaround is fair play. If the return of the painting proved intent to return the painting, then why not infer that failure to return the frame proved the absence of intent to return the frame?

To be sure, Bunton had testified that he had placed the frame in the cupboard of his temporary lodging in London and had unsuccessfully attempted to retrieve it so that he could return it. If jurors believed him, they should have and presumably would have acquitted him of stealing the frame just as they had acquitted him of stealing the painting. But they had very good reason not to believe him, especially since he had initially told the police that he discarded the frame in the Thames. Moreover, Cussen's otherwise shaky cross-

examination of Bunton scored points with respect to the frame. Bunton did not help himself with his flip comments about his efforts to retrieve the frame four years after he had hidden it—saying that it would be "interesting" to see whether it remained with his landlady and that "it could turn up any day."

Even so, the verdict with respect to the frame was questionable. It is obviously true that Bunton did not intend to return the frame if and when he discarded it. But the law defined theft at the time of the taking and required at that time an intent to deprive the owner permanently. How plausible is it that someone sneaks into a museum intending to take a painting and then return it minus the frame?

But it doesn't follow that the jury acted absurdly. More likely, jurors consciously adopted a compromise, one that technically did not make sense but that resulted in a satisfying outcome. The jurors wished neither to punish Bunton severely nor to let him go. The strange Larceny Act, coupled with the missing frame, enabled them to find a comfortable middle ground.

NOT GUILTY OF UTTERING A MENACE BY WRITING THE MAY 20, 1963, LETTER TO ROBBINS

The basis for Bunton's acquittal on the charge stemming from his alleged letter to Lord Robbins is unclear. The jury may have believed that the letters did not constitute a threat (or, in the exact word of the charge, a menace).* Alternatively, the jury may have concluded that the government had failed to prove Bunton to be the author of this letter.

The question of whether Bunton wrote the letter to Robbins presents a fascinating question of historical fact. As discussed above, it pits direct

* Bunton's attorney Eric Crowther recalled in his memoirs that "the jury rocked with laughter" when Hutchinson asked the following rhetorical questions during closing argument: "Can you imagine the editor of the Daily Mirror *sitting trembling in his chair in case he got another letter from the defendant threatening not to return the Goya unless the editor got around to organizing the Kempton Bunton Trust? Do you think the editor is a man of such delicacy that he cares two hoots whether the Duke of Wellington is hanging in the National Gallery or reposing in Mr. Bunton's bedroom?"*

physical evidence against substantial circumstantial evidence. The physical evidence—fingerprint analysis suggesting that Bunton wrote the pendant letter to Lord Rothermere—may seem decisive, but is somewhat neutralized by the disappearance of the original letter to Rothermere. Moreover, fingerprint analysis is not infallible even in the twenty-first century and was surely less reliable in 1965. The jury had seen Hutchinson bloody the government's fingerprint expert on cross-examination.

Under the circumstances, the jury could not find beyond a reasonable doubt that Bunton had written the May 20 letter to Robbins. Accordingly, acquittal on that charge seems proper (quite apart from whether the letter constituted a threat or menace).

Proper, but probably mistaken. Evidence after the fact—specifically Kempton Bunton's memoirs—suggests that Bunton did indeed write the disputed letter to Robbins. Toward the end of his chronicle, Bunton breaks the news abruptly: "And now for the Robbins Rothermere letters. Yes I typed them." While Bunton's word is not always reliable, he had zero reason to take credit after the fact for these letters, and doing so amounted to a confession of perjury.

Why did he, in the May 20 letters, suddenly reduce his demand from £140,000 to the relatively paltry £5,000? Bunton offers an elaborate explanation. The money to be raised by ransoming the Goya was always a means to an end. What mattered was old people being able to watch television. Bunton had decided that he didn't need the full £140,000 because he'd hatched a new idea: to open "something in the nature of a TV shop," which would issue free televisions to aged folks. The idea ("romantic to me, even though it would sound crackerjack to the 'I'm all right jacks'") required seed money, and £5,000 might do the trick. "I thought of the old piece of wood in the cupboard and I cried. Thus came the idea of writing the two R letters."

Why did he type these letters rather than resort to the usual handwritten notes? That was simply a matter of keeping separate his two plans: "I wished to keep the Com plan compact, and if the shop idea failed, I still felt a hope of the Com plan eventually succeeding." The idea of a two-tiered plan, one proceeding by typewriter and one by hand, will seem implausible only to those not familiar with Kempton Bunton's modus operandi. "Too clever by half" aptly describes much of what he did.

Bunton had insisted to his attorneys that he had not authored the disputed Robbins/Rothermere letters, and he went to the trouble of having his typewriter sent over for testing to show that the letters were not his. And the defense expert verified that these letters did not come from Bunton's typewriter. That, Bunton explained in his memoirs, stemmed from his shrewd planning. Back when Bunton decided to send the letters to Robbins and Rothermere, "I knew it would not be prudent to type them on my own typewriter, and so I went to the salerooms and paid a few shillings for an old one which I could destroy afterwards."

Bunton's memoirs offer a healthy distaste for law enforcement, but at least on this occasion he gives credit where it is due. "The fingerprint [on the Rothermere letter]? A complete mystery to me, as I was certain that gloves were worn always. . . . We must give credit to the Yard for that clever piece of detection."

And yet, though we can now presume that Bunton wrote the relevant May 20 letter to Robbins, the jury may still have been correct to acquit him of the charge of "uttering a threat." Robbins himself testified that he did not regard the letter as threatening or menacing, stating that he "always refused to believe" that the thief would deliberately harm the painting. If the recipient of the letter did not feel threatened, why assume that the writer wanted him to?

LETTER TO THE *DAILY MIRROR* NOT A MENACE

Kempton Bunton indisputably wrote the March 21, 1965, letter to the *Daily Mirror,* which formed the basis of count four of the indictment against him. Apparently, the jury decided that this letter did not constitute a threat. That was an understandable determination. Even though technically a threat can be to a third party, we tend to think of threats as direct. Bunton essentially told the *Mirror,* "If you don't exhibit the painting, the National Gallery won't get it back." The indirectness of the threat may have spared him the jury's wrath. In addition, Bunton's letter to the *Mirror* sounds more like a man desperately trying to salvage something from a plan gone awry than someone menacing anyone.

All told, a reasonable case can be made that the Bunton jury acquitted itself well. It had before it someone who, in the grip of a well-meaning crusade, had committed a quixotic act to raise money for charity and had eventually returned what he had taken (except for an accoutrement). And the letters in question had established battiness more than genuine criminality. The jury did not wish to punish severely this odd, well-meaning creature whose behavior caused no lasting harm. On the other hand, he could not be let off entirely, since he had in fact stolen something valuable and had indeed "permanently deprived" the National Gallery of the painting's frame. The jury, it might seem, arrived at a justified compromise verdict.

But major questions remained, starting with the problem identified by Judge Aarvold in his summation: Could Bunton really have performed the "remarkable athletic feat" required to seize the painting?

Related, there was the issue of Mr. Bloxham. As Milton Esterow would write in his book about art theft, published shortly after the trial, "The identity of the young man—Mr. Bloxham—who brought the painting to the railway baggage office in Birmingham, has never been disclosed. . . . [That] is all a mystery, for Scotland Yard has said absolutely nothing about Bloxham." Almost two decades later, in his book about famous art thefts, Hugh McLeave proposed what Judge Aarvold seemed to believe: Bunton was likely involved in the theft but with an accomplice.

McLeave proposed that the accomplice was "the mysterious and bogus Mr. Bloxham"—bogus meaning that he wasn't the "teddy boy" Bunton claimed to have spontaneously recruited at the Birmingham station. Bunton's story about Bloxham did not add up. He insisted that Bloxham was a stranger whom he casually enlisted to return the Goya. McLeave observed that if Bunton's story were true, Bloxham had nothing to fear: Why, then, had he never come forward? The name Bloxham added to the suspicion. Recall that Lady Bloxham figures in an Oscar Wilde play in which a baby is found in a handbag in the cloakroom of a railway station. If Bunton had indeed randomly recruited a passerby to deliver the painting, that his name would happen to be Bloxham seems a far-fetched coincidence.

As later became known (and as shall be discussed in chapter 21), Judge Aarvold and Hugh McLeave were right to believe that Kempton Bunton had not stolen the Goya alone but were wrong to think that he was present when it was stolen. McLeave also receives a mixed score with respect to Mr. Bloxham: The mysterious stranger was indeed involved in the theft, but McLeave wrongly assumed that he never came forward. As with so much of this case, life has more imagination than we do.

Indeed, with the benefit of hindsight, we can say that the jury got things pretty much backward. Bunton had not stolen the painting (frame or otherwise), but he had written threatening letters that probably ran afoul of the law.

Chapter 20: NEW LAW, NEW CONFESSION

Kempton Bunton served the first few days of his three-month sentence in Wandsworth Prison, in a cell of three, but "what does it matter, 1, 3 or 33, was all the same to me." Though assigned the job of cleaner, he intended to use the time behind bars to catch up on reading. He grabbed a few books from the prison library and returned to his cell, planning to read all day. "I would not push myself forward as cleaner until my activities were queried."

After a few days of reading, he learned that he was being transferred to Ford, an "open" prison—a minimum-security arrangement aiming to maximize the inmates' freedom and employment and thereby rehabilitation. Bunton was displeased because Ford was fifty miles from London, making it more difficult to meet with counsel and plan his appeal. In part for that reason, he "decided to forego appeal, go to Ford, do my time quietly, and get the matter over and done with." Indeed, just two weeks after the trial, newspapers reported attorney Hutchinson's announcement that there would be no appeal of the verdict.

In Ford, Bunton worked at a tag shop, making tags, an activity so menial that "a few minutes experience . . . told me that the open prison experiment was a failure." Failure became fiasco when a sadistic warder named Croucher ("out of Dickens," Bunton writes) began harassing him. Bunton complained to the head warder, the prison chaplain, and anyone else who would or would not listen. When going through proper channels failed, Bunton let Croucher himself know what he thought of the man. His candor succeeded only in producing a two-day stay in a punishment cell. Bunton welcomed the sanction, because it meant he could read in peace instead of working in the shop, but before long he was reassigned to a normal cell and transferred to the plastic shop. This, at least, distanced Bunton from his tormentor. Apart from assorted complaints about mistreatment by the authorities (the prison doctor, among

others) and irrational rules (such as a prohibition on tobacco), Bunton passed the rest of his sentence uneventfully.

He ends his memoirs there, except to note his future plans: to tell and sell the full Goya story, in order to "pay off my small debts, and give the rest in one go to my original object"—helping the elderly watch television. He offers a final, ambivalent assessment of his alleged criminal deed. On the one hand, he felt bitter that "this affair is looked upon with suspicion, and not [as] the reckless magnificent adventure it in reality was." On the other hand, "I at least did have a go, and whatever the final outcome, I shall never regret it."

Thereafter he kept in touch with his attorneys, sending occasional letters to Hugh Courts, Eric Crowther, and Jeremy Hutchinson (or Hutch, as Bunton called him). In a letter to Courts in March 1966, shortly after he completed his prison term and returned to New Castle, Bunton explained that London "got my goat, and that is why I left so abruptly." He let on that he was busy at work on his biography. Crowther, who would fondly remember Bunton as "one of the most interesting and idealistic clients I have ever had," recalled that for several years after the trial he would receive occasional signed picture postcards from Bunton—all displaying photographs of *The Duke of Wellington*. It seems safe to surmise that Bunton meant what he said at the end of his memoirs: he never regretted L'Affaire Goya.

But turning his story into a lucrative book, as he hoped, never transpired. He completed his memoirs and many other fiction and nonfiction works, but regrettably before the advent of ebooks and self-publishing. A snippet in 1966 in *Publisher's Weekly* reported that he had written a new novel, a racing story called *Mickey Lowbrow*, but added that his wife called him a frustrated writer. Bunton never sold this novel, his autobiography, or any of his other works; nor did he achieve his aim of sparing the elderly the BBC licensing fee—at least not in his lifetime. In 2000, almost a quarter century after Bunton's death, the UK introduced free television licenses for people seventy-five and older.

Even so, his odyssey would leave a legacy. Almost immediately after his trial, Parliament pondered a change in England's criminal law to make a repeat impossible. A committee created by Parliament addressed the matter in a May 1966 report, noting that "in view of the Goya case," sacred objects in museums and churches appeared to be fair game for thieves. It noted that

the Malicious Damages Act of 1861 authorized punishment for destruction of or damage to works of art, but only six months in prison. More problematic, such a law would not apply to a thief who returned a work undamaged (Bunton arguably could have been—but wasn't—prosecuted under this law because of the missing frame), and in any event, the committee considered a six-month sentence "clearly inadequate" for a crime like Bunton's.

In its own aforementioned 1967 report, the National Gallery weighed in, lamenting that Bunton's trial "had the unfortunate result of informing the world that deeds like his could be performed in England with impunity" and insisting that "legislation is now urgently needed to redress this."

When the Criminal Law Revision Committee met to draft what would become the Theft Act of 1968, it was undertaking a periodical revision of the criminal code that would have occurred even if Kempton Bunton had never hijacked *The Duke of Wellington*. Over the course of the life of any nation, a criminal code becomes rusty. Laws drafted a century before may be a poor fit for a changing society. Many such laws require repeal or amendment, and entirely new provisions become needed to address new ideas, technologies, and other unforeseen circumstances. Sometimes, though, the law must change not because of new developments but because a new case reveals the inadequacy or inanity of an old law.

In 1959 Parliament had created the committee to revise the criminal law. It was charged with making recommendations for a "simpler and more effective system of law . . . with reference to larceny and kindred offenses." The committee worked for seven years, culminating in its May 1966 report presented to Parliament. The report reveals that Kempton Bunton's trial in November 1965 had very much gotten the committee's attention.

The obvious problem with the criminal code exposed by the case was the requirement that someone intend "permanently to deprive" his victim of the object taken. The implicit distinction between a legal "borrowing" (in which a borrower received no permission from an involuntary lender) and illegal theft made little sense. The committee acknowledged this problem, which it succinctly captured as follows in its final report: "There is certainly a case for making temporary deprivation punishable in circumstances in which it may involve dishonesty comparable with that involved in the theft and may cause

serious loss or hardship. The taker gets the benefit of the property without payment, and the owner is correspondingly deprived."

Surprisingly, however, the committee still felt the need to maintain the distinction between taking something with intent to return it whenever one chooses and taking with intent to keep forever. The former is in fact "essentially different from stealing," and thus removing the requirement of intended permanent deprivation would mark "a considerable extension of the criminal law [not] called for by any existing social evil." Accordingly, the committee report recommended maintaining the requirement of intent to deprive permanently as an element of theft.

Not surprisingly, that position proved controversial during debates in Parliament. It nevertheless prevailed, but Parliament inserted a somewhat complicated new provision that modified the old rule substantially: "A person appropriating property belonging to another without meaning the other permanently to lose the thing itself is nevertheless to be regarded as having the intention of permanently depriving the other of it if it was his intention to treat the thing as his own to dispose of regardless of the other's rights; and a borrowing or lending of it may amount to so treating it . . . if the borrowing or lending is for a period and in circumstances making it equivalent to an outright taking or disposal."

In considering acts like the hijacking of Goya's *Portrait of the Duke* to be a "borrowing," this complicated provision remains unsatisfactory. It did, however, mitigate the problem posed by cases like this. The jury, instructed in this new provision, might well have convicted Kempton Bunton of stealing the painting (and not just the frame).

But starting in 1968, a jury faced with such a case would have another option as well. While the committee's final report recommended maintaining the requirement of intending permanent deprivation, it recognized that something must be done to deal with "special cases" like that of Kempton Bunton. The committee opined that extra protection must be given to "articles displayed in churches, art galleries, museums and other places open to the public" and noted that "a striking recent instance is the removal from the National Gallery of Goya's portrait of the Duke of Wellington." Bunton's case might be thought unique, but it turns out that the committee drew on somewhat

similar cases, such as that of an art student who stole a Rodin statuette from an exhibition, in order to "live with it for a while," and returned it four months later. The committee noted that while such conduct would seem punishable, particularly because it affected items "of the greatest importance and value," the case could be made for leaving these odd instances unaddressed by the law: "It can be argued that serious cases of the kind are rare and, judging from the cases mentioned, these offenders are more eccentric than genuinely criminal."

Wildly eccentric though Kempton Bunton may have been, he was the rare man whose conduct changed the terms of debate over a nation's criminal law. The committee wrote, "Before the Goya case few people would have said that there was an evil unprovided for and serious enough to require the creation of a new offense." The committee expressed reluctance about allowing a crank like Bunton to dictate the nation's criminal code and acknowledged a special danger in doing so in the manner contemplated: If the law explicitly punished takings from museums and other public places, someone wacky like Bunton, having indulged his impulses, would be less inclined to return the work.

The committee, however, overcame its reluctance. "We have come to the conclusion that the situation, *especially in view of the Goya case,* is serious enough to justify the creation of a special offense in spite of the possible objections" (italics added). Parliament agreed, adopting what everyone called the Goya Clause—a new crime called "Removal of an Article from a Place Open to the Public." This provision, section 11 of the Theft Act, states, "Where the public have access to a building in order to view the building or part of it, or a collection housed in it, any person who without lawful authority removes from the building or its grounds the whole or part of any article displayed or kept for display to the public in the building . . . shall be guilty of an offense." The offense carries a penalty of up to five years imprisonment. They could have called it the Kempton Bunton Act.

Thus Bunton *did* have an impact on the law, albeit nothing to do with the BBC licensing fee. As a result of his odyssey, it became harder for people to "borrow," not easier to watch television.

In June of the next year, 1969, Bunton was again in the news, with his seemingly settled affair taking another major twist. According to several newspaper reports, someone new had come forward and confessed to having stolen the Goya back in 1961. Someone identified in the media only as "a man from Leeds" gave a signed statement at West End Police Station, claiming that he, not Kempton Bunton, had taken the painting. Newspapers reported that the confession would be sent to the Director of Public Prosecutions (DPP) for evaluation and any necessary follow-up.

The *London Times* account of this new development harkened back to the hoopla surrounding the theft eight years earlier, noting that "hundreds of people claimed to know where [the painting] was. There were tales of how it had been smuggled out of the country by international art thieves." The *London Telegraph* gave the most exhaustive coverage of the new confession, reporting that the confessor was in fact somehow connected to Kempton Bunton. He claimed to have taken the painting as support for Bunton's campaign with regard to the BBC licensing fee and then notified Bunton about the theft. According to the new confessor, Bunton had proceeded to travel to London and the man turned the painting over to him.

Police would not release the name of the new confessor, but newspaper accounts indicated that this resident of Leeds was a twenty-eight-year-old (hence twenty at the time of the theft) who denied having a prearranged plan with Bunton. It was only after the fact that he thought to notify Bunton and eventually transfer possession of the painting to him. Newspaper accounts further indicated that, following the confession, detectives interviewed Bunton and his son John. These accounts did not explain why John Bunton had entered the picture, but they indicated that Kempton had corroborated the new confession: "I know the man involved. He is the man who did it."

As promised, the confession, along with an accompanying report on the matter, was passed along to the DPP. And then? Nothing. For reasons not made public, the government chose not to prosecute the new confessor. The media, apparently regarding a nonprosecution as a nonstory, failed to stay on the trail. The matter faded, and Bunton's guilt remained a matter of public record, occasionally alluded to in the media. For example, in May 1972, in his *London Times* column about famous art thefts, Bernard Levin, arguably

the nation's most famous journalist, complained tongue-in-cheek that the "splendid Mr. Kempton Bunton" had been "railroaded to jail in a very shabby manner" via the outrageous charge that he had stolen the frame of the painting that he was acquitted of having stolen. While lamenting Bunton's mistreatment, Levin assumed that Bunton had in fact taken the painting.

After his declaration that the man who had come forward in 1969 was in fact the "man who did it," Bunton himself never again publicly asserted his innocence. He undertook no action to clear his name and went to his grave in 1976 a convicted felon. Numerous books and articles thereafter cited and sometimes discussed Bunton's daring theft.

So things stood for two more decades. Then, in 1996, *something* happened, though it is hard to say just what. One finds on the Internet and elsewhere many references to a statement released by the National Gallery in 1996 that apparently declared (without explanation) Kempton Bunton "probably innocent." There was also speculation that the gallery had waited until 1996 because Judge Aarvold had placed a thirty-year gag order on discussion of the case. All of this is a case study in how history gets falsified by what has come to be called circular reporting: Something false gets stated as fact. Before long it is repeated, then repeated repeatedly, until it moves into the realm of long-established and incontrovertible truth.

No record of Judge Aarvold's alleged thirty-year gag order exists, and almost certainly no statement by the National Gallery declaring Bunton innocent was ever given. (None can be found in the gallery's exhaustive archives; nor is there any report of such a statement in newspapers at the time.) However, the misunderstanding can be explained. Gallery policy makes records public after thirty years. Accordingly, in January 1996, gallery records from 1965 were finally released. These records included a letter by director Philip Hendy to trustee Lord Robbins, written on December 2, two weeks after Kempton Bunton's conviction: "I share the conviction of many of the police officers involved that Bunton probably did not organize and certainly did not himself steal the picture. . . . The theft is much more likely to have been carried out by two able-bodied men."

This statement was reported in the media in January 1996. Accordingly, the oft-repeated exoneration of Bunton by the National Gallery actually consisted of the opinion of one man given thirty years earlier, before a jury decided otherwise. (There is no evidence that Hendy was privy to Pamela Smith's claim that the wrong Bunton was being prosecuted, and Hendy's two-thief theory contradicts her account.)

Perhaps because the basis of the belief in Bunton's innocence was never stated (beyond the vague "National Gallery documents suggest"), the circular reporting had only limited impact. Despite the widespread, false suggestion that gallery documents established Kempton Bunton's innocence, the world by and large continued to assume his guilt. Even after 1996, a half dozen books about art thefts, as well as numerous articles and blog posts, blithely declared Bunton to be the culprit in the theft of the Goya.

One important partial exception came from Sandy Nairne, a well-known British museum director and art writer. Nairne's 2011 book on the Turners stolen from the Isabella Gardner Museum in Boston in 1990 includes brief discussions of other famous stolen artworks, including Goya's *Portrait of the Duke of Wellington*. In a footnote, Nairne refers to a "Museum Security Network" chat room "where the suggestion is made that the thief might have been Bunton's son John."

Nairne was being cagey. In the chat room he referred to, a blog post on August 15, 2010, did indeed make the suggestion that the real thief was John Bunton. That blog post was written by none other than Sandy Nairne. Talk about circular reporting!

Nairne's reasoning combined two data: (1) the oft-mentioned fact remarked by Judge Aarvold that the seventeen-stone (238-pound) Kempton Bunton would have had difficulty squeezing himself in and out of a lavatory window and making his way down to the ground fourteen feet below, much less doing so with a heavily framed painting in hand; and (2) newspaper coverage of the 1969 confession suggesting that the new confessor claimed that he had given the painting to Kempton Bunton. Of course, these data hardly yield an airtight case against John Bunton. Realizing as much, in his book Nairne relegated his speculation to a footnote that referenced his own blog post. The true story remained unknown.

Chapter 21: CRIME SOLVED

In 2011, fifty years after the theft of the Goya, the author of this book became involved in the case. As noted in the foreword, I planned to write the book mostly because I thought the saga captivating but also because I doubted Kempton Bunton's guilt. My skepticism hardly required remarkable sleuthing. It required only common sense and familiarity with the facts. For one thing, there was the sheer physical difficulty of the crime. I was hardly the first to find this point compelling: Judge Aarvold and Sandy Nairne had publicly expressed doubts about Bunton's ability to pull off the theft of the painting.

Other aspects of the case also gave me pause, starting with Bunton's statements to the police when he turned himself in in July 1965, as well as his testimony at his trial later that year. To put it mildly, his various accounts didn't entirely ring true. Moreover, when in 1969 someone came forward and took "credit" for the crime, Bunton confirmed the truth of the new confession and asserted his own innocence. Bunton may have lacked credibility, but his say-so was the only real evidence that he had taken the painting in the first place. What reason was there to believe him in 1965 rather than to believe his recantation in 1969, especially when the latter was corroborated by the new confessor?

As recounted in the foreword, Noah Charney and I took the opportunity of the fiftieth anniversary of the crime in August 2011 to author two articles expressing skepticism about Bunton's guilt, and the publication of these articles brought forward someone claiming that he could establish Bunton's innocence. More specifically, and better still, he claimed to know the actual culprit.

Through this intermediary, I asked the alleged culprit some questions. In response, he assured me that he could prove his own guilt and Kempton Bunton's innocence, and he made references to details about the crime that bolstered his credibility. He declined to meet with me but allowed the intermediary (whom, with a self-conscious sense of self-drama, I thought of as my Deep Throat) to do so on his behalf. As I prepared for the meeting, I saw my

task as twofold. I had to satisfy myself of the new confessor's bona fides and also ascertain what he wanted in exchange for his story. Intimately related, why was this man (whom I'll call John Doe) coming forward now?

The first concern was resolved easily via email. Deep Throat explained how he had come to learn of John Doe's guilt and why there was little doubt about that conclusion. He convinced me and gave a sensible explanation for John Doe coming forward all these decades later: John Doe had long felt bad that Kempton Bunton had taken the blame (albeit voluntarily) for the theft, and he wished to set the historical record straight. When he heard that people were writing a book about the case, he thought this the ideal opportunity to vindicate Bunton at long last. Posthumous vindication beats no vindication.

Of course, John Doe could have achieved his goals without my help. One phone call to the authorities, or for that matter to any British newspaper, and he could have set the record straight without relying on a stranger to publish a book. Why involve me? What did John Doe want in exchange for me outing him and clearing Bunton?

Deep Throat assured me that John Doe did not want money. Nor was he making any other unreasonable demands. That said, he did have one demand that, though entirely reasonable, would make my job difficult. John Doe insisted that I not write anything that could land him in prison.

Great Britain does not have a statute of limitations for most crimes. If I identified John Doe as the culprit in the theft of the Goya, he could be arrested and charged with the crime. Of course, the odds that the British authorities would go to the trouble of prosecuting someone for a theft a half-century old, when the item stolen had been returned forty-six years earlier, were close to zero. Nor, presumably, would the National Gallery urge law enforcement to do so. Just the opposite—why would the gallery want this embarrassing chapter of its history reopened?

I explained all that to Deep Throat, who relayed the message to John Doe, but the latter's reply was a conversation-stopper: He was not interested in taking chances. Still, while understandably unwilling to risk his freedom, John Doe felt strongly about shedding the burden of this crime and vindicating Kempton Bunton. I just had to find the right way to balance these competing concerns. A delicate negotiation ensued, and it culminated in my promise to

protect John Doe's identity in exchange for his story. I would find a way to write the book without naming him or saying anything that would give away his identity.

For various reasons, John Doe did not wish to meet with me personally. Instead, he agreed to type out his account of the crime and his answers to whatever questions I posed and to convey them to me via Deep Throat. I met with Deep Throat at a mutually convenient location—a nondescript coffee shop in New York's Penn Station. It was a far cry from the stealthy meetings in parking garages between the original Deep Throat and Woodward and Bernstein that had led to Richard Nixon's fall, but it was thrilling just the same, especially when my Deep Throat turned over John Doe's written account of the crime. Right before my eyes, I saw solved a crime that Scotland Yard had investigated for years only to end up with the wrong guy.

That wasn't the end of my good fortune. As mentioned in the foreword, Deep Throat revealed to me something almost as intriguing as the identity of the real thief: After his trial and conviction, Kempton Bunton had authored his memoirs. Bunton's 114-page, single-spaced narrative had never been published. Indeed, during his lifetime it had never left his Newcastle home. Now, just as John Doe wished the world to know of Bunton's innocence, Deep Throat wished the world to know all about Bunton's life. He let on that he actually had the memoirs in his possession, and before long he sent them to me.

The memoirs were a godsend, but my arrangement with John Doe remained flawed, perhaps fatally. I knew the story of how he, and not Kempton Bunton, had stolen Goya's *Portrait of the Duke of Wellington*, but I couldn't tell it—not fully anyway, not if I was to protect John Doe's identity, as I'd promised to do. I could, of course, call him John Doe, rather than by his real name, but that would hardly suffice. The problem was that John Doe had stolen the painting in part for reasons related to Kempton Bunton. Indeed, John Doe had testified at Kempton Bunton's trial! The more I told, the greater the risk that the authorities would be able to identify John Doe. The more I withheld, the less I would be able to tell a satisfying story. Can you really write a whodunit without telling . . . who done it?

My problem dissolved on November 30, 2012, when the *London Guardian* reported that the release of a confidential DPP file at the National Archives

established the innocence of Kempton Bunton and identified the actual culprit. Yes, John Doe (aka John Bunton) was publicly outed as the man who had pulled off the perfect crime. Lucky for him, the authorities made clear that they had no interest in prosecuting him for his ancient crime. For the record, Deep Throat was Christopher Bunton, John's son and Kempton's grandson, a thirty-five-year-old man living in New York City.

You may wonder why John, who had outed himself in 1969, only to see the government decline to prosecute him, would worry that his identification in a book fifty years later could lead to his prosecution. I made this very point to him, but it understandably failed to convince him. Just because some cautious or prudent DPP officials in 1969 had elected not to reopen the embarrassing case did not guarantee that some ambitious officials in 2011 would feel the same way.

In any event, the outing of John Bunton was bad news/good news. Bad news: My secret was no longer secret. Good news: John Bunton no longer had any reason to withhold, or ask me to withhold, any aspect of the story of perhaps the greatest art theft ever. I was finally in position to tell the whole story— of the crime, the criminal, and the innocent man who chose to take the fall. While the who was now known (at least to readers of the *London Guardian*), I could reveal the how, why, when, and where, most of which had never been told.

THE REAL STORY OF THE THEFT

The conviction and three-month sentence of Kempton Bunton for stealing the frame of Goya's *Portrait of the Duke of Wellington* was perhaps a case of what T. S. Eliot called "the greatest treason—the right thing for the wrong reason." Bunton had not stolen the frame, or for that matter the painting. But nor was he blameless. The theft of the Goya did indeed result from his obsessive crusade against the government policy requiring the elderly to pay the BBC licensing fee, and he did indeed write the various ransom notes that perhaps constituted crimes in their own right.

Even though they ended up with the wrong man, Scotland Yard and the prosecution at Kempton Bunton's trial got some things right. For starters, they

were right to conclude that the government's substantial expenditure to keep *The Duke of Wellington* in England had set off Kempton Bunton and had set in motion events leading to *The Duke*'s disappearance. It may seem psychologically bizarre to connect the government's purchase of the Goya with its television licensing fee, but the injustice of the latter, once it took hold of Bunton's mind, never let go. From the moment he heard about the extravagant expenditure for a mere painting, he writes in his memoirs, "something clicked within me, seeming to say that the picture and I were fated to cross swords."

Kempton Bunton loved to talk, loved pubs, and spent a fair amount of time indulging those passions simultaneously. We'll never know how many people in how many pubs heard about his bitterness that the government had spent a substantial sum to keep *The Duke of Wellington* in London while forcing old people to spend money to watch television, but quite likely it was more than a few. It also seems safe to speculate that virtually all of them dismissed Bunton as a crank. But at least one young man took Bunton seriously: his own son John, nineteen at the time.

It wasn't so much that John Bunton shared his father's outrage about the BBC licensing fee or the government's expenditure on the Goya. He was a ne'er-do-well who didn't much follow or feel strongly about public affairs. To some extent, he was a rebel without a cause, and his father supplied one. Young Bunton felt sympathy for Kempton; he recalls that his father "got no support from the OAP [old age pensioner] community and only received one letter while in prison, and was mocked and a bit of an outcast as a result." He figured he could make amends—"the Goya could be used as leverage for [my father's] campaign."

John also had a second motive, albeit one that backfired. He thought he could take advantage of the system whereby insurance companies would pay 10 percent of the value of stolen art to get it back on the quiet. He did not realize that this practice did not apply to government property. Looking back at that foiled incentive, John Bunton says he pulled off the "perfect crime in reverse." Yes, he seized a valuable object without getting caught, but what could he do with it?

As Scotland Yard surmised early on, and Judge Aarvold openly asserted at Kempton Bunton's trial, the theft required a "remarkable athletic feat." John

Bunton, a rugged man near his physical prime, was equal to the task. A half century later, he described a childhood that produced impressive physical fitness:

> My childhood was free and loose, [I was] allowed to do what I wanted. We were pretty much chucked out of the house, they just wanted to be rid of us. . . . Nature was a free baby sitter for us all day. I was never into any specific sports but always active from a young age. I had about 16 different boats between the age of 10 and 15. At 10 years old I would swim in the Tyne River and moor my boat in the middle of the river (so no one would steal it). I would have to swim to get to it, by judging the tides 200 yards upstream when setting off.

John Bunton, like his father, was a self-described drifter, more apt to get into a fight than to get (or at least keep) a job. He recalls, "I always seemed to have money in school, hustling one way or another." And, as his actions on August 21, 1961, vividly demonstrate, he shared his father's keen sense of mischief and almost ridiculous optimism.

Notwithstanding some marked similarities, the Buntons weren't buddies. Asked what Kempton was like as a father, John, the youngest of seven children, offered a not terribly fond reminiscence:

> We had a poor upbringing (like Oliver Twist) at the end of WW2. Kempton wanted to be a writer and wasn't concerned about getting a stable job, he was always in and out of menial jobs and my mother was always nagging him to get a job. My father never harmed me. Never hit me in my life. We were never hungry. The only way we were abused in a sense was by having no education whatsoever. When I was leaving the school as an 11 yr old to go to secondary school, the teacher said I should go to Rutherford College instead of Whickham View Comprehensive. I remember the head teacher and another teacher arguing my case saying, I should go to Rutherford because I was too clever to go to Whickham View. However,

> I ended up at Whickham View because my parents wouldn't
> pay for a uniform and you didn't need one at Whickham View!
> That was pure ignorance, and that's the way it was all the time
> with my father. I even had a dog that he sold when I was at
> school. [P]robably for beer money. It was a big disadvantage
> having a father like mine.

According to his devoted son, Chris, John Bunton was an opinionated young man, intelligent and idea oriented but not well educated. Financial exigency forced him to leave school when he was fifteen. Like his father, he worked many jobs across the UK, often as a mechanic. Chris, who speaks highly of his father in most respects, does note his dad's Kempton-like tendency to "simplify things to a black and white level" and adds, "I think this is how he approached the Goya heist."

The facts support Christopher's surmise. As John explained, looking back a half century later, he was living at home in Newcastle with his parents when he heard his father grouse about television licenses and the government's purchase of the Goya. Two days later, "I went to London with a purpose and with £1.50 in my pocket. Two weeks later, I had the painting"—one worth £140,000.

John Bunton did not tell his father (or anyone else) what he planned to do, and it all happened rather quickly. He arrived in London with virtually no money and no particular plan. He recalls "taking things one step at a time" and continuing until the end only because "things kept going in my favor." John Bunton felt prepared to back out at any point, but it was as if "God was helping," so there was no reason to stop.

He stayed one night in a hostel but spotted a newspaper advertisement for a live-in position as a bell boy/chauffeur at a hotel in South Regents Park. He applied for and got the job. During his three weeks in London (two before the theft, one after), he worked a number of odd jobs.

In the off hours, young Bunton visited the National Gallery several times, undertaking what we might call a feasibility study regarding the theft. On his first visit, he located the offending Goya in its special exhibit. During his second visit, he waited until he was alone with the painting, then stuck fluff be-

hind it to test whether the painting got moved. On the third visit, he noted the presence of the fluff, suggesting that the painting was being left alone. He also took note that a lavatory window looked onto a building site in the courtyard behind the gallery. He obtained the gallery plan so that he would know the precise route from the lavatory window to the painting. He also took note that there were parking meters on the street abutting the courtyard, so he could park fairly close to the wall that would enable him to climb to the lavatory window. He noticed that workers doing construction in the courtyard had left a ladder lying around, which would enable him to do the necessary climbing.

But, of course, none of that would matter if the painting were closely guarded. John Bunton struck up conversation with security guards about their work, in the guise of interest in applying for a job as one of them. At least one guard let down his guard (so to speak) too much, informing Bunton that the alarms were switched off in the wee hours to allow cleaners to come in without setting off an alarm.

More planning had to be done, starting with the acquisition of an escape vehicle (since Bunton owned no car). Given his background, acquisition of a vehicle figured to pose little difficulty. He had worked as an auto mechanic and knew how to break into and start a car without a key. He chose an enclosed parking garage roughly three miles from the National Gallery, picked a dark green Wolseley to pilfer, and opened the hood (or bonnet, in British parlance) in search of the power source. Then he encountered his first piece of bad luck—he heard voices, presumably two or more people approaching their own vehicle in the vicinity. Bunton shut the hood and climbed under his chosen vehicle. While he hid, a car with a young couple in it drove in and parked next to him. They opted for serious necking, and Bunton estimates that he remained under the car for an hour, though one's sense of time can hardly be reliable in such an adrenaline-flowing situation. When the couple finally drove off, he emerged covered in oil.

Well after midnight he drove to the gallery and parked his new vehicle on the street abutting the gallery. He wore gloves, and a jacket to match the guards' attire. When he entered the gallery, he feared "only" two things: alarms going off and security guards. He encountered neither, and acquiring the Goya turned out to be the easiest part of the operation. He quietly walked with it into

the lavatory and climbed down the ladder into the courtyard, picture in hand. The gate had closed behind him, so to leave the courtyard and get to his car, he had to climb a wall that was topped with barbed wire. Holding the picture in one hand, he used the other to grab the barbed wire and hurl himself over the wall. He and *The Duke* both fell hard to the ground, but neither was injured. He tossed the painting into the backseat of the car and started to drive off.

Bunton had driven maybe three hundred yards when a policeman in the street stopped the car. With Goya's *Duke* sitting unconcealed in the backseat, Bunton thought that his caper was over and he was headed for the hoosegow. But the policeman was simply checking the sobriety of someone driving at an improbable hour. Whatever offenses he may have committed, Bunton did not drink while thieving. The policeman looked the sober young man in the eye, then waved him past. (Reflecting on the various near misses, Bunton says that he must have been watched over by a guardian angel.)

Bunton drove to the inn he was staying in on Grafton Way off Tottenham Court Road. He whisked the picture up to his room and put it under his bed. He then drove the car several miles west before abandoning it in a suburban street and taking the Tube back to Warren Street Station. After catching up on sleep, he decided that the painting's frame was an unnecessary encumbrance. He removed it and chopped it up with a junior hacksaw. Later that day, he dumped the parts in the Thames River at Victoria Embankment. Of the various versions Kempton Bunton gave regarding what happened to the frame, the true one involved it ending up in the Thames—albeit with John, not Kempton, the man who so disposed of it.

John called his father that night and said that he had in his possession a stolen painting. It was the second shock that day for Kempton, who earlier had heard about the theft of the Goya on the news. When his son mentioned stealing a painting, Kempton immediately put two and two together and said, "It's the Goya." He offered to rush down to London to help his son with the next step but had to borrow money from another of his sons, Kenneth, to make the trip. Kempton and John met at Kings Cross, found inexpensive lodging, and smuggled the painting in. They then found an even cheaper room, a Swiss cottage (a "basement bedsit") in Northwest London, for the purpose of storing the painting.

The unemployed Buntons had in their possession a valuable painting, but between them no cash, so each sought immediate employment. Kempton landed a job in a bakery, while John found employment driving fur coats around London. The latter employment gave John a van, which he used to transport the pilfered painting from their digs to the cottage. As a result, John received the only punishment he ever experienced related to the theft: "I was sacked from my job because I used the work van to transfer the painting from Grafton Way to a Kings College Road basement room, and somehow they noticed I went off route."

The discharge made him concerned that someone had seen him moving the picture, which led the Bunton father-and-son team to contrive to move it up north. They packaged it carefully, and Kempton took it on the train back to Newcastle—as he described in his memoirs and I recounted in chapter 6. His account of the theft and its aftermath in the memoirs artfully mixes fiction (the whole fabricated story of him stealing the painting) and fact (his description of how he handled the painting over the next four years).

John recalls Kempton's state of mind upon learning what his son had done: "Surprised and anxious, worried about the consequences. Not organized at all." John further describes the two of them scrambling to improvise in the wake of his ill-considered venture. "If you're in London with no money it's a hard business, and if you've got that picture under your bed, it's a harder business! It wasn't planned properly because when you do a thing like that, you don't think you're going to get away with it, and the further you go on you just make it up on the fly."

John followed Kempton to Newcastle. As he sat on a bus from the train station to his home, he saw someone seated in front of him reading a newspaper (the *Daily Express*) with the headline "No Goya, No Clue." As John Bunton would soon learn, "There were headlines about the case all over the world."

The first ransom note, written by Kempton just ten days after the theft, might suggest a man with a plan, but in reality, according to John, Kempton was winging it. He wrote the original ransom note because he feared instant apprehension and, in John's words, "wanted to soften the blow" by claiming that the theft was for charitable purposes so "we would not be classified as red hot thieves."

One thing led to another, and what began as an improvised effort to miti-gate the severity of the crime morphed into an extended ransom effort in which Kempton actually hoped to obtain money in service of his crusade on behalf of the elderly. The Com ransom notes were written by Kempton. The cause of safeguarding and eventually returning the painting became his. John Bunton had been the prime mover, but after the fact, the Goya caper became a solo op-eration by and for his father. Between September 1961 and the spring of 1965, John Bunton and his father never discussed the theft or the painting's fate.

That changed in March 1965, when Kempton asked John for his help in returning the painting. It is unclear why Kempton did not return the paint-ing himself, but perhaps a sense of symmetry appealed to the would-be play-wright: His son's involvement was the story's alpha and omega, with nothing in between. John Bunton stole the painting and returned it. Kempton did everything else.

He eventually concocted the plan to return the painting to the left lug-gage office in Birmingham, as well as the name Bloxham for John. John, aka Mr. Bloxham, is the one who actually returned the painting. That suggests one of the more remarkable aspects of this entire caper—John was in the courtroom throughout Kempton's trial, and he even took the witness stand at a time when the police were looking for Mr. Bloxham and had circulated an Identikit image of him.

Since the police remained on the lookout for Mr. Bloxham, it seems aw-fully cheeky, if not suicidal, for John Bunton to testify at his father's trial—in the very presence of some of the police officers involved in the case. When, almost a half century later, I asked John whether he in any way had altered his appearance or was worried about being recognized in court, he replied: "No, because I didn't know about the artist's [Identikit] impression that was circulated. When I took the stand I knew I'd only have to answer one question (about the typewriter) because it was arranged beforehand by Hutchinson, so I wasn't unduly concerned about being recognized." And thus, at a trial in which the jury convicted the wrong man, the actual culprit took the witness stand to testify about a minor matter.

Two months after the painting's return, Kempton gave himself up for exactly the reason he gave in his memoirs—he feared that Pamela Smith was

about to come forward and collect the £5,000 reward. This was consistent with the version he gave police and at trial, except for the identity of the person to whom he had recklessly confided. However, even apart from claiming that the would-be rat was an old male friend, rather than his son's girlfriend, at trial Bunton dissembled a bit about his motives for coming forward. It wasn't so much a desire to keep Pamela Smith from making off with the reward money. Rather, Kempton sought to protect his son John: If Smith came forward, she was going to say (as she later in fact did) that John had stolen the painting. Kempton sought to preempt her identification of his son as the thief by taking responsibility himself.

Meanwhile, both John and his brothers Kenneth and Tommy sat silent during their father's trial, watching him testify at length about a crime they knew he did not commit. The reason they did so is simple: They were following Kempton's unambiguous orders. Kempton had little trouble convincing his sons that the opportunity to evangelize about his cause easily trumped the risk of a short prison sentence (and he didn't expect worse). So Kempton took the fall for his son's crime.

Chapter 22: SECOND MYSTERY SOLVED

As discussed in chapter 20, in 1969, four years after Kempton Bunton's conviction, someone else came forward and confessed. Though the new confessor was never publicly identified (much less prosecuted), decades later writer Sandy Nairne correctly speculated that this man might have been John Bunton. And with the benefit of the lengthy DPP file, along with John Bunton's recollection, we can piece together what transpired when he came forward and why the authorities chose not to prosecute him.

On May 30, 1969, John Bunton, accompanied by his brother Kenneth, was driving south. The plan was for Kenneth to help John get a job at Granton Lions railway sweeper company, where Kenny worked in a supervisory capacity. The brothers failed to make it that far, getting pulled over by police (for reasons that remain unclear) just outside Huddersfield. A quick check revealed their vehicle to have been stolen. Because Kenneth had a few prior convictions, John, who was behind the wheel, took sole responsibility for the theft. The police accepted Kenneth's claim of ignorance and let him go. They arrested John, took him into custody at Milgarth Street Police Station in Leeds, and charged him with theft of a motor van and operating the vehicle without insurance. While in custody, he was read his caution before being interviewed by Detective Constable Christopher Roy Forder.

Early in the interview, John Bunton said, "There are a couple of things that have been troubling me for some time. Are you going to take my fingerprints?" Forder replied that his fingerprints and photograph would be taken in due course and his fingerprints would be matched against marks found at the scenes of outstanding crimes. That prompted Bunton to reply, "I want to get something off my chest. It happened in London, but I don't want to say any more until I've seen a solicitor."

Forder did what the law required, terminating the interview and advising Bunton as to the procedure for obtaining legal counsel.

The next day, Bunton appeared at Leeds City Magistrate Court, where the magistrate denied him bail and remanded the case until June 6. On that date the case was further postponed until July 8, but Bunton was allowed out on bail and appointed legal aid assistance: Richard Vaughan, a solicitor from the Leeds firm of Fox Hayes Airedale House.

On Monday, June 9, Vaughan phoned Forder and informed him that his client wished to admit to an unrelated offense in London. Since that involved a different jurisdiction, Forder informed Detective Inspector George Chandler of West End Central.

On June 11, at 1 P.M., Chandler and Detective Sergeant Richard Bott interviewed John Bunton, in the presence of his solicitor Richard Vaughan, at the Leeds police station. Immediately after introductions were made, Vaughan declared his client responsible for the removal of the Goya from the National Gallery in 1961 and asked his client to verify as much. "Yes," Bunton replied. Vaughan stated, "Mr. Bunton was told by me that he was letting himself in for trouble. Nevertheless, I am not sure that he has committed an offense." Bunton was coming clean, Vaughan explained, because he "has no previous convictions and would like to clear up the old matter from London."

Chandler proceeded to read Bunton his rights and asked if he was willing to make a statement. Bunton replied, "It's not so simple. I took the painting from London but after that up until I handed the painting into the left luggage office in Birmingham, I did not see it."

Chandler responded, "After the statement has been taken, I will clear up any points which have been raised by way of questions which will be recorded with the answers given by you."

Vaughan chimed in to remind the officers that Bunton's father had been convicted only of stealing the painting's frame and had received a sentence of just three months. He angled for similar lenient treatment for his client, noting that "Mr. Bunton said to me that when he took the Goya he had no intention of permanently depriving anybody of it."

Chandler ignored this remark and asked Bunton to explain what had

happened, going "stage by stage," starting with the theft in August 1961. Bunton agreed and proceeded to give a lengthy statement, taken down by Sergeant Bott. The statement was read back to Bunton, who signed it. At that point Chandler asked a series of clarifying questions, which, along with Bunton's replies, were taken down by Bott. These too were signed by Bunton. The entire process took five hours. At 6 P.M., Chandler informed Bunton and his attorney that the matter would be referred to the DPP and that they would receive the results in due course.

Bunton's fifteen-hundred-word statement began with his father's unsuccessful campaign for free television for the elderly and his own determination, in early August 1961, that "if I was to remove a picture from the National Gallery this would draw attention to my father's campaign." He then described in detail his employment and whereabouts in and around London throughout August and how "on a number of occasions while I was in London I visited the National Gallery." He explained exactly how he had stolen the painting, giving roughly the account set forth in the previous chapter.

After Bunton gave the statement, Chandler asked why Bunton hadn't told the police the truth during an interview (discussed below) conducted in the aftermath of his father's trial.

"It would have been ridiculous," John Bunton replied. "I didn't want to be involved in any charges."

Chandler asked whether Bunton was certain he had been alone when he had taken the painting.

"Of course I was on my own. That's obvious."

Chandler asked several questions about the mechanics of the theft, which Bunton answered in convincing detail. Having established the likelihood that John Bunton had in fact taken the painting, Chandler sought to determine what had happened in the aftermath, including the possible role of accomplices. He asked about Kenneth Bunton's role, and John said that he had never discussed the theft with his brother. Chandler asked whether, in the immediate aftermath of the theft, John had told Kempton that he wished to burn or otherwise dispose of the painting. (Chandler had in front of him the statement Pamela Smith had given police during Kempton's trial, which included the claim that John had considered arson.)

Quite the contrary, John Bunton replied, "Extra care was taken with it and such a thing would not enter one's head."

He said that when he turned the painting over to his father, the latter explained that he "intended to use it as a tool in his campaign and that it should ultimately be returned to the National Gallery." John Bunton reiterated that in March 1965 he dropped the painting off at the left luggage office in Birmingham, but he did not recall giving Bloxham as his name. As far as he could remember, he gave no name because "none was required."

Under Chandler's prodding, John Bunton recalled that he had testified at his father's trial about the typewriter and "absolutely" had told the truth.

Why had he allowed his father to be prosecuted for his crime?

"He ordered us. It was his wish."

Chandler asked Bunton if he would supply a handwriting sample, and Bunton readily assented.

It would have been easy for the police to dismiss John Bunton's confession. The case, for several years an embarrassment to the government, had finally been brought to a resolution by the jury verdict in November 1965 and then had mercifully faded from public view. Why reopen it? The public already knew that the government had failed to recover the painting for four years. Did it now have to know that, after the painting was finally returned, the wrong man had been prosecuted and convicted? Sweeping this new development under the rug must have been sorely tempting.

To its credit, the DPP did no such thing. To the contrary, it delved deeply in an effort to corroborate or disprove John Bunton's confession. It began by contacting the men he had listed as his employers and landlord during the summer of 1961. According to the 174-paragraph report eventually produced, it was "established beyond doubt that he was in London at that time." The DPP noted that his account of how he had stolen the painting made sense, though it could not verify that an automobile had been stolen in the area where Bunton claimed to have seized his getaway car. The report on the investigation noted only one "major discrepancy" between Bunton's account and the evidence in the case: "He claims to have taken the painting during the

early hours of the morning . . . whereas the attendants at the Gallery discovered the painting was missing before midnight the previous day."

Chandler's report revealed, for the first time, an intriguing postscript to Kempton Bunton's trial. As noted in chapter 13, the trial was interrupted by Pamela Smith coming forward to tell police that John Bunton, not Kempton, had stolen the painting. While it was in both the defense's and government's interest to ignore her contention, and thus her allegation never came to light, the police apparently took it seriously. Chandler's report noted that, on December 2, 1965, two weeks after Kempton Bunton's conviction, Detective Chief Superintendent Ferguson McGregor Walker and Sergeant William Johnson had interviewed John Bunton. Indeed, the DPP file following Bunton's 1969 arrest includes that interview.*

The first substantive question asked of John Bunton at that time was whether he had assisted his father in posting any letters. He replied: "I don't know who has been saying these things. I don't want to discuss this affair at all." He wasn't kidding. Asked for "some details about where you have been living for the past four years," he replied, "I couldn't remember." He pointedly denied that he had deposited the painting in the left luggage office and also denied any knowledge of what had happened to the frame. Probably primed by Pamela Smith's statement, the authorities asked why he had written his father from London in August 1961, saying that he was in trouble and wanted his father to come see him. John Bunton said, "I can't remember writing such a letter." They asked point-blank if he had taken the painting, and of course he denied doing so. The interview ended abruptly when Walker noted that there were marks on some relevant letters and asked if Bunton would supply his fingerprints so it could be determined whether he had written or posted any of them.

"No," he said, which surely did nothing to dampen their suspicion. But they opted to let the matter lie.

Reviewing the transcript of this interview four years later, during the 1969 investigation triggered by John Bunton's confession, Detective Inspector Chandler noted that "in view of what has since transpired it is significant that [Bunton] refused to allow the officer to take a set of his finger impressions for elimination

* John Bunton recalls that this interview took place at 3 A.M. in the Roughton House hostel, with the cops for some reason paying him a middle-of-the-night visit. The DPP file neither verifies nor refutes this recollection.

purposes." With Bunton now under arrest, they no longer needed his permission (which in any event he granted). They took his fingerprint impressions.

Chandler also interviewed the other relevant Buntons. In the late afternoon on June 19, he and Sergeant Bott visited Kempton Bunton in his home in Newcastle upon Tyne. Now sixty-five, Bunton was unemployed and living on his old age pension, supplemented by national assistance. Chandler told Bunton what he already knew: His son John had given a statement claiming that he, not Kempton, had taken the painting. Chandler showed the statement to Bunton, who simultaneously declined to read it and corroborated it. "It's a long statement, too long to read," he said. "One question I can answer. Did he steal it? He did take it."

"Were you with him when he took it?" Chandler asked.

"I can say no more than he took it. I know I am liable for a false trial."

"What do you mean by that?"

"Telling lies in Court. I never took the painting, it was John."

At this point Chandler saw fit to give Bunton the legal caution. Bunton found himself in a bind—wanting to acknowledge that John had taken the painting but wishing to avoid conceding that he had perjured himself in claiming his own guilt on the witness stand. He tried to thread the needle, telling Chandler, "The only question is that John has admitted something that is quite true. Where do you go from here? Is there any purpose of going further?"

"That is a matter for the Director of Public Prosecutions. Will you tell me why you said you took the painting?"

"John is a young chap and I didn't want to see him in trouble."

"Did you send a telegram to John when he was living in Grafton Way, London, in 1961?"

"I don't know, I can't remember."

"Did he meet you at Kings Cross Station?"

"That's all been said. I was not anywhere near when he took the painting."

At this point Bunton saw the wisdom of actually reading his son's statement and asked for "a carbon copy . . . so I can read it at leisure."

Chandler replied, "No, there's plenty of time for you to read it now," and handed Bunton a copy. Kempton read through it and said, "That seems pretty right."

"You mean that what your son has said coincides with what actually happened?"

"Yes."

"Do you wish to make a written statement?"

"No. Definitely not."

Chandler informed Bunton that the findings from the investigation would be turned over to the DPP and he would soon learn his fate.

"I'm not worried about myself," Kempton Bunton replied. "I'm an old man now, but John is a young man. Surely he needn't be charged."

"That is not a question I can answer," Chandler said, and the twenty-five-minute interview came to an end.

Several days later, joined by a different officer, Detective Constable Eric Price, Chandler interviewed Kempton's son Kenneth. A little after 2 P.M., on June 24, they summoned Kenneth to Oldham Police Station. Upon arrival, he said, "I've heard of you from John, you saw him in Leeds, didn't you? But why do you want to see me?"

Chandler ignored the question, asking Bunton to verify that he had lived "with a woman called Pamela Smith" from 1963 until 1965, and he received a surprising reply.

"Yes. I'm still living with her now."

"I understood that she left you and went back to live with her husband in November, 1965," Chandler said.

"Yes, for three days. She has been with me ever since."

If Kenneth is to be believed (and he had no motive for dissembling on this point), Pamela Smith's decision to come forward during Kempton's trial was triggered by a short-term crisis in her relationship with Kenneth. Chandler turned the interview with Kenneth away from Pamela Smith and toward the question of ultimate fact.

"Your brother John has admitted to me that he took the Goya painting from the National Gallery in August, 1961. Do you think he is telling the truth?"

"I'm certain he is," Kenneth said.

"Why are you sure?"

"Well, back in 1961, my father used £70 belonging to me to go down to London to help John, who he said was in some sort of trouble. When he came back he told me that John had stolen the painting from the National Gallery."

"Would you like to make a written statement regarding this matter?"

"No. I am putting nothing in writing."

"Has John ever told you himself that it was he who took the painting?"

"Yes, but only since he was arrested in Leeds."

"Did you assist your father in packing the painting when he brought it back to Newcastle?"

"No. I never saw the painting and never had anything to do with it."

"Wasn't there an agreement between you and your father for yourself to get a quarter of any reward for the recovery of the painting?"

"No."

"Why didn't you come to the police when your father gave himself up in 1965 and tell the true story?"

Kenneth gave essentially the same answer his brother John had given two weeks earlier (bolstering their credibility, unless they had coordinated their stories): "The old man wanted it that way. If any of us had gone against him he would never have had anything to do with us again."

Thus concluded the forty-minute interview.

In his statement, John Bunton claimed to have written the May 20, 1965, letter to the *Daily Mirror*, which included with it the ticket to the luggage office where the painting could be retrieved. Ronald Mitchell, director of the forensic science laboratory in Cardiff, then compared Bunton's handwriting sample to the writing in the letter and on the envelope. In a letter dated July 8, 1969, Mitchell acknowledged similarities but also differences between John Bunton's sample and the original items. He could neither implicate nor exonerate Bunton.

The authorities left no stone unturned in their effort to verify John Bunton's confession. For example, John claimed to have received from his father a telegram in August 1961, after he notified his father of the theft. The authorities attempted to trace the telegram but discovered that records of telegrams are kept for only nine months. The eight-year gap between the theft and John Bunton's confession hindered the investigation, but some of the relevant events had taken place in 1965 and were more easily corroborated. For example, the investigation confirmed that John Bunton had been employed as a radial arm

driller and living in Birmingham from May 1965 until August 6, 1965, leading Chandler to find it "more than likely true" that he had posted the letter to the editor to the *Daily Mirror* (postmarked Birmingham) that led to the painting's recovery in the left luggage office in Birmingham. Bunton also appeared to be truthful in claiming to be the man who returned the painting, since he had worked in Birmingham at the time and the description given by the luggage room attendant who received the painting "undoubtedly fits John Bunton."

In July Chandler issued a lengthy report detailing the full narrative of the theft given by Bunton, as well as the results of the exhaustive investigation to determine its accuracy. Toward the end of the report he wrote that "in view of the somewhat complicated nature of this admission, i.e., John Bunton's father already having served a sentence of imprisonment for stealing the frame of the painting," he had arranged with the head of the DPP, Sir Norman Skelhorn, to discuss the new developments and how best to proceed.

Chandler's report acknowledges the absence of definitive proof corroborating John Bunton's confession, but it clearly comes down on the side of regarding the confession as true. The reasoning seems sound. Kempton and John Bunton had given similar accounts of how each had taken the painting. Presumably, the false confessor had adopted the details given to him by the true confessor. Paragraph 168 of the report states, "If the painting was in fact stolen in the manner described by both Kempton and John Bunton, I am more inclined to accept the admission of the latter as the correct one." The reason is straightforward—the very reason Kempton's claim to have taken the painting was initially greeted with skepticism by the police and later Judge Aarvold. As Chandler's report observes, the heavyset, fifty-seven-year-old Kempton Bunton would have been hard-pressed to pull off the theft, whereas his son "was only 20 years of age, is still of good physique and would have been quite capable of taking the painting in the manner in which he describes."

In addition, Chandler's report notes, "There is no reason to suppose that he made this admission with any ulterior motive, i.e.,—for him or his father to obtain money from a newspaper for the 'true story' of the theft."

What then *was* the motive for John Bunton coming forward in 1969, four years after his father's conviction? In its 2012 article breaking the news that John was the culprit, the *London Guardian* explained that Bunton had

"panicked when he was arrested and fingerprinted in Leeds in July 1969 for a minor offense. He was worried that he had left his prints at the National Gallery or on the stolen painting" and figured he would be better off telling police than if they discovered the truth themselves. The *Guardian* presumably based its assessment of Bunton's motive on the DPP file from Bunton's 1969 arrest and confession, in which Chandler's report states that the confession was "only made because Bunton, who following his arrest at Leeds had had his fingerprints taken for the first time, believed that he had left them at the National Gallery or on the stolen painting, and thought that he would be treated more leniently by the courts if he admitted his guilt."

But Bunton claims this account of his motives is inaccurate. In fact, he knew he had left no prints behind but was concerned, nevertheless, that he would somehow be discovered and prosecuted in the future. He decided to confess because "he was already in custody and thought he might as well be killed as a sheep than a lamb, and thought if they didn't prosecute him now they wouldn't be able to prosecute him in the future."

As noted, Bunton wasn't charged, and the authorities did not release his name to the media. Bunton speculates that the police "regarded the case as closed. They didn't want any kerfuffle. They were probably embarrassed by the whole episode, convicting the wrong man. . . . They shoved the whole thing under the rug as quickly as possible."

In fact, the DPP file establishes that the authorities took John Bunton's confession seriously, investigated it exhaustively, and indeed came to believe it. Why then did they not prosecute Bunton? Chandler's report noted that doing so would not exonerate Kempton. Even in John's account, Kempton had possessed the painting for several years. Accordingly, Kempton was "quite clearly an accessory after the fact," and thus "his conviction would appear to be still good in law." The case file shows that government attorneys researched the matter thoroughly, with one memorandum citing and summarizing numerous cases to establish that Kempton's involvement after the fact, receiving and holding onto goods he knew to have been stolen, may have constituted *animus furandi* (intent to steal) under the law.

But the matter wasn't so simple. Since it couldn't be shown that John Bunton intended to keep the painting permanently, his act of taking it did not

constitute theft under the odd Larceny Act. Accordingly, Kempton's receipt of (and caretaking of) the painting arguably did not constitute receipt of stolen goods. However absurd, Kempton had essentially received and concealed legally borrowed goods. But there was also the matter of the frame. As the author of this legal memorandum declared, "the destruction of the frame by the father is evidence of an animus furandi."

Far be it from Kempton being wrongly punished, he had gotten off easy. As the Chandler report acknowledged, if John Bunton's confession was true, Kempton had committed elaborate perjury at his trial. Although the report did not discuss this point, criminal defendants are rarely prosecuted for perjury, especially when they are found guilty of the underlying offense. Prosecuting Kempton for taking the fall, while defensible (especially since he had shielded the actual wrongdoer from prosecution), would hardly be a great use of prosecutorial resources. One unsigned memorandum in the DPP file discussed the pros and cons of prosecuting John Bunton for the theft while declaring without explanation, "I do not think we need pursue the matter of Kempton Bunton's perjury."

As for prosecuting John, well, the same defense made by Kempton at his trial would be available to John: He never intended to deprive the National Gallery of the painting permanently and therefore was not guilty of theft. The jury had accepted that argument in Kempton's case, and there was no reason to think that another jury would find differently. Was it worth going through another lengthy trial so that John Bunton, like his father, would serve a few months in prison? Besides, John was probably headed for prison anyway on account of the auto theft that had brought forth his confession to the Goya theft in the first place.

Internal DPP documents suggest that the authorities were of two minds about the matter. The aforementioned unsigned memorandum opines that "all the surrounding circumstances tend to point to John as the actual thief" but notes that Kempton and Kenneth Bunton "refused to make [written] statements and obviously would be unreliable witnesses," leaving the difficulty of prosecuting John "solely on his own admission," especially in a matter "so stale." However, the author of the memorandum ruefully concluded, "The press have got hold of this and I feel that it would be difficult not to take action."*

* The press "getting hold" of it angered John Bunton. The DPP file includes a letter from him complaining that his statement had obviously been divulged to print reporters and the BBC and that "I was told before making the statement that it would be a private statement."

Ultimately, that is exactly what the authorities did—nothing. (And the press failed to hold them to account.) While they took their time reaching that decision, John Bunton anxiously awaited word. On July 11, Bunton's solicitor, Richard Vaughan, sent a letter to the DPP brimming with impatience. The letter noted Bunton's heretofore clean record and urged that "all proceedings against him be concluded at the earliest possible opportunity" and that "we should be obliged if you would let us know as soon as possible when a decision has been reached upon the reports relating to the painting."

Vaughan's missive apparently spurred action. He received an instant reply, dated July 14, from a DPP official named P. J. Palmes, informing him that a decision would be reached within the next few days. As it happens, the very next day Palmes received Chandler's report. A little over a week later, in a letter dated July 24, Palmes informed New Scotland Yard that he would not propose prosecuting John Bunton, because "in my view, there is not sufficient evidence that he had the requisite intent of permanently depriving the owners of the painting or the frame at the time of the taking." The quirk in the larceny law that had spared his father (mostly) also spared John Bunton, although Palmes failed to mention that in saying that there was insufficient evidence of intent to steal the *frame*, he was implicitly disagreeing with the jury that had convicted Kempton on that count. Palmes added, "I do not propose taking any proceedings for perjury against Kempton Bunton for any apparently false evidence he gave at his trial," but he offered no explanation for that decision.

In a terse letter dated July 24, Palmes gave Vaughan the good news: "It is not proposed to take any proceedings against your client John Bunton in respect of the taking of the Goya painting from the National Gallery in 1961."

Philosophers and psychologists consider inaction a species of action, but government agencies don't necessarily see things that way. The government saw no reason to inform the media of the decision not to reopen the Goya case. No press conference was held, no statement released. The media forgot about the matter. Concern about adverse publicity proved unfounded.

Had the media remained vigilant, it would have learned that the decision not to prosecute stemmed from the nuance of the larceny law and that the authorities in fact believed that John Bunton, not Kempton, had stolen the painting. The winner from the media's neglect was the government (which

wanted no publicity); the loser was anyone concerned with historical accuracy. For several decades, almost everyone assumed that Kempton Bunton was indeed the thief.

Of course, John Bunton was not completely out of the woods. In his July 24 letter, DPP spokesman Palmes wrote, "As far as the offense respecting the van is concerned, the Director will not be intervening in that case." Bunton's liability for stealing the van and driving without insurance rested in the hands of the Leeds police. Here again, he proved fortunate. They allowed him to plead guilty and get off with a fine of £200. John Bunton had stolen a valuable painting and two automobiles (the getaway car in 1961 as well as the one that landed him in trouble eight years later) and never served a day in prison.

His ability to escape punishment reached a rather ridiculous point evocative of O. Henry's *The Cop and the Anthem,* in which the protagonist, Soapy, cannot land in jail despite his best efforts. John Bunton had testified at his father's trial, even as an Identikit of him circulated widely, without being spotted as the Bloxham who had returned the painting. Four years later, even when he confessed to the crime, nothing happened.

From that point on, John and Kempton, and John's brothers Kenneth and Tommy, maintained the tightly kept family secret. Pamela Smith, the only other person in on the secret, died in the early 1970s. Kempton died in 1976, his obituary identifying him as the man who had stolen the Goya.

John Bunton, for his part, went on to live a long and happy life. Like his father, he worked various jobs as a driver (taxi, chauffeur, bus, delivery van, ice cream truck) all over England. That changed when he met his future wife, Irene Richardson, whom he married in 1974. His wife stayed home raising their three children and tending to nine German shepherds (over twenty years), while John worked as a mechanic for twenty years before establishing a household furniture removal business, which he ran until his retirement in 2012.

Christopher Bunton notes that his father combined an entrepreneurial spirit with impressive mechanical ability: "He would go to auctions monthly to purchase broken typewriters and lawn movers, which he would fix up and sell to supplement his income." Chris also notes that, during his upbringing,

his father was never out of work and never broke the law. (Indeed, John claims never to have broken the law after 1969, and no evidence contradicts him.) John loves boats, and he took his children on several boat trips as well as ferry holidays to Norway, Belgium, Holland, and the Norfolk Broads.

The son who helped make Kempton Bunton famous became, certainly by comparison to his father, a font of stability and responsibility.

Chapter 23: **A HERO FOR OUR TIME**

If in centuries hence, novelists, dissertation writers, or documentarians want to understand modern times with reference to a single story, they could do worse than study the kidnapping of *The Duke of Wellington* and its long aftermath. From a police force besieged by cranks and actively seeking assistance from cranks (such as psychics), to a justice system ill equipped to ferret out false confessions and too willing to take the path of least resistance, to a newspaper with an uncanny instinct for self-promotion procuring the purloined painting—from start to finish the caper exhibits features that reflect both the farcical and serious sides of modern times, especially the bit character who thrust himself onto center stage.

One could see Kempton Bunton as a perfect hero. Unselfishly motivated by a good cause? Check. Willing to take risks for that cause? Check. Eager to protect others? Check. Stoical when caught and punished? Check. An ordinary man who through imagination and daring thrusts himself upon history and becomes a name? Check.

While his particular cause may seem puny, Kempton Bunton recognized it as a subset of something larger. We can mock the idea that old people need easier access to television, but, as Bunton himself at times insisted, the very smallness of this cause arguably accentuates a larger evil. With the poor in our midst suffering endless deprivations and indignities, must we gratuitously add to their plight by denying them the tiniest daily pleasures and palliatives? And, of course, Bunton's crimes with respect to *The Duke of Wellington* were not random acts to raise funds for charity. Rather the immediate trigger was the expenditure of a large amount of money—including the very taxpayers' dollars that could alleviate pain and poverty—on a single work of art. One needn't be a philistine to question the priorities of advanced Western societies

and lament that the well-to-do have the luxury of valuing ornaments while others struggle for subsistence.

But, of course, an opposite narrative is equally available. Kempton Bunton was not a historian, a philosopher, or a statesman, and certainly not a connoisseur of art. He lacked any understanding of how masterful works of art can elevate civilization—indeed, how they can even provide insight, however indirectly, into the kinds of social issues he felt so passionately about. His command of history was questionable too. Aside from a few puerile attacks, Bunton never gave the Duke of Wellington much thought, never considered whether a society might need men like him (as icons as well as on the battlefield itself), much less why the world might prosper from masters like Goya. Accordingly, he was not one to appreciate the possibility that a portrait of the duke by Goya might actually have importance. And to the extent Bunton ever asked himself whether a society can afford to accommodate thievery, even by well-meaning crusaders, the answers he received were weak and self-serving. Kempton Bunton a hero? It is just as easy to see him as a man of grandiose plans and fundamental ignorance—a lethal combination. When we add in his outsized, dramatized self-perception, we have the recipe for a tragic buffoon rather than a hero.

Indeed, there is a strong Falstaffian quality to Kempton Bunton, embracing everything from his name to his girth to his colorful language, his inflated self-image and his comic, antic nature. Through the sheer largeness of his gestures, however weird, Bunton staked out a position on life's stage, forced us to notice him and even admire his audacity. Falstaff is *both* heroic and a tragic buffoon. Might we say the same thing about Kempton Bunton?

Perhaps, but the more one learns about the man, the more one recoils as well. A combination of three traits creates serious uneasiness about Bunton. First, zealotry. It is one thing to attach oneself to a cause, quite another to be so consumed by the cause that one loses all perspective. Let us posit that old people should be allowed to watch television or, more broadly, that more should be done to assist the plight of the poor—not just in England circa 1960 but in most places at most times. Let us even posit for the sake of argument that governments should spend little on the arts, or at least should prioritize them less than assisting the poor. Let us go one step further and posit that the

BBC licensing fee was foolish, even cruel. And to complete the circle, let us assume that the government should not have spent a substantial sum to keep Goya's *Portrait of the Duke of Wellington* in England. (The painting ending up in the United States would hardly have amounted to cosmic injustice.) Even if we posit all that, Kempton Bunton's reaction was overwrought.

By any measurement, *stealing* the painting and attempting to ransom it off was sheer folly. Moreover, anyone could see as much except someone so blinded by his cause as to ignore all competing considerations, not to mention all rational calculations of means and ends. Such zealotry became all too common in the twentieth century. We've witnessed more than a few people (first Japanese pilots, then Middle Eastern terrorists) who have forfeited their own lives to inflict maximum suffering. Small-time zealots like Kempton Bunton cause infinitely less harm, but to the extent they are driven by excessive attachment to an idea, they reflect the same temperamental flaw, a destructively passionate intensity.

Bunton also exhibited a second dubious trait that even more directly ties to the zeitgeist: his lust for the limelight. Andy Warhol is often quoted as predicting a world in which everyone would enjoy fifteen minutes of fame. In the program accompanying an exhibition of his work in Sweden in 1968, Warhol did proclaim, "In the future, everyone will be world-famous for 15 minutes." It appears that Warhol was drawing on a discussion he had had two years earlier (1966, the year after Kempton Bunton turned himself in) with the accomplished American photographer Nat Finkelstein. At least according to Finkelstein, Warhol remarked to him that "everyone wants to be famous," and Finkelstein replied, "Yeah, for about fifteen minutes, Andy."

Regardless of who gets credit for the sentiment, it proved prophetic—increasingly so in the world of social media to emerge in the twenty-first century. Almost anyone reasonably resourceful and perseverant can achieve a brief appearance in the limelight, often for something trivial and transient. Because even fleeting flame can be alluring, the daily fare of social media and cyberspace more broadly includes a fair amount of craziness (not to mention dishonesty and malice). Increasingly, the talented and talentless alike exploit technology and play to our society's collective weakness for real and contrived thrills and diversion. The man who brought New York to a standstill

by walking across a tightrope connecting the World Trade Center towers in 1974 is the subject of several books and documentaries. Just a decade earlier, Kempton Bunton exploited the same aesthetic weakness. It is hard to imagine a better instance of Everyman making himself Somebody and briefly commanding the stage. Zealotry combined with that instinct for fifteen minutes of fame—does that not make Kempton Bunton the quintessential man for (or slightly ahead of) our time?

We have, to this point, been ignoring a crucial datum about Bunton— one that was in fact ignored for fifteen years and that necessarily calls for a reassessment of the man. He did *not* steal the Goya. Of course, it has always been assumed otherwise for a good reason. The wrongful conviction of Kempton Bunton was a case of inaccuracy but not injustice. Rather, from almost the moment he learned what his son had done, Kempton Bunton embraced the act as his own. He never corrected the misconception, not even in his memoirs. There was a fleeting moment, after his son confessed in 1969, when Bunton acknowledged his own innocence. But when the authorities chose not to pursue the matter, he blithely resumed his identity as the proud convicted felon, the man who had pulled off a great crime in service of a great cause and gladly paid the price for his deed.

This leads directly to the third of Bunton's potential tragic flaws—his indifference to truth. In his interview with the police, in depositions, at his trial, and in his memoirs, he did not hesitate to lie. While many of Bunton's fabrications centered on the theft of the painting, and thus helped deflect attention from his son John, his motivation went beyond paternal protectiveness. He may have convinced himself that this was his sole motivation, but he didn't quite convince his son. A half century later, John Bunton described his father's motives as follows: "His goal was to ensure I wouldn't be in any danger, and his TV license campaign was a convenient personal motive aimed to put the focus on him. The fact that it was able to draw attention to his campaign was a bonus. I also think he thought the publicity may help him get his plays published."

John Bunton is surely correct that his father's mixed motives involved a degree of personal aggrandizement. But, all things considered, John's assessment seems too generous. Kempton Bunton could have helped his son cover

up the theft easily enough simply by concealing or anonymously returning the painting. Instead, he did almost the opposite. He seized on his son's action and turned it into his own crusade. Even more, he turned it into his identifying act, that for which he would be long remembered. (In his biography of Jeremy Hutchinson, Thomas Grant observed that Bunton had established his place in an "English gallery of demotic hero-villains" led by Robin Hood.)

Bunton clearly relished his notoriety. His detailed memoirs, which he tried to market, revolve around the theft. He went to his grave cultivating his image as the man who had stolen the Goya. It was a brazen case of identity theft (although his clever attorneys might have argued that it is not identity *theft* when the "victim" voluntarily yields his identity, as John Bunton effectively did).

Kempton Bunton didn't just seize credit for a crime he had not committed; he clung tenaciously to that credit. In his seventy-five-thousand-word memoirs, he never gets more worked up than when discussing Pamela Smith's claim that he was not the actual thief. When considering his comments about Smith's accusation that John Bunton was the culprit, we must keep in mind that she was *correct*. Nevertheless, Bunton refers to Smith as a "dangerous lunatic," a "troublemaker," a "hysterical unstable woman," a "slanderer," and "a public nuisance." And he's just getting started. Smith's claim that John was the Bunton who stole the Goya was a "cock and bull story" bred of "desperation" for some combination of money, revenge, and notoriety. Or so Kempton speculates while lamenting that her dastardly motives "will forever be a mystery to me."

Bunton excoriates a fair number of people in his memoirs, but often with some leavening reflection, some recognition of nuance or mitigating circumstances. His assault on Pamela Smith, who *exonerated* him of a felony, stands out for its single-minded ferocity. Maybe an element of this is personal—there is an intimation of some unusual relationship between Smith and Bunton, and she and his son Kenneth had a volatile relationship. But what drove Bunton crazy was Smith's official declaration that someone else had pulled off the daring theft of the Goya. She threatened his (bogus) identity, an unforgiveable sin.

A Bunton defender might respond that he waged his hyperbolic attack on Smith to divert attention from the accuracy of her charges and thus to protect

his son. That hypothetical defense is unconvincing. If all he cared about was protecting John, Bunton could have left Pamela Smith's accusation out of his memoirs altogether rather than highlighting it. Smith's claim was never aired publicly. Bunton went out of his way to address it and (if his memoirs were to be published, as he hoped they would be) therefore publicize it. She clearly touched a nerve. How dare someone suggest that he was not in fact the important historical figure who had pulled off an art theft for the ages?

The fact that Kempton Bunton did not actually take the Goya only enhances his allure. Seizing on someone else's crime has a special audacity and also illustrates the difficulties that pervade any legal system. Possessing a stolen object for four years and attempting to ransom it off constituted multiple felonies. On top of that, Bunton committed serial acts of perjury. None of that was punished. Instead he was convicted for something he didn't do. You get your fifteen minutes one way or another, even if for the wrong reason. And, at a time when we are learning about the frequency of wrongful convictions, he stands as a colorful example—someone who wished to be acquitted even as he wished to receive credit for the acts for which he stood trial.

Kempton Bunton was a charming charlatan who took himself too seriously. While he lays a claim to our attention, the real hero of this story is in most respects his opposite, genetics notwithstanding. The apple fell far from the tree.

John Bunton stole Goya's *Portrait of the Duke* in part to support the cause of his overwrought father. In the immediate aftermath of the theft, Kempton came to London to protect John. But, over time, they essentially changed places and reversed the natural order of things—the son protecting the needy and immature father. John wouldn't put it that way, in part because he dislikes attention and lacks grandiosity. For the better part of fifty years, John Bunton lay low and allowed his father to indulge his crusade, enjoy the limelight, and feel consequential.

John Bunton's life, like his father's, lends itself to vastly different prisms. The case for him as anything but heroic is easy to make. John's single public accomplishment involved committing a felony that he himself dismisses as "stupid." He then let someone else take the fall for him, and he spent the rest of his life in anonymity. To be sure, one should credit him with turning away

from a life of petty crime and becoming a responsible citizen and devoted father. Those accomplishments, common though they may be, are the sort that sustain civilizations, recalling the lovely ending to George Eliot's novel *Middlemarch,* the paean to all the ordinary folks "who lived faithfully a hidden life, and rest in unvisited tombs."

But John Bunton's life has been "hidden" in a way that is much more interesting than that of most ordinary folks. If Kempton Bunton's defining act involved stealing his son's identity, John's defining act was willingly yielding his identity to his father. Kempton, but not John, has a Wikipedia page. If someone were to write one for John, it would surely emphasize that the most significant event of his life is one he mostly hid from.

Yet seeing John as a mere supporting actor in his father's farce turns reality on its head.

When Christopher Bunton first confirmed that his father, not his grandfather, had stolen the Goya, he remarked similarities between the two: His father, like his grandfather, had started life as a mischief-seeking ne'er-do-well. But they turned out fundamentally different. Kempton talked a good game, but he never could have taken the Goya. By contrast, his son had the requisite physical ability to squirrel *The Duke* out of the National Gallery, and also the will. But John lacked imagination. He acted first, thought later. What could he do with the painting? Call his father. After that, he was done with it—whereas Kempton's genius lay in his ability to dream up and execute a plan to exploit the theft after the fact. They were, in hindsight, a perfect criminal pair, a father–son team for the ages: One had the wherewithal to do the crime, the other to take the credit.

If Kempton Bunton was all talk and no action (at least with respect to the Goya), John Bunton was all action and no talk. Whereas his father spilled tens of thousands of words fabricating how he had taken the painting, treating the police and jury and would-be readers of his memoirs to multiple versions, John Bunton himself said next to nothing, even when asked. When I queried whether any part of him felt proud to have pulled off the near-perfect crime, the only theft of a painting in the history of the National Gallery, he replied, without elaboration, that the theft was "the stupidest thing I ever did."

John Bunton's recognition that a felony that accomplishes nothing should be lamented rather than celebrated already puts him well ahead of

246 | *The* DUKE *of* WELLINGTON, *KIDNAPPED!*

his father in terms of self-awareness. But the bigger difference between them is really the difference between John Bunton and most people in comparable situations: He never attempted to capitalize on his notoriety. Even after he was outed and could easily have come forward to exploit his youthful escapades, he opted to remain out of the limelight. Asked whether he ever felt that his father had usurped him, John replied tersely: "I never wanted credit." Chris, his son, confirms that John has always been "keen to avoid media attention."

Unlike Kempton and the legions of others who get their fifteen minutes of contrived fame, John Bunton really did do something noteworthy—immoral and illegal for sure, but certainly impressive, indeed (as respects the National Gallery) unprecedented. John Bunton could have taken bows for the physical accomplishment and boldness, even while acknowledging the ultimate folly of the deed. But he has declined to celebrate himself in any fashion. He lacks his father's attachment to public declaration. He will produce no memoirs explaining, justifying, and calling attention to himself.

While John Bunton eventually came forward and agreed to the true story finally being told, he did so out of concern for his family. He maintains hope that this book "will bring attention to Kempton's plays and give them a chance to be published or at least seen by someone that counts." If that happens, he remarked, perhaps it will "lead to some kind of financial legacy that would add more irony and be so fitting."

John Bunton adds, "I wouldn't be surprised if it happens." He may have inherited his father's excessive optimism, but he has surely earned the right to expect the improbable.

Chapter 24: (NON)CONCLUSION

Starting the day the Goya was noticed missing, August 22, 1961, until more than fifty years later, when newly released documents established that the wrong Bunton had been blamed and punished for the theft, the case was always a combination of whodunit and howdunit. For almost half a century, chroniclers of this crime thought Kempton Bunton the culprit, but there were always some who doubted Bunton's guilt. The notion that a large, elderly man could not have committed this crime accounted for the open skepticism of Judge Aarvold at Bunton's trial and may have influenced both the jury and Aarvold himself in holding Bunton only minimally accountable.

As it turned out, the doubters were right—the theft was pulled off by the much younger and more athletic John Bunton. That Kempton Bunton knew the actual culprit explained the major piece of evidence supporting his guilt: the bizarre ransom notes revolving around his pet cause. His son stole the painting, but Bunton wrote the notes. It all came together.

It *should* come together—such is the nature and appeal of true crime. When law enforcement, reporters, or amateur sleuths eventually piece together the facts surrounding a crime, the seemingly inexplicable becomes explained, mysteries are resolved. Robert Frost's epigram about poetry's payoff, the "momentary stay against confusion," applies equally to crime solving. We figure out not just the who but the how and everything else. The world, or at least this slice of it, comes to make sense.

When I was first attracted to the Goya theft many years ago, it was precisely because of the tantalizing unanswered questions. Was it sheer coincidence that the painting was stolen fifty years to the day of the theft of the *Mona Lisa*? How *did* Kempton Bunton pull off this athletic feat? Or, if Bunton was innocent, why did he take credit/blame for the theft? Why did a jury produce the remarkable verdict of guilt for stealing the frame but not the painting? Who was the Mr. Bloxham who returned the painting? Who was the man who confessed in 1969?

As I began finding answers to these questions, other questions emerged. The fact that John Bunton, not Kempton, kidnapped *The Duke of Wellington* explained a lot but opened up new lines of inquiry—because, as it turns out, people should have known all along that John Bunton was the actual culprit. Pamela Smith came forward and fingered John Bunton as the thief during Kempton's trial. John Bunton *himself* came forward and confessed in 1969. The confirmation decades later that he was telling the truth raised anew a crucial question: Was he disbelieved and if so why? If he was believed, why did the authorities not prosecute him? It is particularly difficult to put together a puzzle in which the pieces keep changing.

I have tried to answer all the pertinent questions raised by this case. Readers will judge how successfully. But if the goal of true crime is to put together a large and complex puzzle, it is rarely fully achieved. The awkwardness of experience usually frustrates the attempt to create a consistent narrative that explains all the pertinent facts. Think about the O. J. Simpson case, a crime exhaustively investigated and the subject of literally dozens of books. Virtually all observers conclude that Simpson did in fact murder his ex-wife Nicole and Ron Goldman, and most pieces of the puzzle fit, but a few remain discordant, such as the fact that the glove left behind by the killer did indeed appear too small for Simpson's hand. Was it sheer coincidence that this glove was discovered by Mark Fuhrman, a rogue cop who had been removed from the case and thus had a motive to "solve" the crime dishonestly? In leaving such issues unresolved, the Simpson case was more rule than exception: In the real world, the evidence rarely fits tidily into a narrative that explains everything.

On the other hand, when the pieces that do not fit are too large or too central, we cannot be confident that the crime really is solved. In the Simpson case, there are reasonable explanations for the ill-fitting glove, various ways it may have shrunk. As for Fuhrman being the one to find it, well, such things happen. Moreover, maybe Fuhrman *did* plant the glove, in an effort to frame a man who was in fact guilty. Perhaps none of these things seems likely, but one of them is probably the case. If improbable meant impossible, numerous solved crimes would have to be declared unsolved.

But when it comes to the theft of Goya's *Portrait of the Duke of Wellington*, a *large* problem remains. After perusing thousands of pages of documents and

talking to various people with firsthand knowledge of the theft and/or trial, after reading Kempton Bunton's memoirs and peppering John Bunton with questions, after reading the files of Kempton's attorneys, just about everything fits into place. Indeed, all but one question has been answered satisfactorily. As it happens, that one question goes to the heart of the case: the timing of the theft.

Timing is obviously a crucial component of many criminal investigations, particularly in murder cases. The authorities have numerous vehicles for estimating time of death, ranging from the well-known (autopsies) to the more obscure (forensic entomology—the study of insects surrounding corpses). These sciences tend to be inexact, creating a focus, in many cases, on whether the accused could have committed the crime given the relevant time frame. Depending on the particular set of facts, either the prosecutor or defense argues that the apparent time of the crime is more flexible than one or more witnesses or other evidence would suggest.

The situation involves different particulars, but the same general idea, with crimes other than murder. No expert could shed light on when *The Duke of Wellington* had been kidnapped from the National Gallery, but none was needed: Eyewitnesses did the trick. Because the painting was seen at 7:40 and noticed missing shortly after 10 (and again shortly after midnight), and given that the security system went on around 9, it seems obvious that the painting was taken sometime between 7:40 and 9 P.M. However, this irresistible inference contradicts the account of the crime given by John Bunton.

In the original typewritten account of the crime that he gave me, Bunton said he entered the gallery at roughly 4:30 A.M. Of course, he could have been mistaken—but by so many hours? Could he really recollect going in at the crack of dawn when he actually did so at night? The unlikelihood is compounded by his specific recollection that, in the days before the crime, he held conversations with a security guard, who told him that the alarms were switched off at 4:30 A.M. for cleaners entering the building. Moreover, Bunton gave me a detailed account of how he spent the hours before the crime, including the fact that, after entering the yard post-midnight, he "had to hang around for 2 hours hoping alarms were off. At around 4:30 I went in."

What could possibly explain the enormous discrepancy between the apparent time of the crime and Bunton's recollection? The most obvious explanation is that someone simply remembers incorrectly. If so, whom? It has to be either two security personnel or John Bunton, but either option poses problems. On the one hand, it seems impossible that the security men were mistaken—partly because there were two of them and partly because they registered their perceptions contemporaneously, whereas John Bunton gave his account many years later.

It is at least theoretically possible that the two warders (both long since deceased) falsely claimed to have noticed the painting missing because they thought it even more incriminating if they failed to notice it missing. However, that would have been a strange calculation on their part, since no one knew when the painting disappeared.

More likely, then, Bunton was mistaken about the time of the theft. The problem, as noted, is that it seems impossible for him to be off by *so much*. At the conclusion of my research (long after he gave me the narrative stating 4:30 A.M. as the time of the theft), I mentioned to John in an email that security personnel reported the painting missing before midnight. He replied unequivocally, "It was 3 A.M. I'm not sure why they would say otherwise." Note that Bunton originally said 4:30. This change dovetails with a broader phenomenon: On any number of smaller points, Bunton's recollection today is at variance with his recollection at earlier points or with independently established facts. For example, he believes the police did not ask him for a fingerprint when they interviewed him in December 1965, two weeks after his father's trial. But contemporary records show that they did. And in 1969 he told police that he did not recall giving his name as Bloxham when he returned the painting, whereas he told me that he did in fact give that name (at his father's suggestion).

But the issue of timing is more significant. The time of the theft could have been 3 A.M. or 4:30 A.M., and there is no reason Bunton would remember—if he ever knew— the *exact* time. Imprecise recollection would not be unusual in the most normal of circumstances, and he was in the midst of committing a breathtakingly risky felony. Surely fear and adrenalin would compromise memory. But to be off by five or more hours? Again, this seems

nearly impossible, especially since taking the painting in the wee hours was central to John Bunton's narrative of the crime.

Is it conceivable that neither Bunton nor the security personnel are mistaken? In a Grisham-like potboiler, reality imposes few constraints and one could surely invent scenarios in which the painting was missing at 10 P.M. and stolen many hours later. Maybe the earlier disappearance was indeed on account of one of the innocent explanations originally assumed by the men who noticed it missing—it had been temporarily removed, only to be returned a few hours later, and then stolen by Bunton several hours after that. But such scenarios require fanciful speculation unsupported by any evidence. Occam's razor dictates the conclusion that either Bunton or the men who saw the painting missing are mistaken.*

So, in the final analysis, what can be done with the timing mystery? I close this book with a reflection and a question pertaining to this crucial unresolved issue.

Kempton Bunton essentially stole John Bunton's identity as the thief who pulled off the impossible crime. As John put it plainly, "He took my story and adapted it." The adaptation involved Kempton borrowing from the actual facts as described to him by his son, but there was also his characteristic embellishment and invention. To take just one example, the disguise and toy gun that Kempton claimed to have used (at least in some of his versions) figure nowhere in John Bunton's narrative; they can be chalked up to Kempton's fertile imagination. Or, to take a less exotic but more important example, John Bunton gives one clear and consistent account of what he did with the painting's frame; Kempton gave multiple accounts and multiple explanations for giving different accounts.

So we know that Kempton Bunton could not resist putting his own stamp on his son's story in the course of making it his own. Perhaps one of those liberties involved the time of the theft. Perhaps he saw something extra-romantic about making the heist in the wee hours rather than a more jejune time like 9 P.M. If Kempton Bunton appropriated his son's act, and to a great

* Occam's razor, an approach to problem solving created by medieval scholar William of Occam and accepted by most philosophers today, counsels selecting among competing hypotheses the one that requires the fewest assumptions.

degree his narrative, is it possible that John Bunton consciously or uncon-sciously did the same thing in reverse? After all, he was in the courtroom when Kempton testified in detail about how he pulled off the crime. Kempton then took ownership of the crime right up until his death in 1976, and apart from his panic-driven confession in 1969, John played along with the fiction of Kempton-as-thief until he was outed in 2012. Did John Bunton simply adopt Kempton's version of the theft, at least with respect to many particulars?

It may have been tempting for John to say, "The crime happened the way my father described it, except I was the thief, not he." That would have been easier than himself reconstructing all the details, many of which he might have forgotten by 1969 (eight years after the theft), the first time he was called upon to provide a narrative of the theft. And, having imported his father's timeline, did he perhaps come to believe it? Faulty memories can drive out the real thing. That, at any rate, is one possibility.

The discrepancy between reality (the likelihood that the painting was stolen the night of August 21) and John Bunton's firm recollection (that the painting was taken in the wee hours of August 22) is a nice note on which to end the tale of a saga that from the beginning sparked and sustained enormous confusion. The theft of Goya's *Portrait of the Duke of Wellington* befuddled Scotland Yard and gave rise to a trial notable for Kempton Bunton's elaborate perjury and the suppression of Pamela Smith's truthful account. The prosecu-tor, judge, and jury all acted oddly, in part because they were hampered by an incredible law. For good measure, the media and historians got things wrong for half a century. Is it not fitting that such a story still resists closure?

NOTES

CHAPTER 1

11. "so brazen that Agatha Christie herself would most likely have dismissed it as too farfetched"—"Art: And Now—The Duke," *Time*, September 1, 1961, 48.

11. "the most spectacular art robbery since an Italian workman lifted the Mona Lisa from the Louvre"—"Gone—The Iron Duke," *Newsweek*, September 4, 1961, 61.

11. "the most spectacular art robbery of the century," Frank Whitford, "The Secret Life of Kempton Bunton," *Arts Review*, 1972, 27.

11. "the most famous art rip-off England has ever known"—Sean Steele, *Heists: Swindles, Stick-ups, and Robberies: Crimes That Shocked the World* (New York: Metro Books, 1995), 74.

12. "The Great Duke" and "England's greatest son"—Alfred Lord Tennyson, "Ode on the Death of the Duke of Wellington."

13. "strained but full of energy, as well he might be"—"The National Gallery, January 1960–May 1962," National Gallery, 1962, 30.

14. "inarticulate almost to the point of incoherence"—Arthur Marwick, *Britain in the Century of Total War* (Boston: Little Brown, 1968), 424.

14. "a license should be refused because of the picture's national importance"— "Expert Advice If Export of Goya Sought," *London Times*, June 16, 1961, 14.

15. "Mrs. Wrightsman and I lead a very quiet life and we try to avoid publicity I had a father who told me, 'I never saw a deaf and dumb man in jail'"—"Charles Bierer Wrightsman, Philanthropist, Is Dead at 90," *New York Times*, May 28, 1986, B-7.

15. "would not wish to export the painting if it was considered of overriding aesthetic and historical importance to Great Britain"—"Goya Wellington Offered to Nation for £140,000," *London Times*, June 22, 1961, 12.

16. "a great and historic picture should now become the property of the nation"—"£100,000 Saves Goya's Duke for the Nation," *London Times*, August 3, 1961, 8.

17. "stealing art is a branch of burglary suitable only to the most skilled criminal"—"Amateur Burglary," *Time*, August 11, 1961, 45.

17. "protect it from moisture and strong light"—"Gone—The Iron Duke," *Newsweek*, September 4, 1961, 61.

17. "the sensation was dampened by the fact that everyone believed it to be a political gesture. And so it turned out to be" and "valued at 10 times as much as the Morisot"—"The Missing Goya," *London Guardian*, August 23, 1961, 6.

17. "Goya's portrait of the Duke of Wellington has disappeared from the National Gallery, it was announced yesterday," "removed for a legitimate purpose, such as being photographed elsewhere in the building," and "Interpol have been warned and ports and airports are being watched to prevent the picture from being smuggled out of the country"—"£140,000 Goya Vanishes," *London Times*, August 23, 1961, 8.

18. "the wide distribution of the thefts might suggest that an international gang is at work," "The motive for them seems obvious enough," "how and why they may be disposed of is more of a puzzle," and "no doubt many thieves count on being able to extract some form of ransom"—"An Unprecedented Year of Thefts," *London Times*, August 23, 1961, 8.

18. "from the same small group of artists and connoisseurs" and "practical experience of security in other fields"—letter to the editor, *London Times*, August 26, 1961, 7.

18. "false sense of security"—letter to the editor, *London Times*, August 26, 1961, 9.

18. "independent inquiry" and "the nation's art treasures are too precious for their safety to be left in the least doubt"—"Might It Happen Again?" *London Times,* August 31, 1961, 9.

18. "had considerable repercussions, even worldwide"—Eric Crowther, *Last in the List: The Life and Times of an English Barrister* (Plymouth, UK: Bassett Publications, 1988), 245.

CHAPTER 2

All quotes are from Kempton Bunton's unpublished memoirs, in the possession of the author.

CHAPTER 3

27. "should rule out the possibility of theft," "further patrols made [were] primarily regarded as precautions against fire," and "in a jocular manner, to keep myself clear in case something had happened"—Philip Hendy, "Director's Interim Report on the Theft of Goya's 'Duke of Wellington,'" National Gallery, August 25, 1961.

28. "Only an expert could have removed the picture undetected"—"Hunt Goes on for Missing Goya," *London Times,* August 24, 1961, 8.

28. "damaged by a maniac" and "easy detachment of pictures"—Philip Hendy, "Director's Report on Security before and after 21st August, 1961," National Gallery, September 8, 1961.

29. "Since August 22 the windows of both lavatories have been sealed"—Philip Hendy, "Director's Interim Report on the Theft of Goya's 'Duke of Wellington,'" National Gallery, August 25, 1961.

29, "an instruction particularly relevant to the events of August 21 was that
30. during closed hours a post was to be maintained if possible in the vestibule, "this has been impossible since 1957," "Immediately after the theft the Instructions were revised orally, "a completely new series were typed and issued before the end of August," "At least one Warder is stationed in the Vestibule during closed hours," and "kept permanently under lock

and key, day and night"—Philip Hendy, "Director's Report on Security before and after 21st August, 1961," National Gallery, September 8, 1961.

30. "Of all the incredible aspects to the theft last week of the famous painting, perhaps the most astonishing was that it went unreported for eleven hours"—"Gone—The Iron Duke," *Newsweek,* September 4, 1961, 61.

30. "These rules have had to go into abeyance during any large-scale rehanging of the Gallery such as has only recently been completed"—Philip Hendy, "Director's Interim Report of the Theft of Goya's 'Duke of Wellington,'" National Gallery, August 25, 1961.

30. "the fixing of tablets had been resumed immediately," "certainly been resumed nearly two months before the theft," and "the practice of fixing tablets was never regarded as a security measure"—Philip Hendy, "Director's Commentary on the Report of Enquiry into Security at the National Gallery," National Gallery, February 21, 1962.

31. "Warder Sergeant Barber on leave. Acting W.S. knew he should inspect lavatory but did not"—National Gallery emergency board meeting minutes, September 11, 1962.

32, "a first class man," "was on the list of staff which I recommended the
33. Committee to interview," "Frequent failure to fix the tablets," and—Philip Hendy, "Director's Commentary on the Report of Enquiry into Security at the National Gallery," National Gallery, February 21, 1962.

34. "from July 28, those yards have been made accessible to the Old Barrack Yard"—Philip Hendy, "Director's Interim Report on the Theft of Goya's 'Duke of Wellington,'" National Gallery, August 25, 1961.

35. "a piece of mud which looked as though it had been left by someone's shoe," "marks on the south gate," "I assumed to be marks of egress," and "on that gate I found long vertical marks on the inside"—deposition of Detective Inspector John MacPherson in case of *Regina v. Bunton.*

35. "inevitable weakness of contact in places, such as those caused by slight faults in doors, and owing to the presence of late workers in some parts of the building"

35. "The picture must have been taken from its place between 7:40 p.m. and about 9 p.m."—Philip Hendy, "Director's Interim Report on the Theft of Goya's 'Duke of Wellington,'" National Gallery, August 25, 1961.

35. Kenneth Clark's theory "Gone—The Iron Duke," *Newsweek*, September 4, 1961, 61.

CHAPTER 4

All quotes from Kempton Bunton's unpublished memoirs, in the possession of the author.

CHAPTER 5

47. *Swinging England—Time*, April 15, 1966, cover.

47. "the rollicking revolution of merrie England"—*Daily Express*, December 19, 1962, 69–70.

48. "in the interests of humanity at large"—"Demand for Goya 'Ransom' to Be Paid to C.N.D," *London Times*, September 2, 1961, 6.

49. "the poor hopeless little nut"—Ben Rogers, *A. J. Ayer: A Life* (New York: Grove Press, 1999), 279.

50. "might be a crank, someone playing a joke, someone who doesn't like the Duke of Wellington" and "I wouldn't be surprised if the painting isn't already on its way to one of those very, very private collectors in the U.S."— "Gone—The Iron Duke," *Newsweek*, September 4, 1961, 61.

50. "If a miser can find joy"—Richard Condon, "The Art Thefts," *Nation*, October 7, 1961, 229.

50. "Piccadilly Lock Pickers"—"They Remember Mona," *Miami News*, August 31, 1961, 6b.

51. "the theft may be prompted by misguided patriotism"—"Pictures as Booty," *London Times,* September 27, 1961, 13.

52. "Personally I see no reason to doubt the story"—"£140,000 Ransom Demanded for the Goya," *London Times,* September 1, 1961, 8.

53. "The art thieves I met in my career ran the gamut—rich, poor, smart, foolish, attractive, grotesque"—Robert Wittman, *Priceless: How I Went Undercover to Rescue the World's Stolen Treasures* (New York: Crown, 2010), 15.

54. "strict measures were taken by the National Gallery last night to protect their collection of Renoir paintings"—"Strict Guard on National Gallery after New Threats," *Sunday Times,* September 3, 1961, 1.

CHAPTER 6

All quotes from Kempton Bunton's unpublished memoirs, with the exception of the following:

58. "ridiculous tax" and "he said that he intended to carry the case to the end even if it meant going to prison"—"Viewer Objects to 'Ridiculous Television Tax,'" *London Times,* April 30, 1960, 4.

59. "treat the B.B.C. levy with the contempt it deserves," "sick of empty promises given by forgetful governments," "only concerned that you should pay your fine," "one man campaign against the Inland revenue and the BBC," and "I expect to be in and out of gaol a lot"—"Man with No TV License Faces Prison," *London Times,* May 20, 1960, 9.

62. "Perhaps the extraordinary price tags that have been placed on great art"—Richard Condon, "The Art Thefts," *Nation,* October 7, 1961, 229.

63. "flair for history"—Milton Esterow, *The Art Stealers* (New York: Macmillan, 1966), 15.

CHAPTER 7

70. "magnificent portrait of a great soldier" and "the joke has gone on long enough"—"Return Goya Plea by Lord Montgomery," *London Times,* July 6, 1962, 15.

70, "Whether the label is authentic or not, we do not know," "quite sure,"
71. "it is undoubtedly our label," and "This may be a clue that will lead somewhere"—"Letter Claims Stolen Goya Painting Is Safe: Duchess of Leeds 'Recognizes Label,'" *London Times,* July 5, 1962, 12.

75. "would like to contact those who have the missing Goya portrait in their possession"—*New Statesman* 66, no. 1708 (December 6, 1963):859.

78. "agreed that the letter came from the same source as two previous communications from the present holder of the picture" and "there was no action which could usefully be taken"—"Report from the Director," National Gallery, January 9, 1964.

78. "to me they were the ashes of something hard. . . . I am no expert, but it might have been the painting"—"'Goya Ashes' in Left Luggage Office," *London Times,* January 1, 1964, 10.

78. "To destroy the painting would give no real satisfaction"—"The Missing Masterpiece," *London Times,* January 6, 1964, 11.

79. "record-breaking crowds now coming to the Royal Academy would be delighted" and "I challenge those concerned with the Duke's present safety to accomplish this 'Rafflesian' task"—Sir Charles Wheeler, letter to the editor, *London Times,* January 7, 1964, 9.

79. "would probably be intensified rather than relaxed if it were returned anonymously" and "an opportunity for getting evidence that would catch the thief or thieves"—"No Yard Bargaining on Goya Return," *Daily Telegraph,* January 8, 1964, 17.

CHAPTER 8

All quotes from Kempton Bunton's unpublished memoirs, with the exception of:

87. "slightly built, well-educated man, probably over 35 years of age, living alone with his fear and mild paranoia"—Cal McCrystal, "The Mind of the Goya Thief," *Sunday Times,* March 21, 1965, 5.

CHAPTER 9

90. "I should have thought that a man of this degree of ingenuity," "temporarily appropriated," "do the sensible thing and return the picture," and "place all the treasures committed to our care"—"LD. Robbins Says Goya Offer Authentic," *London Times,* March 17, 1965, 12.

91. "People buy the *Mirror* not for the day's news, but to be entertained"—Cecil Harmsworth King, *Strictly Personal: Some Memoirs of Cecil H. King* (London: Weidenfeld & Nicolson, 1969), 105.

91. "bite-sized news, crime, sensationalism, astrology, sentiment, social conscience and sex"—Ruth Dudley Edwards, *Newspapermen: Hugh Cudlipp, Cecil Harmsworth King, and the Glory Days of Fleet Street* (London: Random House UK, 2003), 119.

91, "national art treasure," "deposit it in any safe place of his choice," "for the
92. benefit of any charity nominated by the present possessor of the painting," "cannot bargain. Nor can the Mirror," "this newspaper can and does invite the letter-writer to return the Goya," and "What matters most is that the historic painting by Goya should be speedily restored to the National Gallery and the nation"—"The Missing Goya and the Mirror. Our Sporting Offer to the Mystery Letter-Writer," *Daily Mirror,* March 18, 1965, 1.

93. "The man with the Goya has been in touch with the Daily Mirror" and "Nobody can guarantee that £30,000 will be raised by public exhibition of the Goya portrait"—"The Missing Goya: A Letter to the Mirror," *Daily Mirror,* March 24, 1965.

94. "be very careful with this," "well spoken and [having] sharp features," and "The paint surface was right and because of a general thing I can't explain about recognizing paintings"—Godfrey Smith et al., "The Goya Is Back: Hunt on for 'Mr. Bloxham,'" *Sunday Times*, May 23, 1965, 1.

95. "the man who had once asked £140,000 for the portrait had ended by paying 14 cents to get rid of it"—Milton Esterow, *The Art Stealers* (New York: Macmillan, 1966), 6.

97. "The man who defeated Napoleon at Waterloo was captured singlehandedly by a slightly crackers Robin Hood"—"The Duke Returns," *Newsweek*, June 7, 1965, 79.

97. "My Goya. The Mirror Found It"—*Daily Mirror*, May 23, 1965, 2.

97. "There are things which judges can do"—Ibido.

98. "I hope whoever had the Goya feels better now that he has sent it back"—George Martin and Barry Stanley, "How the Goya Returned Home," *Daily Mirror*, May 23, 1965, 40.

98. "The Man Who Got the Goya Back" and "It might have been some other newspaper, but it was, in fact, the Daily Mirror that brought the Goya portrait back to the nation" —*Daily Mirror*, May 24, 1965, 15.

98. "probably an artist"—Sally Moore, "Microscope on the Thief's Letters," *Daily Mirror*, May 24, 1965, 15.

99. "The man who returned the Goya is angry with this newspaper. In fact, he is very rude about its editor" and "perhaps the happiest ending of all would be for the man who stole the Goya . . . to choose this moment to vanish from contemporary history"—"Did the Mirror Pinch the Goya Back?" *Daily Mirror*, May 27, 1965, 1.

CHAPTER 10

All quotes from Kempton Bunton's unpublished memoirs, in the possession of the author.

CHAPTER 11

109- Account of interrogation of Bunton by Officers Andrews, Weisner, Johnson,
114. Walker, and Ion—depositions in case of *Regina v. Bunton.*

114. study of proven-false confessions [footnote]—Richard Leo and Steven
 Drizin, "The Problem of False Confessions in the Post-DNA World,"
 North Carolina Law Review 82 (2004):891–1007.

117. "Bunton sat impassively with his arms folded. Only when the portrait
 was produced as an exhibit did he move slightly to get a better look"—
 "How £140,000 Goya Was Stolen," *London Evening Standard,* August 17,
 1965, 12.

117. weighed seventeen stone—"Menaces Charge over £5,000 Goya 'Ransom
 Note,'" *London Times,* August 18, 1965, 5.

118. "the plea [to the landlady] went unheeded and the Duke stood un-
 adorned in the Old Bailey"—Eric Crowther, *Last in the List: The Life
 and Times of an English Barrister* (Plymouth, UK: Bassett Publications,
 1988), 245.

118. "just rather a darling. I had an affection for him"—Sandy Nairne, "From
 National Gallery to Dr. No's Lair," *Guardian,* August 6, 2011, 14.

CHAPTER 12

The various quotes from Bunton's trial depositions are in the public domain
and on file with the author.

129. "cunning"—Eric Crowther, *Last in the List: The Life and Times of an Eng-
 lish Barrister* (Plymouth, UK: Bassett Publications, 1988), 244.

129. Popat's recollection [footnote]—interview with author.

CHAPTER 13

The numerous quotes from the trial are from the trial transcripts, on file in the National Gallery archives.

131. "not only gracious in defeat but fluent in French"—Huw Richards, *A Game for Hooligans: The History of Rugby Union* (Edinburgh: Mainstream Publishing, 2007), 1927.

144. "If that's a Goya, I'm a virgin"—Bruce Page and Colin Simpson, "Doubts about the Duke," *Sunday Times*, May 30, 1965, 9.

CHAPTER 14

All quotes from Pamela Smith's account come from her written statement (November 11, 1965), on file with the author.

149. "But when I arrived in the morning at the usual hour"—author's interview with Hugh Courts.

150. "extraordinarily difficult legal question"—Ibido.

150. "knows of a credible witness who can speak to material facts which tend to show the prisoner to be innocent, [it] must either call that witness himself or make his statement available to the defense"[footnote]—*Dallison v. Caffery*, 1 QB 348 (1965).

151. "The only possible road to follow is to have closed the trial; to have dismissed the jury; then to convene a new trial; collect a new jury"—author's interview with Hugh Courts.

CHAPTERS 15 AND 16

The numerous quotes from the testimony of Kempton Bunton are from the trial transcripts, in the National Gallery archives.

CHAPTER 17

The numerous quotes from the testimony of Kempton Bunton are from the trial transcripts, in the National Gallery archives.

264 | The DUKE of WELLINGTON, KIDNAPPED!

184. "two charming old gentlemen having a sparring match"—Eric Crowther, *Last in the List: The Life and Times of an English Barrister* (Plymouth, UK: Bassett Publications, 1988), 242.

CHAPTER 18

The quotes from the trial testimony, closing statements, and judge's instructions are from the trial transcripts in the National Gallery archives.

188. Crowther recollections about John Bunton—Eric Crowther, *Last in the List: The Life and Times of an English Barrister* (Plymouth, UK: Bassett Publications, 1988), 243–244.

CHAPTER 19

The judge's instructions to jury and colloquy in court before, during, and after sentencing are from the trial transcripts.

196. "absolutely furious"—Thomas Grant, *Jeremy Hutchinson's Case Histories* (London: John Murray, 2015), 189.

197. "fulfill its function of administering justice with mercy and understanding"—Judge Carl Aarvold, "A Note from the Recorder of London," *American Bar Association Journal* 55 (November 1971):1105.

197. "Defendant Can Say He Was Framed"—*Reading Eagle,* November 17, 1965.

197. "MAN ACQUITTED OF STEALING GOYA"—*London Times,* November 17, 1965, 5.

197. "three months of prison we thought was harsh"—author's interview with Hugh Courts.

197. "normally a kindly and understanding judge" and "intrigued by the verdict"—Eric Crowther, *Last in the List: The Life and Times of an English Barrister* (Plymouth, UK: Bassett Publications, 1988), 245.

200. "The jury rocked with laughter"[footnote]—Eric Crowther, *Last in the List: The Life and Times of an English Barrister* (Plymouth, UK: Bassett Publications, 1988), 242–243.

203. "The identity of the young man—Mr. Bloxham—who brought the painting to the railway baggage office"—Milton Esterow, *The Art Stealers* (New York: Macmillan, 1966), 19.

203. "the mysterious and bogus Mr. Bloxham"—Hugh McLeave, *Rogues in the Gallery: The Modern Plague of Art Theft* (Boston: David R. Godine, 1981), 51.

CHAPTER 20

Various quotes of Kempton Bunton are from his unpublished memoirs, except:

205. newspapers reported attorney Hutchinson's—"No Appeal in Bunton Case," *London Times*, December 2, 1965, 12.

206. "got my goat, and that is why I left so abruptly"—letter to Hugh Courts, March 15, 1966, on file with author.

206. "one of the most interesting and idealistic clients I have ever had"—Eric Crowther, *Last in the List: The Life and Times of an English Barrister* (Plymouth, UK: Bassett Publications, 1988), 245.

206. "in view of the Goya case"—"Eighth Report: Theft and Related Offenses," Criminal Law Revision Committee. All subsequent quotes of the committee in this chapter refer to this work.

207. "had the unfortunate result of informing the world that deeds like his could be performed in England with impunity" and "legislation is now urgently needed to redress this"—"The National Gallery, January 1965–December 1966," National Gallery, 47.

210. "hundreds of people claimed to know where [the painting] was"—"Goya Theft Confession Will Go to DPP," *London Times*, June 23, 1969, 2.

210. "I know the man involved. He is the man who did it"—"I Know Who Stole £140,000 Goya," *Daily Express,* June 23, 1969, 7.

211. "splendid Mr. Kempton Bunton" and "railroaded to jail in a very shabby manner"—Bernard Levin, "Iconoclasts I Have Known," *London Times,* May 23, 1972, 16.

212. "where the suggestion is made that the thief might have been Bunton's son John"—Sandy Nairne, *Art Theft and the Case of the Stolen Turners* (London: Reaktion Books, 2011), 267.

CHAPTER 21

The various quotes from Christopher Bunton and John Bunton come from their interviews with the author.

CHAPTER 22

The various quotes from DPP interviews with John Bunton and other witnesses, as well as DPP memoranda and letters, come from the official DPP file on the case.

The various quotes from John Bunton and Chris Bunton are from their interviews with the author.

233. "panicked when he was arrested and fingerprinted in Leeds in July 1969 for a minor offense"—Alan Travis, "In The Frame: The Van Driver Who Confessed to Lifting a Goya—and Got Away with It," *Guardian,* December 1, 2012, 14.

CHAPTERS 23 AND 24

243. "English gallery of demotic hero-villains"—Thomas Grant, *Jeremy Hutchinson's Case Histories* (London: John Murray, 2015), 189.

The various quotes from Christopher Bunton come from interviews with the author.

DOCUMENTS AND PHOTOGRAPHS

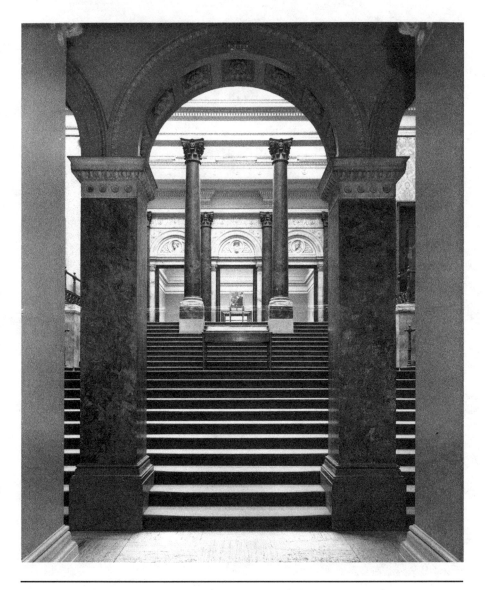

Beginning August 3, the Duke stood alone in a special exhibition.

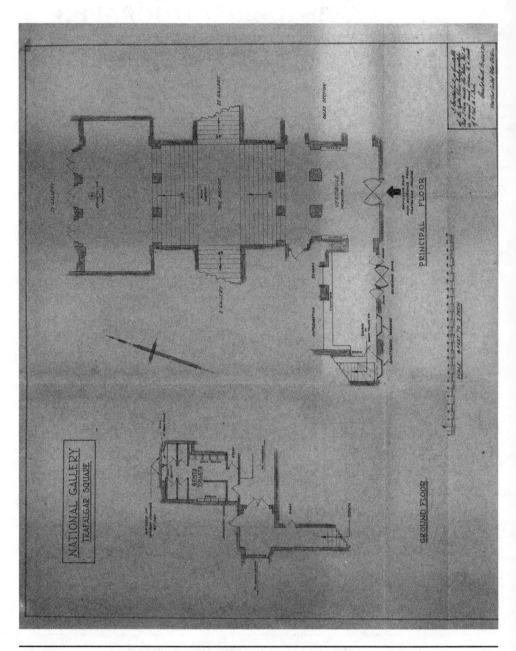

The thief made several visits to the National Gallery to assess the best means of entry.

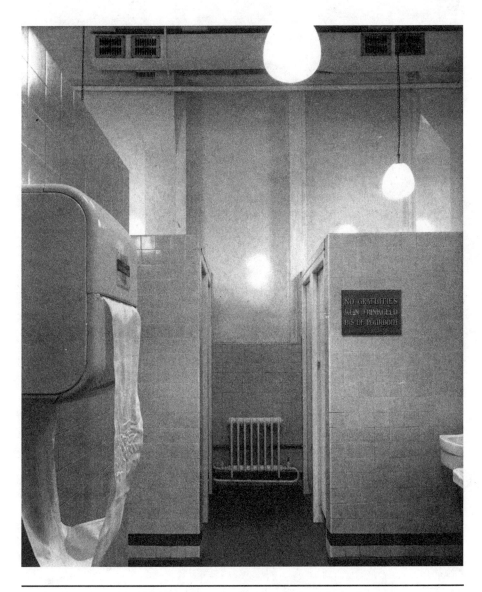

Scotland Yard quickly determined that the thief exited through this lavatory.

... NOT THAT ... I HAVE THE GOYA ... IT

... HAS A STICK LABEL ON BACK SAYING

... GALLAIS & SON DEPOSITORIES JERSEY.

NAME DUKE OF LEEDS. DATE 23.8.57

No. 2. IT HAS 6 CROSS RIBS EACH WAY (BACK)

THE ACT IS AN ATTEMPT TO PICK THE

POCKETS OF THOSE WHO LOVE ART MORE THAN

CHARITY.

THE PICTURE IS NOT DAMAGED APART

FROM A COUPLE OF SCRATCHES AT SIDE.

ACTUAL PORTRAIT PERFECT,

THE PICTURE IS NOT) AND WILL NOT BE FOR

SALE — IT IS FOR RANSOM — £140,000 — TO BE

GIVEN TO CHARITY)

IF A FUND IS STARTED — IT SHOULD BE QUICKLY

MADE UP, AND ON THE PROMISE OF A FREE

PARDON FOR THE CULPRIT — THE PICTURE WILL

BE HANDED BACK.

NONE OF THE GROUP CONCERNED IN THIS

ESCAPADE HAVE ANY CRIMINAL CONVICTIONS.

ALL GOOD PEOPLE ARE URGED TO GIVE, AND HELP

THIS AFFAIR TO A SPEEDY CONCLUSION.

13

Ten days after the theft, the first of several bizarre ransom notes arrived.

ACKNOWLEDGMENTS

I'd like to offer sincere thanks to the many folks who offered invaluable assistance.

For reading and commenting on drafts, special thanks to Noah Charney, Mark Simon, Christian Merkling, John Kleiner, Kathy Kenyon, Sheldon Hirsch, Joni Hirsch, Sarah Hirsch, and Marjorie Hirsch.

For invaluable research assistance, my sincerest gratitude to Rita Dicello and Kathy Kenyon.

Of the many people kind enough to share recollections about John Bunton, Kempton Bunton, and/or Kempton's trial, the following were particularly helpful: Hugh Courts, Surrendra Popat, Valerie Bailey, John Bunton, and Christopher Bunton. In addition, Mr. Courts and Christopher Bunton shared with me indispensible documents. Christopher's support and cooperation throughout warrant special mention.

Heartfelt thanks to Noah Charney for his enthusiastic encouragement and assistance at every stage of this project. Noah's contribution includes leading me to agent extraordinaire, Eleanor Jackson. Special thanks to Eleanor, in turn, for leading me to editor extraordinaire Rolf Blythe, and his team at Counterpoint, whose superb suggestions and editing are most appreciated.